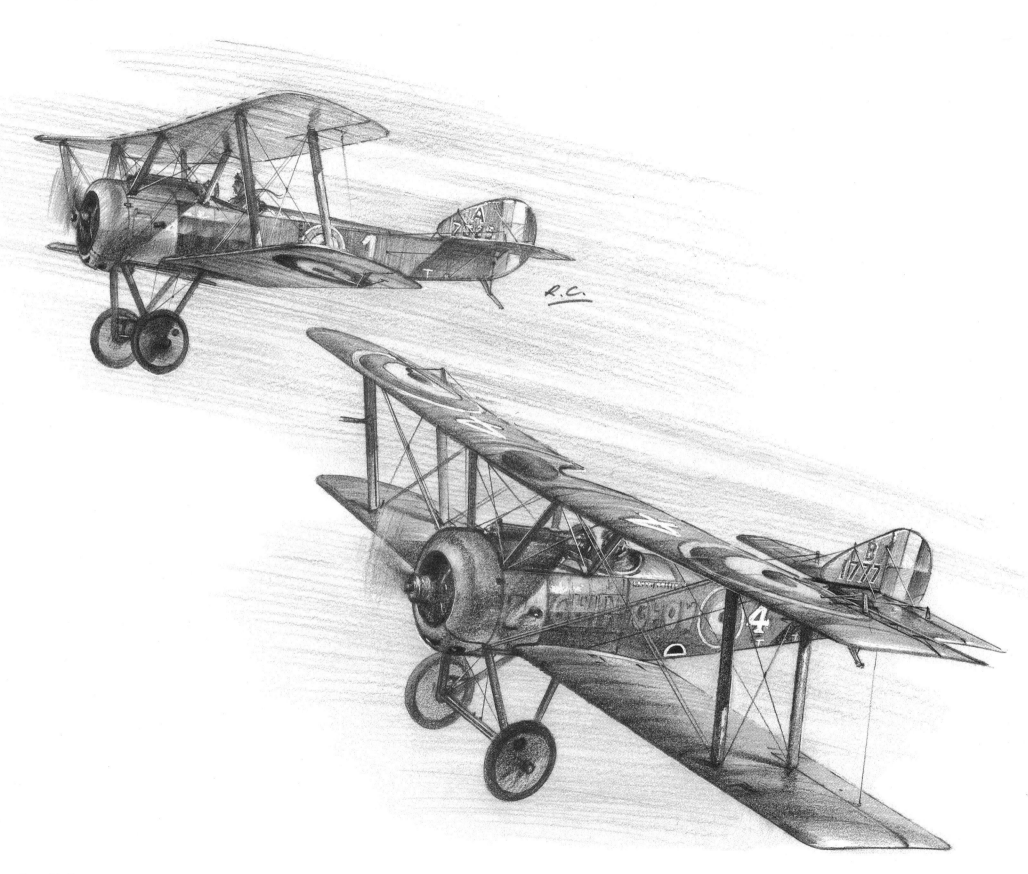

Sopwith Pups

CELEBRATION
OF FLIGHT

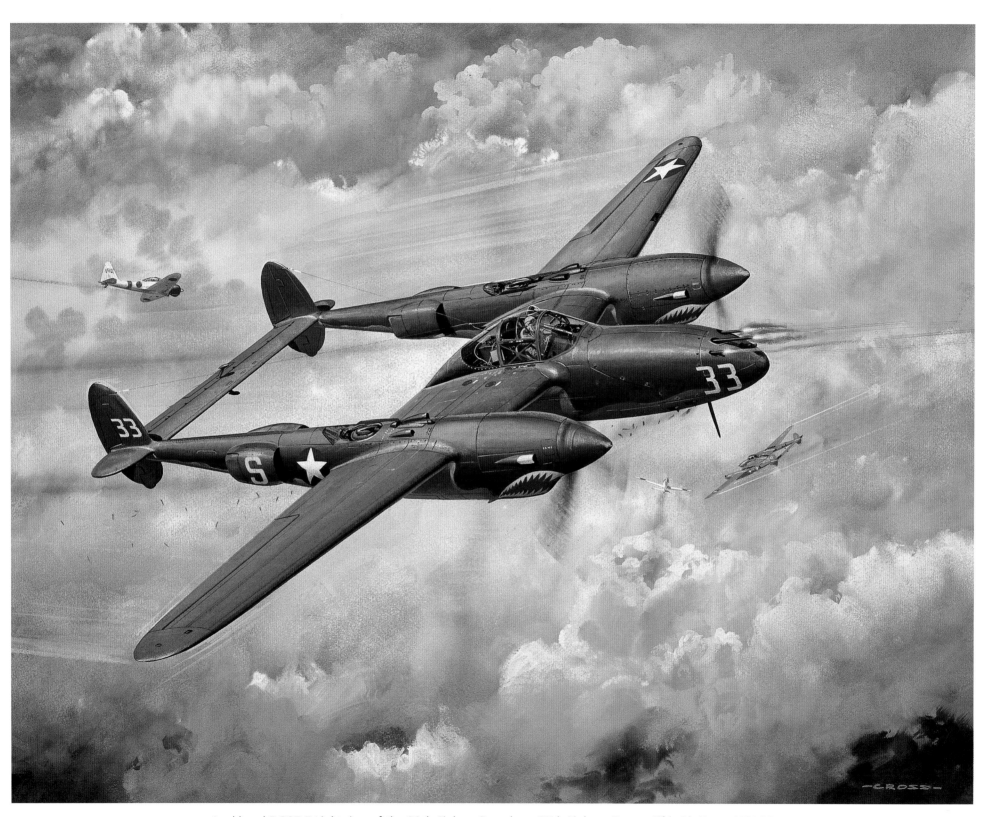

Lockheed P-38F-5 Lightning of the 39th Fighter Squadron, 35th Fighter Group, Fifth Air Force, USAAF.

CELEBRATION OF FLIGHT
THE AVIATION ART OF ROY CROSS
with Arthur Ward

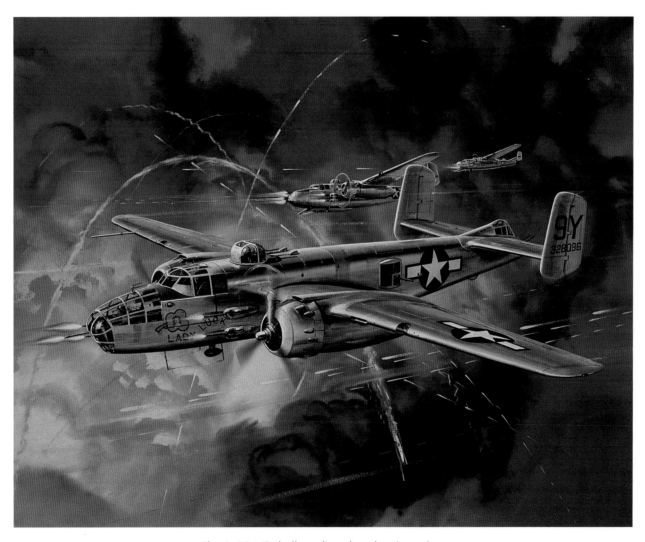

The B-25 Mitchell medium bomber in action.

Airlife

Acknowledgements

Dedication

To Rita and Anne

A helping hand and a slice of luck are useful ingredients in a budding career, and I am more than happy to mention some of these influences upon my artwork and endeavours later in these pages. More immediate acknowledgements for assistance in the preparation of this book are as follows: Humbrol Ltd for permission to include many illustrations originally created for the famous Airfix plastic construction kits. Without these this book would have been much slimmer and certainly less colourful (front cover, pages 2,3,13 bottom, 20 top, 22 top, 23,25,26,28,35,38 bottom, 43 middle, 50 bottom, 53 bottom, 58,59 bottom, 63 top, 64,72 top and bottom, 73,74,75,76,77 bottom, 78,79,81,82,83,84,85,86,87,90,91,93,98 top, 100,101,103,115 top, 119,122,123 top and bottom right, 124,125,126,128). Michael Oakey, editor of the splendid monthly *Aeroplane*, and Tim Hall who arranged the reproduction of illustrations and cutaways from the original publication *The Aeroplane* – and IPC Media Ltd (pages 24,31 inset, 109,112/113,116/117,120/121). Rights involving work done so long ago for the following are hazy; indeed some of the firms no longer exist or have been swallowed up in vast corporate entities. Nevertheless, they are acknowledged here as follows: Fairey Aviation Co. Ltd (page 5); Hawker Siddeley Group Ltd (pages 6,110,111); Shell Mex and BP Ltd (page 21 bottom); Rolls-Royce Ltd (page 29); *Eagle* (page 36 top); *Swift* (pages 108,114). Personal thanks are due to Trevor Snowden who has been of tremendous help with transparencies of so many illustrations; Gerald Coulson G AvA who allowed me to borrow his idea of a Spitfire Gallery; Wing Commander Bob Doe, DSO, DFC and Bar, RAF Rtd, leading Battle of Britain ace who helped me with the markings of his Hurricane fighter (page 55); Group Captain Ken Cornfield RAF, OBE, MA for his help with the Tornado painting (page 127); Elizabeth Cross for her computer skills and Anthony Cross for his boundless encouragement; of course to Airlife Publishing and to Arthur Ward for his major contribution to this book and, not least, for his enthusiasm for my artwork!

Roy Cross

First published in 2002 by
Airlife Publishing, an imprint of
The Crowood Press Ltd
Ramsbury, Marlborough
Wiltshire SN8 2HR

www.crowood.com

This impression 2012

British Library Cataloguing-in-Publication Data
A catalogue record for this book is available from the British Library.

ISBN 978 1 84037 326 4

Printed and bound in China by Everbest Printing Co. Ltd

Foreword

Aviation illustration appears to be as old as practical flight itself; pioneering balloon flights were the subject of popular art prints starting in the eighteenth century. The Wright brothers' successful flights in 1903 initiated an astonishing growth in worldwide development of the aeroplane, and the general public could attend an increasing number of air shows and aerial competitions, publicised by splendid full-colour posters by leading commercial artists of the day. As happened with the motorcar, technical journals appeared such as *Flight* (1909) and *The Aeroplane* (1911), which almost from the start featured engineering sketches and general arrangement drawings of the innumerable aircraft and aero-engines under construction. In fact, most of the elements of modern aviation art were in existence well before 1914.

Official war artists during the First World War, including academicians, created some early masterpieces depicting aerial combat and more general aviation subjects. Growing public interest sparked by the great pioneering flights of the 1920s and 1930s was fuelled by new popularist aviation periodicals, especially in Great Britain and the United States, and it was the artwork in these that stimulated my youthful imagination and led me to try to emulate them.

Roy Cross

Like many other plastic modellers of my generation, I was often inspired to choose a particular Airfix kit because of the quality of the striking illustrations on their box-tops. At the time I didn't know the originator's name, but his paintings were a crucial motivator in my choice of kit and a contributing factor to the firm's pre-eminence in the 1960s and 1970s. I well remember rushing home with the Series 7 Boeing B-29 'Superfortress' kit, the artwork for which, I'm pleased to say has been chosen for the cover of this book. In adolescence I became aware of the artist's name, but it was not until I was introduced to him as I prepared my fiftieth anniversary commemorative history of Airfix, that I got the chance to meet Roy Cross. Later he invited me to collaborate on a planned book of his aviation art, and I discovered that 'the Airfix years' were but part of a very rich and diverse story (for example during the last three decades he has also carved an enviable niche in the field of maritime art), some of which I attempt to relate within.

Arthur Ward

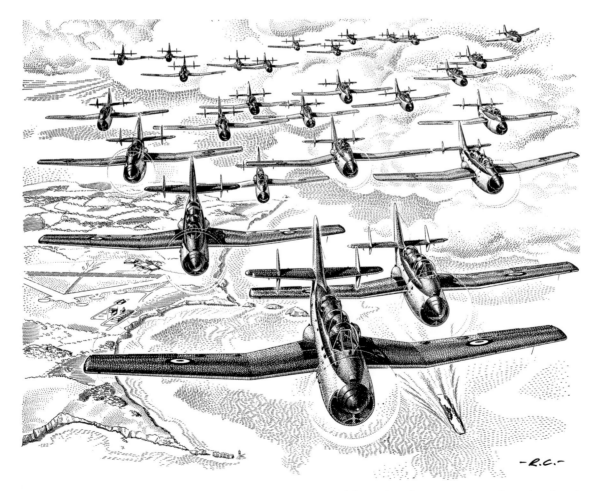

Line version of a colour advertisement for Fairey Aviation Co. Ltd featuring the Gannet search and strike aircraft.

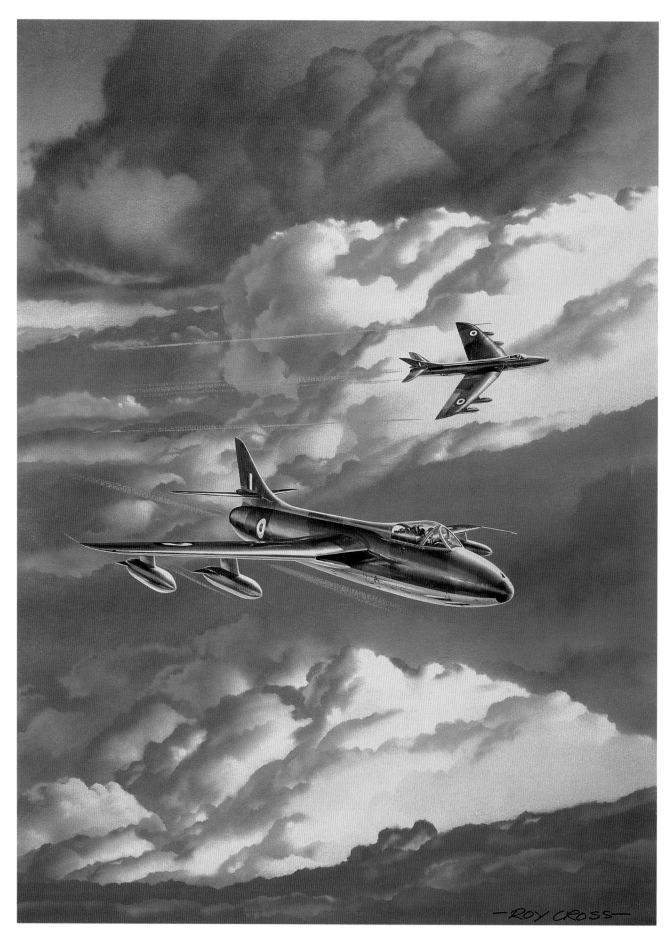

The Hawker Hunter, generally accepted as one of the best-looking aircraft of its day. The painting was one of a series of advertisements for Hawker Aircraft Co. Ltd.

FAR RIGHT:
Front elevation of the Nieuport Type 24bis flown by French First World War ace pilot Charles Nungesser.

Contents

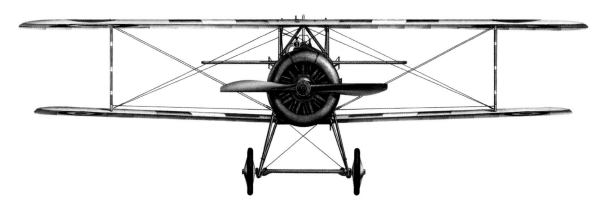

Beginnings and Influences

Like many schoolboys during the 1930s, Roy Cross was 'air-minded' – fascinated by everything to do with aviation. Because of his interest, he joined the Air Defence Cadet Corps (later the Air Training Corps) in 1938. Despite this start, he did not ultimately join the RAF as he had originally planned but instead embarked on a long association with aircraft via an altogether different route – employment in an aircraft factory, where his creative talents propelled him towards the comparatively new field of technical illustration. His early induction into the British aircraft industry began an association with aeroplanes which spanned more than half a century and saw Roy create some fine examples of British aviation art, earning him an enviable reputation as a master of his craft.

Roy's acquaintance with the shop floor and drawing office of an aircraft firm at such a young age was of inestimable value. Being so closely involved with the process of aircraft design and manufacture gave him an intimate knowledge of the intricacies of aircraft construction.

Although his first 'proper' drawing was of a sailing ship (today, he is an acclaimed marine as well as aviation artist), as a boy he never tired of drawing aircraft. During the 1920s and 1930s the aerial exploits of pioneers like Jim and Amy Mollison in Britain and Charles Lindbergh in the United States were front-page news, catching the mood of the time and Roy's imagination. Roy remembers seeing the giant Zeppelins, which had been introduced during the 1930s ostensibly for civil aviation purposes but of equal use for propaganda and espionage. He still recalls the steady beat and drone of the *Graf Zeppelin's* giant Maybach engines as the leviathan made its stately progress overhead.

Inspiration for his drawings came partly from pre-war airshows and Roy was lucky enough to visit some of the annual RAF pageants at Hendon – the core of the Air Defence of Great Britain organization. 'I also remember going to Kenley before the war to one of the Empire Air Days,' he recalled. 'Those lovely old silver biplanes – Gloster Gladiators – and the smartly turned out pilots, all spick and span in their white flying suits and helmets, are snapshots from memory'.

Having a relative who possessed a substantial collection of books about art history – and who just happened to live near to an aircraft factory – Roy was able to combine his growing interest with his curiosity about painting and illustration. 'We had the privilege of having an aunt who lived in the country, and with my brother I would spend long summer holidays at her home near de Havilland's new factory at Hatfield.' He remembers tramping across the fields to view from the perimeter the garden-party atmosphere of de Havilland's open days. 'I also remember sitting in her greenhouse on a rainy day reading books from the Victorian or late Edwardian period full of fine historical paintings – wonderful classical scenes by masters like Frederick, Lord Leighton and Sir Lawrence Alma-Tadema.' His interest in historical detail can probably be traced to his early fascination with the works of the pre-Raphaelite and neo-classical artists whose work was so influential in the late nineteenth and early twentieth centuries.

Roy was born on 23 April 1924 and lived with his family in a modest rented house in south London. In October 1935 he entered Reay Central School on Hackford Road, SW9. Though it was not quite a grammar school – Roy had

failed his 11-Plus – he remembered Reay as being 'a cut above the ordinary'. Whilst there he had his first formal art classes. 'Our art teacher was a dear old boy, full of witty rhymes which he amused us with, before setting a drawing task and then retiring to a corner to do his own freelance work. We were left very much to our own devices!'

Although Roy's first love was aeroplanes he remembers being impressed by a classmate's drawing of the then brand-new Cunard liner *Queen Mary* which, with all the other students' efforts, was pinned to a wall during the end-of-

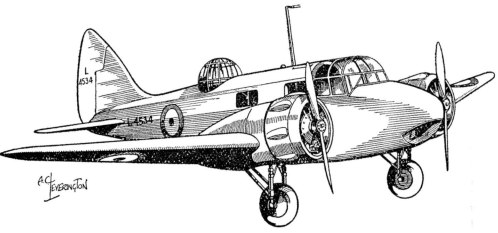

Above: Tidy penmanship from A.C. Leverington provided early inspiration.

Left: An early pencil sketch, doubtless copied from a photograph.

term art exhibition. Roy recalls, 'It left me in awe of the talents of the lad concerned, who later became an electronics engineer, dabbling in early semiconductors!' Ironically, years later Roy was to carve himself an enviable niche as a practitioner of maritime art.

'In addition to the usual class subjects,' wrote his headmaster, Arthur Tasker MBE, in Roy's report of December 1939, 'his course included French, shorthand, typewriting, book-keeping and commerce.' Of Roy's ability Tasker added, 'Cross's best subjects are art and book-keeping and his work in class is well up to the average'. Amongst his 'much good work in art', Roy's etching and paper work were singled out for special praise. Of his earliest techniques, Roy remembers painstakingly cross-hatching on drawings to depict form and tone. This minute line work was applied with mapping pens dipped into Indian ink. One of his young school friends, obviously a budding entrepreneur, purchased many of Roy's early drawings – 'I believe at a penny a time,' he laughed.

The 1930s had spawned a number of aviation books and magazines, many of which highlighted the exploits of the fighting airmen of the First World War, a conflict still fresh in the minds of all but the very young. They provided fuel for Roy's imagination. There was a little bookshop near his home that specialized in American aviation 'pulp' magazines. With little pocket money with which to buy them, Roy spent longer than he should poring over copies of *Flying Aces*, *Air Trails* and others, watched through a back window, he imagined, by an indulgent shopkeeper whom he seldom saw.

He also spent hours poring over copies of the latest *Jane's* and aviation magazines in the Walworth Road Public Library, opposite the Labour Party's original London headquarters. He soon became adept at pen and ink illustration and was gradually able to absorb the techniques used by his heroes.

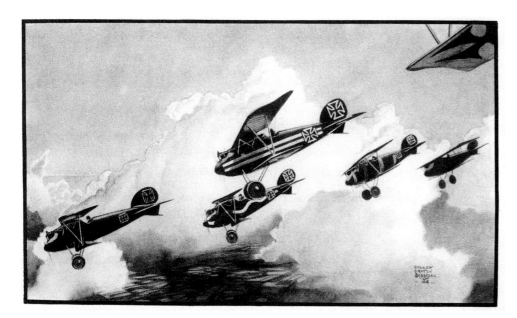

'Apart from the covers, most illustrations in the pulps were reproduced in line – so to begin with I emulated some of the existing techniques I saw and then gradually evolved my own style,' he remembers.

One talent above all – James Hay Stevens – shone out as a major influence on Roy's early work. Jim Stevens' love of aircraft led him to play a leading role in the success of the Skybirds aircraft construction kits in the early 1930s. By 1935 there were twenty tiny wood, brass and acetate models available. Perhaps Skybirds' most important contribution to the hobby was that Jim Stevens established the standard of ½ scale, or 1 in to 6 ft which eventually became common among all the construction kit firms including, some twenty years later, Airfix. At the time, Roy had not seen the Skybirds' replicas except in advertisements. They were rather too expensive for his modest pocket-money allowance. He came to know Stevens' artwork through the latter's drawings in the George Newnes magazine *Air Stories*. His illustrative techniques attracted the fourteen-year-old who soon began to adopt his methods and mannerisms in his own work.

Other publications which influenced Roy at this time included *Popular Flying*, edited by Captain W.E. Johns of 'Biggles' fame. Along with the work of Johns himself, *Popular Flying* introduced the talents of aviation artists such as Howard Leigh and Frank L. Westley, and the works of illustrators such as George E. Blow ('some fine cut-aways'), Algernon Rowe and A.C. Leverington appeared in *Air Stories*. *Air Stories*, which ceased publication as the war started, is still in demand and collectable – good issues command £5 and upwards.

In 1938, aged fourteen, inspired by his artist heroes, Roy sent a three-view drawing of a Nieuport Scout to W.E. Johns of *Popular Flying*. 'Although it was pretty basic by my later standards of course,' he told me, 'Johns must have recognised some burgeoning talent, because he sent me a lovely letter saying in effect: "Sorry, we can't use them but do keep on trying."' Roy is irritated that despite extensive searches he cannot find this inspirational missive from a man who invented 'Biggles', a hero to generations of British schoolboys.

Publishers such as John Hamilton also produced a number of aviation books, which could be obtained from the public library. From these books Roy singles out the illustrations of Stanley Orton Bradshaw and Leonard Bridgeman. 'Their talents were far beyond my wildest aspirations. Bradshaw was an accomplished watercolourist, as was Bridgeman, who had the added facility of possessing a quite exceptional "eye" for capturing the accurate lines and "sit" of an aeroplane. To call him a fine draughtsman, a compliment in itself, would be seriously to underestimate his prowess as an aviation artist. Although better known as co-editor (with C.G. Grey) and finally as editor for a period of *Jane's All the World's Aircraft*, he was perhaps the finest of the pre-war aircraft portraitists.' The paintings of Stanley Bradshaw were rather more 'imaginative' than Bridgeman's. Bradshaw concentrated on creating finely composed illustrative action scenes featuring evocative cloudscapes.

'I could only marvel at the elaborate line, scraper-board and spatterwork – almost half-tone in effect – of Blow and others,' Roy said. 'Jim Stevens' three-views were immaculately drawn with thick and thin line work to give a "shaded" effect, with a simplified style in his perspective drawings which I could readily understand. I was still too young to begin a formal art training, so Stevens, as well as others, became at a remove my instructors.'

One book in particular, *The Clouds Remember*, was a treasured acquisition and its purchase required some hard saving. It was full of Leonard Bridgeman's work. His beautifully depicted aircraft of First World War vintage were accompanied by superb first-hand commentaries by Major Oliver Stewart, MC, AFC, who as an operational and test pilot flew most if not all of the aircraft shown. Roy still greatly values this and other books of the period. 'All the modern tomes with their superb photographs or paintings in colour cannot displace them.'

Roy was enrolled into No. 343 (Camberwell) Squadron, Air Training Corps (ATC). Like hundreds of other youths, he wanted to serve as aircrew but because of poor eyesight – at his RAF medical he only passed A2 – flying duties were out of the question. His 1942 ATC 'demob' notice states that whilst there he 'attended 296 parades and lectures and received instruction in radio mechanics, musketry and aircraft recognition'. His acting CO, Flying Officer Baker, said Roy was 'one of the Squadron's outstanding members. Promoted to Flight Sergeant for general efficiency, he gained 96% in signals…Is recognised as a capable draughtsman and is engaged to draw 'plane sketches for publication in the *ATC Gazette*… He also served as the Squadron's lecturer on aircraft recognition.'

ABOVE: *Strikingly marked Albatros fighters from the brush of Stanley Orton Bradshaw.*

RIGHT: *An early effort by Roy, the ubiquitous Piper J-3 Cub.*

Whilst with the Air Training Corps Roy, in common with hundreds of his contemporaries, had hoped for the opportunity to fly. 'We were promised the chance of an occasional flight or even some glider training,' he recalled. 'But in fact, due no doubt to the exigencies of wartime none of these promises came to fruition whilst I was with the squadron. In fact the only real aeroplane we were able to see and touch was an ancient Fairey Gordon used as an instructional airframe. Into this we climbed and at last could wiggle the controls, breathing in the odours peculiar to flying machines.'

At the outbreak of war in 1939, Roy's entire school was evacuated to the comparative safety of Reading in Berkshire. Here, however, he and his fellow evacuees idled away their time. 'We were allowed each morning off and played football most of the afternoon! By early 1940 my father suggested that, since I seemed to be receiving no formal education, it might be better to return to London and earn my keep at work.' He was sent out to face the big wide world bearing the school's final endorsement: 'We believe he will make an excellent employee.' He was still fifteen years of age.

He began his first full-time job with a shipping agent in London's Lower Thames Street. As a young clerk, he spent his days delivering inventories, manifests and bills of lading to the many vessels which crammed London's busy docks. He witnessed the Thames during its commercial heyday and saw the river full of ships of all kinds, including the occasional fully rigged merchantmen and majestic coastal sailing barges – survivors of the last days of sail. Perhaps all those marine images were being stored away for future use!

Going about his duties for the shipping company he cycled across London's bridges, which were littered with scores of fire hoses to quench the fresh fires of the blitz and all drawing their water directly from the Thames itself. Later, in 1944, he was one of the first to experience the *Luftwaffe*'s early V1 attacks. 'To this day I can still hear the strange sound of the first "buzz bombs" arriving overnight, and because by then I worked in an aircraft factory I was familiar with the sound of aero-engines and so I knew that this was something entirely different.'

The way in which Roy came to the attention of *ATC Gazette* (the official Air Training Corps magazine) is typical of his initiative and self-belief. 'As my Squadron, No. 343, has not yet been represented in the *ATC Gazette*,' he wrote to the editor, Leonard Taylor, in February 1941, 'I am submitting the following article and sketches for publication.' Roy's drawings were of the new US Kittyhawk and Tomahawk fighters, which had recently entered RAF service. 'Curtiss fighters now form a large part of our fighter strength in the Middle and Far East. As the article is a little long, and space is so valuable in the *Gazette*, my piece is in four main parts, any of which may be deleted if need be.'

In fact his work did not appear in the *ATC Gazette* until April 1942. Then, illustrating an article by Wing Commander G.H. Keat entitled 'The Spice of Life', about the social side of life in the Corps, Roy provided a variety of line drawings. His illustrations were of aircraft ranging from the Bristol Beaufighter, Fairey Albacore, Short Stirling and Consolidated Catalina to exotica such as the French Morane-Saulnier MS 406 and the *Luftwaffe*'s Heinkel He 111.

He subsequently provided dozens of precise line drawings finished in black Indian ink, ideal for printing on the variable-quality paper rationed to publishers and printers during wartime. To support these he included photographs and short articles describing the subjects of his drawings.

In April 1942, Roy applied to *Flight* magazine for a job in their drawing office. Whilst praising his 'very neat' line drawings Managing Editor Geoffrey Smith wanted to know about Roy's call-up position before he could consider taking matters any further. When he received Roy's reply, he responded:

'I note your feeling that you will be called up in six months which I think is almost definite, and for that reason, much as I should like to have given you a position in our artists' room, I fear we cannot do so because it would take us roughly that time to train you in our particular styles. I am bound to confess that your work is so neat and promising that, in your case, you would probably beat this period, but even so, it would upset our organization were you called up so soon as your training was complete. If you care to submit any of your drawings from time to time, we shall be happy to consider them on their merits.'

As will be seen, Roy entered a reserved occupation and did not join the RAF after all!

ABOVE: This early pen drawing has characteristics of James Hay Stevens' work.

LEFT: A year or two later his technique has visibly evolved in this drawing of a Brewster Buffalo.

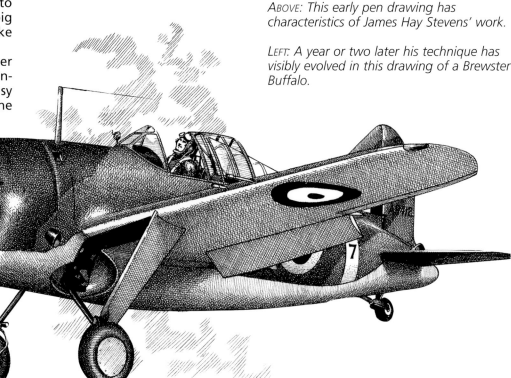

RIGHT: A plate from a first book illustration commission, Birth of the Royal Air Force.

BELOW: I remember my brother and me standing in a long cinema queue and whiling away the time trying to think up ideas for some aviation cartoons. This was one result. It was just after the end of the war in 1945 and we were beginning to learn of all the advanced secret design trends from captured German and other aeronautical engineers. The caption was 'No! I absolutely put my foot down this time.'

Another highlight from 1942 was the receipt of Roy's first 'fan letter.' This landmark missive praising his work in the *Gazette* came from one C.E. Orten, a cadet in No.132 Squadron. A year later another, simply from an 'RAF man' was equally complimentary. 'By the way, Roy Cross is to be congratulated on his fine drawings. From the look of the few cut-aways he has drawn so far, it looks as though Clark and Millar had better look to their laurels.'

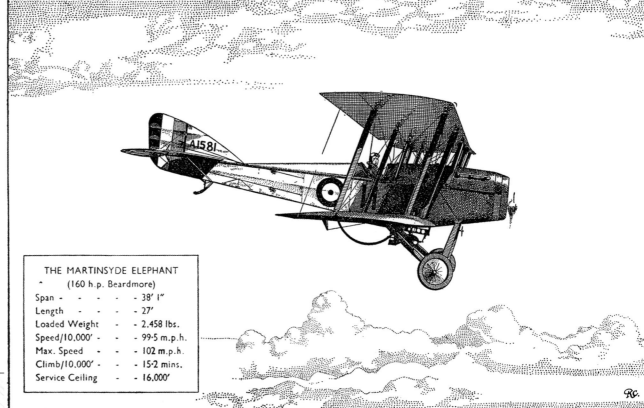

THE MARTINSYDE ELEPHANT (160 h.p. Beardmore)	
Span - - - -	- 38' 1"
Length - - -	- 27'
Loaded Weight -	- 2.458 lbs.
Speed/10,000' -	- 99·5 m.p.h.
Max. Speed -	- 102 m.p.h.
Climb/10,000' -	- 15·2 mins.
Service Ceiling -	- 16,000'

Roy's first complete work was *US Army Aircraft*, published in 1942 and costing 7½d. It combined words and pictures, and was promoted as 'a detailed list of the principal American Army aircraft with eighteen pen and ink sketches'. Its introduction was written by Leonard Taylor, editor of the *Gazette* and Secretary of the Air League of the British Empire. 'An aeroplane is an impermanent thing', he wrote. 'But a drawing by Roy Cross captures its fleeting beauty and makes it a joy for ever.' He was a published author at eighteen!

The first book Roy was commissioned to illustrate was *Birth of the Royal Air Force* written by Air Commodore J.A. Chamier and published by Sir Isaac Pitman & Sons in the summer of 1943, when he was all of nineteen. His line drawings for the book could be mistaken for the work of an older artist; he was fast learning to master his line renderings. In March 1943 Roy received the not inconsiderable sum of £42 for the Chamier book drawings.

Perhaps the most important event in 1942 was Roy's inclusion, at the instigation of Leonard Taylor, in the Air Ministry list of approved representatives for press visits. One H.D. Blow signed the confirmation of Roy's new status. It read: 'It is now open to him to make application to my branch for a permit for any specific occasion on which he requires to enter Croydon or other Royal Air Force aerodromes for sketching purposes. Each application should also state the proposed subject of his sketches, i.e. named aircraft.' It was not official war artist status perhaps, but it did lead to a mention in the London newspapers! Air Ministry sanction also allowed Roy to get into operational aircraft, and during the following months to visit service aerodromes, making as he said 'more contact with the machines and personnel of the Royal Air Force'.

As a result of these authorized visits Roy prepared some notable sketches of a Hudson communications aircraft and the single-engined Tomahawk fighter. His visit to the Tomahawk squadron (No. 414) stationed at Croydon was particularly memorable because the squadron actually invited him to join them in the mess. 'You can imagine how I felt – a young cadet – seated facing the top table of the Wing Commander and other officer ranks! This was a Commonwealth tactical reconnaissance squadron with pilots from all the Dominions – great guys!'

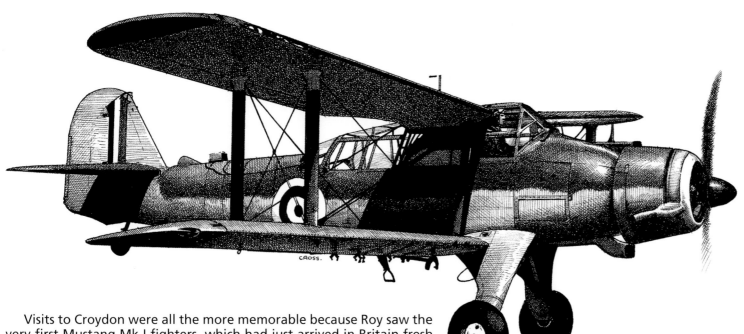

Visits to Croydon were all the more memorable because Roy saw the very first Mustang Mk I fighters, which had just arrived in Britain fresh from the USA. These were to be converted to RAF standards as regards flight instruments and radio equipment. 'With an eye for a "scoop" I did some sketches of those and was ticked off roundly when I tried to get them cleared through the Ministry [usually secured via the Ministry's public relations department], which you always had to do,' said Roy. 'I still have the letter telling me in effect: You shouldn't have attempted to do this! You must get permission for each new aircraft you draw. But since you've already done it, we will allow you to publish them.' Thus, Roy can claim to be amongst the first Britons to sketch what eventually became one of the finest RAF and USAAF fighters.

At Croydon, too, he had his first flight in a service aeroplane, a de Havilland Dominie (Dragon Rapide) filled as he recalled with 'screaming, giggling WAAF girls onboard for a flight around the aerodrome'. Roy remembers this flight as an 'altogether exhilarating experience'!

Working now in the City of London for the famous International Stores retail organization, Roy braced himself for the start of his service career and his entry into the Royal Air Force as a wireless mechanic with the rank of AC2.

Experiments in Line

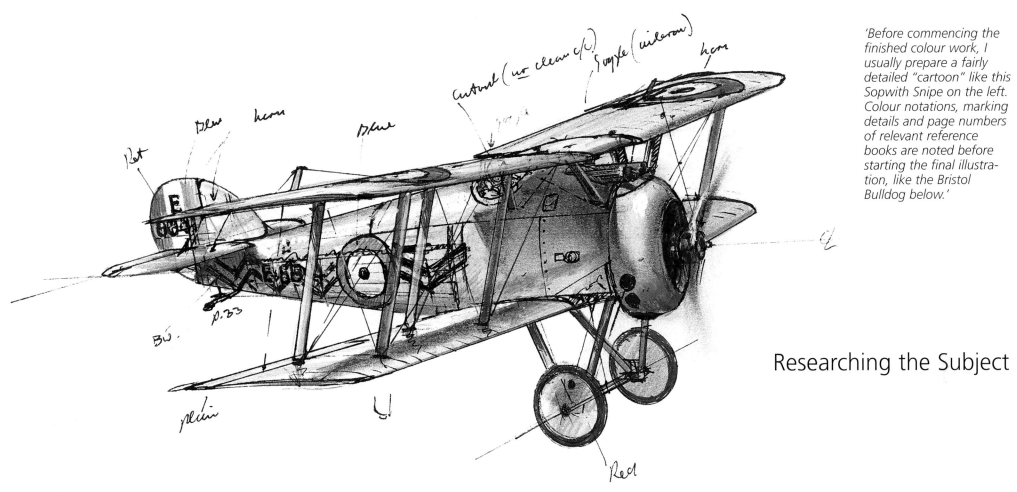

'Before commencing the finished colour work, I usually prepare a fairly detailed "cartoon" like this Sopwith Snipe on the left. Colour notations, marking details and page numbers of relevant reference books are noted before starting the final illustration, like the Bristol Bulldog below.'

Researching the Subject

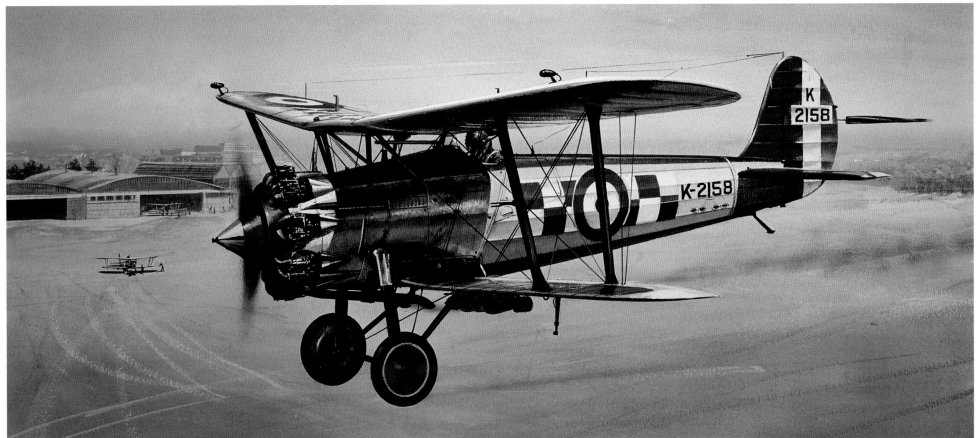

However, some of his recently published drawings in the *ATC Gazette* had come to the attention of fellow contributor James Hay Stevens. Apart from his involvement with Skybirds, Stevens, had drawn and written for the *ATC Gazette* and contributed to other popular aircraft publications. He was an accomplished aeronautical engineer and was now working in the Ministry of Aircraft Production (MAP). He urged Roy to reconsider the prospects before him, stressing that his drawing talents would be wasted if he was employed solely as RAF ground crew, and gave him an introduction to the technical publications departments of manufacturers within the thriving and widely dispersed wartime British aircraft industry.

There was a growing need for skilled artists as British industry caught up with the Americans in the creation of comprehensive illustrated instruction manuals. These included the 'Pilot's Notes' series, designed to illustrate the position and function of the myriad controls and instruments which filled the increasingly complex cockpits of new aircraft designs. The famous Air Ministry 'Air Publications' series helped aircrew convert to alternative aircraft types and ground crews service and repair them.

Roy's search for a job ended at Fairey Aviation Co. Ltd at Hayes in Middlesex to which he could travel on a daily basis. 'They took me on in the embryonic Technical Publications Department. Together with two older commercial artists, we started the drawing side of Technical Publications.'

Although he worked in the drawing office he was not an engineering draughtsman in the traditional sense, his team being involved with easy-to-understand perspective illustrations to aid operation, maintenance and repair. Since the late 1930s, aircraft development had proceeded at such a furious pace that each new mark of a particular type meant countless revisions to existing instruction manuals – effectively new owner's handbooks! Indeed the Spitfire, first flown in 1936 had, by the war's end in 1945, less than a decade later, been produced in twenty-four basic marks, plus various Seafire naval variants. All this development created vital work for technical illustrators and authors.

'I wasn't a draughtsman, of course and if I had been I would have needed diplomas and certain technical qualifications – along with a stint on the shop floor,' Roy said about his time at Fairey. 'However, my field – technical publications in the modern sense – was really in its infancy in this country and you picked it up as you went along! With the Air Ministry and MAP regularly feeding new and amended requirements to them, Fairey were feeling their way. Although, during and after the First World War, the demand for instruction manuals gradually accelerated these were often quite crude by modern standards – certainly they would rarely have featured graphics of a complexity similar to the perspective drawings we worked on. This "new" style of drawing was pioneered particularly in Britain in journals such as *Flight*, *The Aeroplane*, *The Autocar* and *Motor* by artists such as Max Millar and James Clark, both heroes of mine. This work in the technical press evolved between the wars to attain high standards by the late 1930s.'

'At Fairey we worked in the Drawing Office but just across the way from this department we were able to pop into the factory and sketch from the actual aircraft on the production line. The two seater Firefly naval fighter was being made and I remember also going up to the Stockport factory to do some work on the Albacore whilst it was still in production there. This journey was my first experience of a night sleeper train and, incidentally, of eating tripe and onions!'

From the Drawing Office, Roy could request any engineering blueprints he might need to help him ensure accurate detail and precise scale. 'It was during this period that I first learned to draw from blueprints and to sketch from "life" so to speak in the factory.' He amalgamated these two disciplines to produce three-dimensional perspective drawings which could be easily deciphered by the huge intake of service personnel unused to traditional two-dimensional engineers' general arrangement drawings. 'I was also developing my skills in precision line techniques.'

Although Roy seldom visited Fairey's local aerodrome at Harmondsworth (now Heathrow), he did manage to 'crew' the test flight of a production-line Albacore biplane piloted by test pilot C.S. (Chris) Staniland. 'I didn't disgrace myself by being sick, but I still remember the quite considerable G-forces generated even by the venerable Albacore and of being helped from the aeroplane on wobbly legs at the end of the flight…

'I was getting more and more work published in the *ATC Gazette*, sometimes of the aircraft we were working on such as the Barracuda. Of course the articles all had to be passed by the censor. As late as 1947 I was asked to remove some of the radio detail faithfully recorded in my sectioned drawing of the Bristol Brigand.'

Because he had so much work published in the *Gazette*, in 1944 Leonard Taylor suggested that Roy join his small staff. So, following a letter to the authorities from the Editor, Roy was given special dispensation to leave his reserved occupation at Fairey Aviation to join the staff of the *Gazette*. Here, it was argued, his skills would be put to better use for the war effort.

'I must mention the influence of Leonard Taylor as Editor of the *Gazette*,' said Roy. 'He must have had an eye for talent, because at various times he encouraged as employees or contributors to the magazine the young John W.R. Taylor, Maurice Alward, Jim Oughton, William Green (like myself, another cadet), John Stroud, Edward Shacklady and several others.'

While working full-time at the *Gazette*, Roy submitted articles to *Flight* and *Aeronautics*. The same Major Oliver Stewart who had penned fine commentaries in *The Clouds Remember* edited the latter. For one article in particular, he thanked Roy for 'a really fine job' and even offered to pay more for the youngster's work. 'I am going to pay you 25 gns,' he proclaimed, 'and not the 20 gns I originally proposed.' Great encouragement for a young would-be journalist-artist.

As the chief – indeed the only – artist, Roy worked on the *ATC Gazette*'s layout and created many of the cut-away drawings. One of these was of the P-51C Mustang. Roy drew this with the help of the superb American handbooks supplied with the permission of the USAAF and the manufacturer North American Aviation Inc. (whose technical representatives were in Britain as advisors to USAAF squadrons stationed on this side of the Atlantic).

After the war, Roy left the *Gazette* and, earning £7 per week, had a brief spell in Technical Designs Ltd, a commercial studio based in London's Queen Anne's Gate. Here he came across other commercial artists, and learned more about the business. 'One of them,' he recalled, 'was a dear little old chap who was an absolute "ace" with the airbrush and taught me some techniques particular to that instrument.' However, he recalls the airbrush only as a temporary 'crutch'. Up until then, simply because he had no formal art training, he did not become involved in the application of half-tones or colour washes – both quite highly skilled techniques of the commercial artist. The airbrush, however, meant that for the first time Roy could apply areas of graduated shading to denote camouflage colours to help to suggest an aircraft's form. To this day many artists, especially in North America, rely on the airbrush, which Roy reckons is 'a fine medium in its own right'. But, as he says 'over many years I learned to do everything with the artist's brush and now, of course, my airbrush is rusting away!'

Following his stint at Technical Design Ltd, Roy went back to Fairey for a bit. But he found 'nothing new there' and decided that apart from the security of a regular income there was no real advantage to going back to a salaried job. So, in 1947 he took the courageous decision to rely entirely on freelance activity for his livelihood – and 'I've been freelance ever since!' The decision was made easier by the fact that he was already earning extra income from spare-time writing and artwork. Indeed, his advice to the would-be freelancer is always to ease into freelance work gently whilst staying in a regular job. Then, without too much risk one can wait for the big commission to come along, making the change a practical proposition.

Recalling the precariousness of depending on a freelance income, Roy told me: 'You obtained any work you could. By writing letters of enquiry and keeping one's eyes open you got the work.' In his early twenties, and while still living at home with his parents, Roy was enjoying the fruits of two quite separate careers: the income from his freelance illustration and the irregular fees from

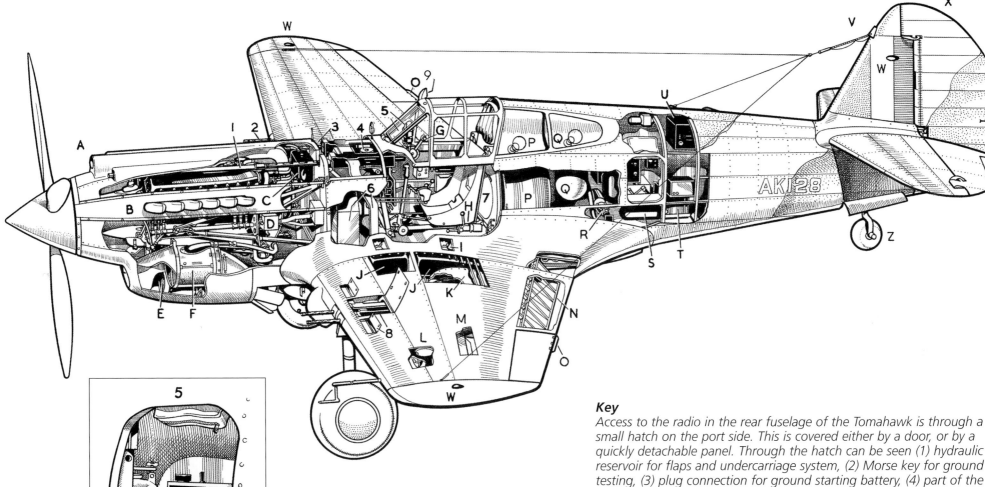

An early cut-away drawing, of a P-40 Tomahawk IIB, the result of a 1942 'press' visit to No. 414 Squadron based then at Croydon Airport. At left, a P-40 of the USAAF, and bottom, a peek into the radio access hatch of the Tomahawk.

Key

Access to the radio in the rear fuselage of the Tomahawk is through a small hatch on the port side. This is covered either by a door, or by a quickly detachable panel. Through the hatch can be seen (1) hydraulic reservoir for flaps and undercarriage system, (2) Morse key for ground testing, (3) plug connection for ground starting battery, (4) part of the radio, (5) first aid satchel.

A, Supercharger air intake; B, detachable panels for access to engine; C, glycol header tank; D, Starter switch; E, oil radiator; F, glycol radiator (two); G, handle for opening cockpit cover; H, flaps and undercarriage selector control; I, filler caps to wing tanks, J; K, canvas wheel well; L, retractable landing light; M, flare stowage in either wing; N, split trailing edge flap; O, trim tabs (not adjustable in flight); P, fuselage fuel tank and filler cap; Q, oil tank; R, electric motor operating hydraulic system; S, oxygen bottle; T, battery; U, radio; V, aerial; W, navigation and formation-keeping lights; X, balanced and fabric-covered rudder; Y, rudder and elevator trimming tabs (adjustable in flight); Z, retractable tail wheel.

1, Blast tubes for two 0.5 fuselage guns; 2, one of the two starboard wing guns; 3, armoured and fireproof bulkhead protecting fuselage guns; 4, windscreen spray container; 5, bullet-proof glass and reflector sights; 6, ammunition box and chute; 7, armour protecting pilot; 8, port wing guns and ammunition boxes; 9, rear view mirror.

the occasional aviation articles he wrote and submitted to the industry's trade and enthusiasts' press. However, 'It eventually dawned on me that I wasn't a writer. I was a much better artist – even learning my way as I was. Gradually I dropped aviation journalism – even though later on I did write a few illustrated books. One book I illustrated early in the 1950s is something of a personal milestone. Produced for Shell, *Know Your Airliners* apparently influenced other budding artists, some of whom mention it to this day.'

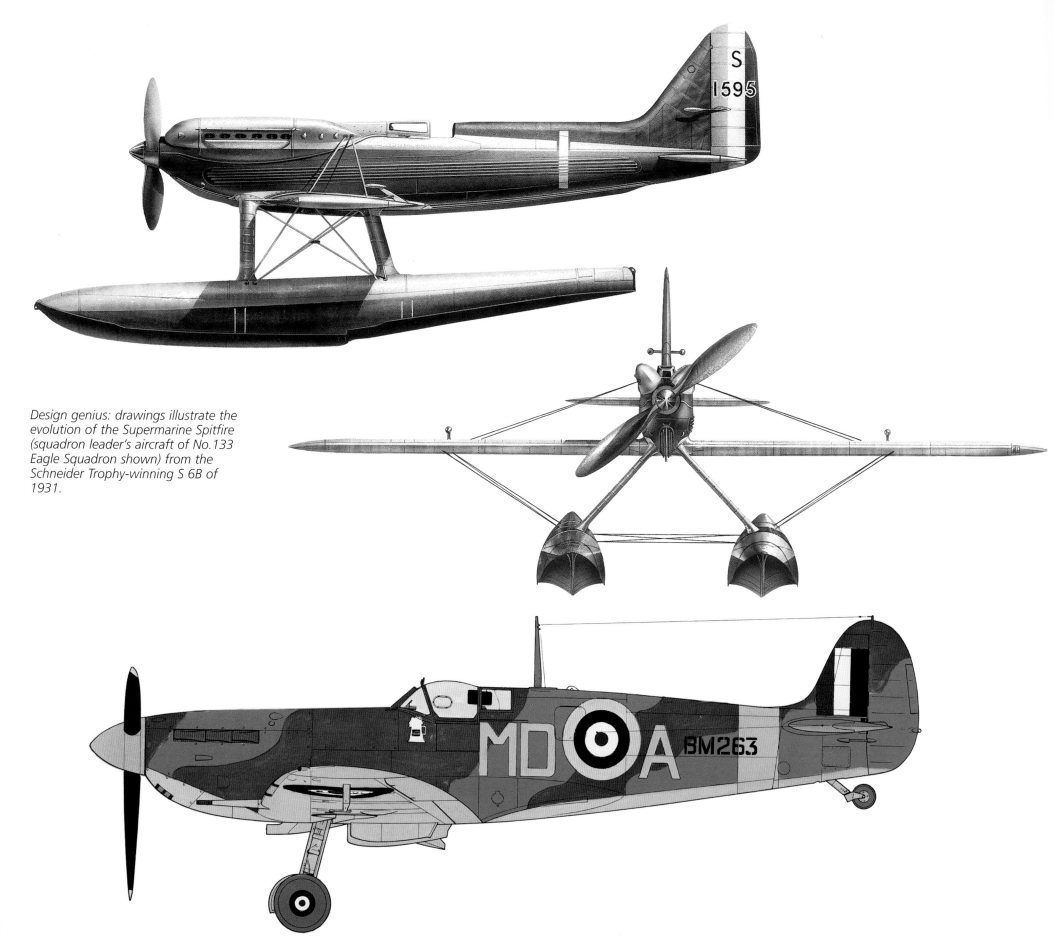

Design genius: drawings illustrate the evolution of the Supermarine Spitfire (squadron leader's aircraft of No.133 Eagle Squadron shown) from the Schneider Trophy-winning S 6B of 1931.

16

BRISTOL BRIGAND T.F. Mk.1

HAND-OPERATED 0.5-IN. GUN

JETTISONABLE CANOPIES
PILOT CREW

T.1154-R.1155 AERIALS

FABRIC-COVERED ELEVATORS AND RUDDERS

MESSIER TAIL WHEEL UNIT

CREW ENTRANCE

BELLOWS-TYPE DIVE BRAKES

FLAP
(WITH DIVE BRAKE)

A.S.V. RADOME

ARMOURED LEADING EDGE

CABLE CUTTER

LOCKHEED U/C UNIT

ROTOL 14 FT.-DIA. AIRSCREW

CENTAURUS 57
POWER PLANT

ROY CROSS

1. Torpedo camera.
2. Blast tubes for 20 mm. cannon.
3. Armoured bulkhead.
4. Undercarriage warning horn.
5. Rudder bar adjustable fore and aft.
6. Hydraulic hand pump.
7. Control column.
8. Pilot's instrument panel.
9. Elevator controls under pilot's floor.
10. Gun-sight.
11. Bullet-proof glass panel.
12. Rear-view mirror.
13. Direct-vision sliding window.
14. Pilot's seat (back folds down to provide access).
15. Armour-plate back to seat.
16. Pilot's hood jettison lever.
17. Torpedo speed and inclination controls.
18. Incendiary bombs.
19. T.R.1143 radio controller.
20. Flaps and undercarriage selector levers.
21. Throttle and propeller speed controls.
22. Seat-raising lever.
23. Map case.
24. Trim tab control wheels.
25. Centre drop tank pressure control lever and jettison for outer wing loads (drop tanks, bombs or R.P.).
26. Master fuel cocks and fuel cut-off controls.
27. Emergency axe (one either side of cockpit.
28. Torpedo contactor.
29. Torpedo director.

30. Black-out curtain.
31. Crew's hood jettison lever.
32. Head protection pads on machine-gun.
33. Ammunition feed for gun.
34. T.R.1143 aerial.
35. GEE (R.1355) radio aerial.
36. Anglepoise lamp for navigator's table.
37. A.P.I. unit (Air Position Indicator).
38. Navigator's table (folds upwards for stowage).
39. Navigator's instrument panel.
40. Occasional seat (used by navigator during torpedo operation).
41. Front centre-section spar.
42. Join line between front and middle fuselage sections.
43. Signalling lamp.

44. Radio transmitter and receiver sets (T.1154-R.1155).
45. Signal pistol.
46. Dotted line shows how spent cartridge bag connects to ejection chute.
47. Spent cartridge bag in stowed position
48. Head rest for wireless operator.
49. Browning 0.5 in. hand-operated gun on swivel mount has recoil damper unit to facilitate aiming.
50. Morse sender for I.F.F. set.
51. Note-pad and Morse sender for transmitter and receiver.
52. Rear centre-section spar.

53. Trailing aerial and winch.
54. Distress signal and cylinder.
55. Reinforcing frame to support gun mount.
56. Armoured doors leading to rear fuselage.
57. Ammunition container for 0.5 in. gun.
58. Wireless operator's seat.
59. Navigator's seat.
60. Ditching belt.
61. Warning horn (A.S.V.).
62. Four ammunition containers for 20 mm. cannon.
63. Ammunition winder.
64. Port twin 20 mm. cannon installation.
65. Guard screen over flying control rods (both sides).
66. Pneumatic components panel.
67. Entrance door with built-in ladder serves as parachute exit.
68. Fresh water tank (6 gallons).
69. Air bottles for pneumatic system.

70. Drift sight.
71. Stowage for four reconnaissance flares, three marine markers and a distress signal.
72. Flare chute.
73. Stowage crates for 36 flame floats.
74. Hydraulic reservoir.
75. Spare valve stowage.
76. Three ration boxes.
77. Upward identification light.
78. Hand fire extinguisher.
79. Thermos flasks.
80. Join between middle and rear fuselage sections.
81. Sword aerial (I.F.F.).
82. D.R. compass master unit.
83. Tail wheel door.
84. Spring-tensioned servo tabs.
85. Metal fins.
86. Metal tailplane.
87. Fabric-covered rudders.
88. Fabric-covered elevators.

89. Rotol fan to assist engine cooling on the ground.
90. Spinner fairing.
91. Cowling nose ring.
92. Sealing baffles.
93. Exhaust pipes.
94. Cockpit heat exchangers.
95. Controllable cooling gills.
96. Carburettor air intake.
97. Hinged inspection panels form cowling.
98. Cowling toggle fasteners.
99. Detachable inspection panel.
100. Fire extinguishing cylinders (three in each nacelle).
101. Oil tank (33 gallons).
102. Mareng fuel tank (176 gallons).
103. Undercarriage operating jack.
104. Engine mounting members.
105. Air intake for dive brakes.
106. Lockheed levered suspension damper unit.
107. Door-operating linkage.

108. Undercarriage fairing doors.
109. Air duct system to dive brakes shown dotted.
110. Mareng fuel tank (150 gallons).
111. Split flap.
112. Dive brake on flap under-surface.
113. Spring-tensioned servo tab.
114. Metal aileron.
115. Navigation lamp.
116. Recognition lamp.
117. Wood wing tip enclosing radar transmitting antennæ.
118. Position of bomb on wing carrier shown dotted.
119. Position of the foremost of two bombs carried beneath fuselage shown dotted.
120. Position of torpedo alternative to bomb load shown dotted.

The Bristol Brigand, done for Harleyford Press.

17

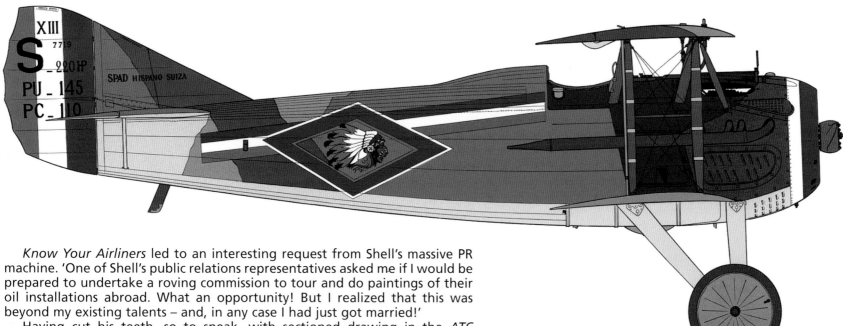

Know Your Airliners led to an interesting request from Shell's massive PR machine. 'One of Shell's public relations representatives asked me if I would be prepared to undertake a roving commission to tour and do paintings of their oil installations abroad. What an opportunity! But I realized that this was beyond my existing talents – and, in any case I had just got married!'

Having cut his teeth, so to speak, with sectioned drawing in the *ATC Gazette*, during 1945–6 Roy started a series of similar drawings (some of which appear in this book) for *Air Review* which was edited by D.A. Russell of Harleyford Publications, publishers of the still collectable 'Aircraft of the Fighting Powers' series. One of the cut-aways, of the new de Havilland Dove, was used by the manufacturer for inclusion in a sales brochure. 'I suppose I was paid twice over for that particular image!' laughed Roy.

About this time, during a trip to garner information in preparation for a cut-away of their new Attacker jet fighter, Roy visited Vickers-Armstrong's Supermarine drawing offices, which were situated in a fine old mansion at Hurseley Park. There, he had the privilege of meeting Joseph Smith, Supermarine's Chief Designer, who, following the death of R.J. Mitchell, had steered the Spitfire's progress through all its subsequent marks, as well as developing later designs.

These 'press' visits occasionally enabled Roy to meet other famous personalities and to obtain 'off-the-record' free flight experiences. Whilst he was sketching Spitfire Mk XIV details at a service aerodrome, a pilot took him up in a Miles Monarch and even permitted him to take the controls for a short while. 'After a while, I got bored with flying straight and level,' said Roy. 'So, I stuffed the nose down for a bit of excitement. I remember looking out on the covering of the wing and seeing it begin to vibrate. The pilot very quickly took over the controls again!'

On a trip to Ferranti to draw some of their new radio equipment Roy met Wing Commander R.R. ('Bob') Stanford-Tuck. The Battle of Britain ace was then Ferranti's public relations chief. Introductions to his RAF heroes were a very real perk of the job. The only time Roy met the legendary Douglas Bader was on a visit to Vickers' Weybridge works. Roy had been commissioned to do a technical drawing of the Spitfire Mk V Bader was flying when his Spit was downed in a mid-air collision and he was captured in 1941. Bader was a frequent visitor to Vickers Weybridge and their public relations people arranged for Roy to meet him at the works. In some awe, he was ushered into an office to meet not only Bader but also test pilot Jeffrey Quill. He recalled

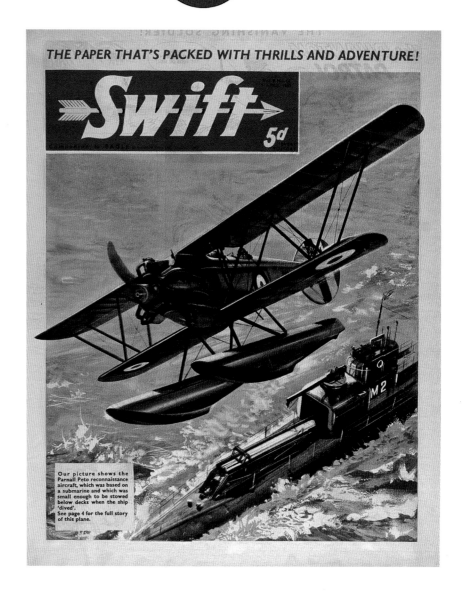

THE PAPER THAT'S PACKED WITH THRILLS AND ADVENTURE!

Swift 5d

Our picture shows the Parnall Peto reconnaissance aircraft, which was based on a submarine and which was small enough to be stowed below decks when the ship 'dived'. See page 4 for the full story of this plane.

ABOVE: One of the largest aviation books of its time was Early Aeroplanes 1907–18 *a coffee-table tome published by Hugh Evelyn of London featuring large coloured line plates which could be detached and framed. Later in Italy Roy had the pleasure of seeing sugar packets sporting these illustrations, obviously pirated by some enterprising manufacturer! Spad S 13, 103rd Pursuit Squadron, US Air Service, France 1917.*

RIGHT: The Parnall Peto, one of a series of covers done for Swift.

the rather inauspicious start to his first meeting with Douglas Bader. 'In answer to my queries about his aircraft markings, colours and code letter, Bader replied to the effect, "Oh, I don't know, I only flew the damned things!" Eventually, I obtained the required information from the RAF's Air Historical branch and one or two fellow journalists/ historians who specialized in that sort of thing.'

During his wartime press visits Roy had not realized that apart from the technical details, notes about exact camouflage colour, special markings, squadron codes, etc. would eventually become of some interest to researchers, aircraft modellers and artists. Consequently, he failed to make accurate notes of the particular operational colour schemes of the aircraft he saw. In any case, as he says, 'at the time such information was probably restricted'.

In 1948 Roy also prepared some articles for the USA's prime aeronautical journals, *Aviation Week* and *Aero Digest*. At the same time he completed some illustrations for the legendary *Aeroplane Spotter* and this work in turn introduced him to the editorial staff of *The Aeroplane*. This relationship resulted in a series of freelance commissions for technical drawings and cut-aways to augment the activities of staff artists – especially the uniquely talented James Clark – who, oddly enough, he never met. With the prestigious name of *The Aeroplane* behind him, Roy was invited to many more aeroplane manufacturers, both big and small. This work took only a proportion of his time, however, and in 1951 came a major breakthrough.

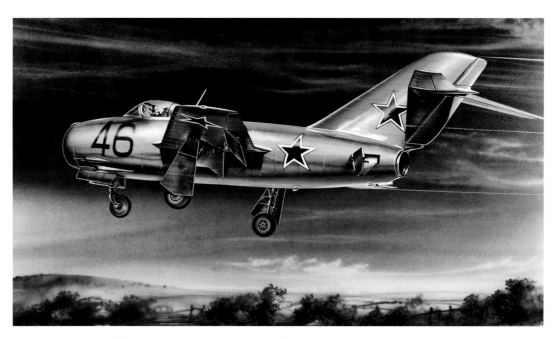

Representations of the MiG-15 prepared well before the full structural details became known.

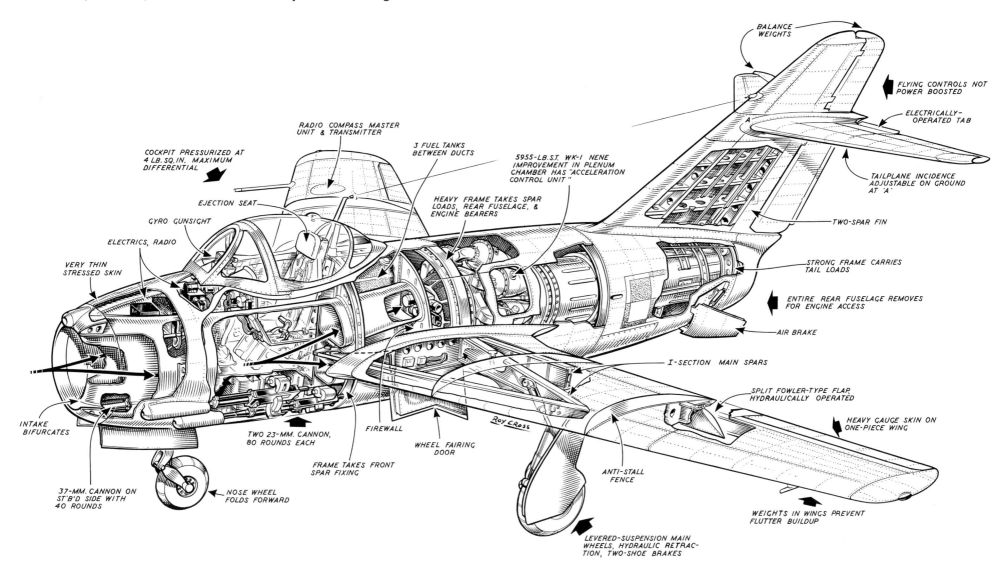

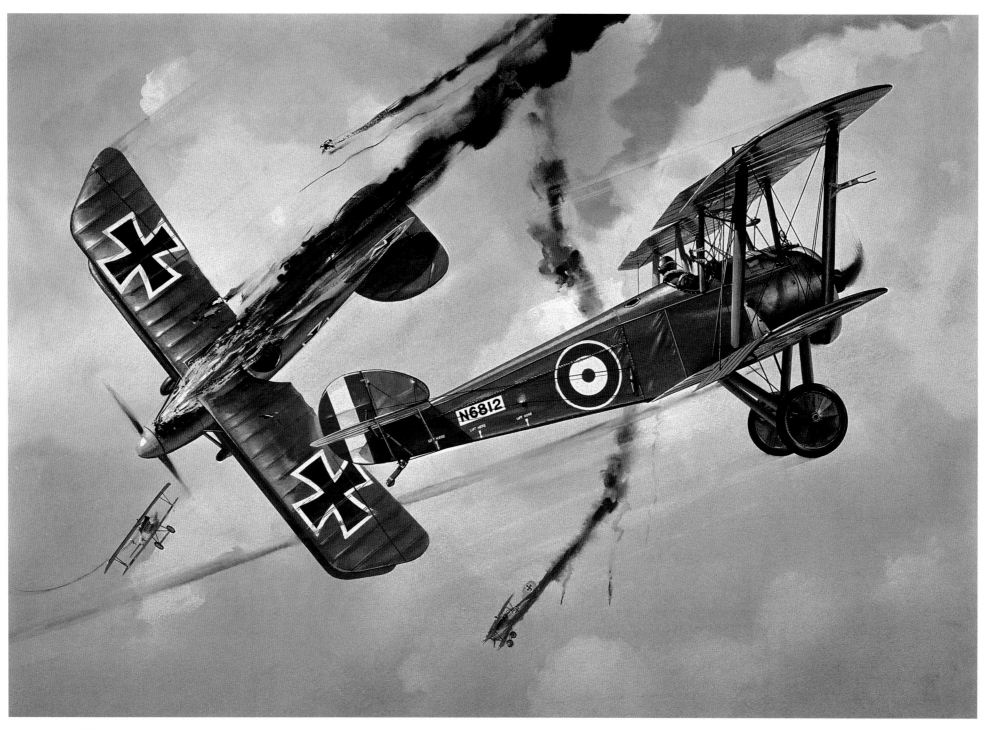

Fok DR I 425/17

ABOVE: Packaging illustrations for the famous Airfix kits had to convey colour and excitement to attract the customers. This box-top painting depicting an Albatros and the Sopwith Camel embellished one of the 'Dogfight Double' series construction kits. The aircraft markings had to be identical to the transfer provided in the box, but the excitement had to come from the assembler's own imagination!

LEFT: From a series of articles and illustrations for Model Airplane News, a magazine published in the USA, the Fokker Dr I. The idea was to combine accurate three-view drawings from which a model could be constructed with an almost photographic rendering showing markings and something of the form and fabric of the machine.

The famous Routemaster London bus was being introduced in large numbers and four or five different constructors around the country were building bodies using their own particular assembly techniques – coach-built, all-metal, composite – all mounted to the common chassis. Roy's job was to prepare perspective cut-aways of each body structure to provide London Transport's maintenance staff with an overall view of the vehicle for use when local repairs were required. His drawings were designed to enable remedial work to be undertaken without requiring the body to be completely dismantled and much of the vehicle's panelling to be removed in the search for a particular defect. At London Transport's Chiswick depot, their Chief Designer told Roy that shop-floor employees much preferred the clarity of his drawings to the usual blueprints.

Another project, which proved a nice contrast to his regular fare, was Roy's commission to provide all the perspective drawings for Blackburn's Bombardier aero-engine handbook. He even worked for the British motor car industry illustrating owners' handbooks for Morris Motors Ltd and Rootes. One totally oddball commission was a request to design a silk scarf for the famous fashion house Jacqmar, featuring a mosaic of his cut-away drawings.

He worked for publications as varied as *Air Trails* (USA) and the *RAF Flying Review*. British newspapers such as *The Times* provided welcome work throughout this period, as did *Model Airplane News* in the USA. The British aircraft industry was also a notable source of income, especially firms like Hawker-Siddeley and de Havilland. He also regularly worked for commercial carriers too, most notably British European Airways (BEA). He even applied his skills to a project for ROMAC car seatbelts.

Roy became increasingly involved with books. One, *Jet Aircraft of the World*, which he illustrated, had the dubious honour of being pirated in its entirety and reprinted in Russian in the USSR – 'for which of course, we received no fees'. Two substantial coffee-table books about aircraft, which he wrote and illustrated, featured large-format colour plates, which could be neatly removed for framing. The work *Supersonic Aircraft* was written, designed and illustrated entirely by Roy.

Around this time the Soviet MiG-15 was giving the US Sabre and other jet fighters serious opposition during the Korean War, and Roy did some tone drawings and a rudimentary cut-away of the machine. 'These were published in a number of journals here and in the States – including *Aviation Week*, the principal industry publication there – and caused much interest because little was known about it generally. Afterwards I was in Jack Beaumont's famous

aviation bookshop in north London and was introduced to a large Russian in full-dress uniform who turned out to be the Soviet Air Attaché. He had seen my work and was extremely inquisitive about where I had obtained my information. Actually, it was inspired guesswork based on the known technicalities of the Nene engine (a mere fifty of which we had sold to the Russians together with many years of technical know-how and research), and a selection of fuzzy photographs and a semi-official three-view drawing previously obtained. For a few days after this event I kept looking over my shoulder to see who was following me – perhaps a little fanciful but don't forget, this was during the height of the Cold War. The sequel to this story is that when the United Nations finally got hold of a MiG-15, after a North Korean pilot surrendered one intact, it bore out substantially what I had shown in my drawing!'

In 1952 Roy began a cut-away drawing of the Gloster Meteor twin-engined jet fighter for *The Aeroplane*. This is perhaps his best work in this style – a time-consuming and highly skilled process. 'This project impressed upon me that cut-away work seemed rather a hard way of earning a living! In any case my ambitions were beginning to lean towards the better paid and, as I thought, less time-consuming field of colour advertising work.'

That same year the Society of Aviation Artists was formed by such luminaries as Frank Wootton, Terence Cuneo and Roy Nockolds, and with tongue in cheek Roy submitted his (mainly cut-away) work. Somewhat to his surprise he was accepted, and whilst there rubbed shoulders with rising young stars like Gerald Coulson, John Young, Keith Shackleton and David Shepherd. 'In such prestigious company I felt slightly the odd man out and determined to progress into the full-colour artwork which seemed to offer a better-paid future.'

Roy introduced himself to London's advertising agencies and his colour work began to feature in such publications as *Flight* and *The Aeroplane*. He began to think his career was on the way up. But no sooner had it begun to take off than a series of catastrophic cuts in British government orders to the aircraft industry caused the flow of work to come to a halt. Reductions in advertising revenues and perhaps the introduction of colour photography meant less work for the established artists, and none for Roy. He had to look elsewhere.

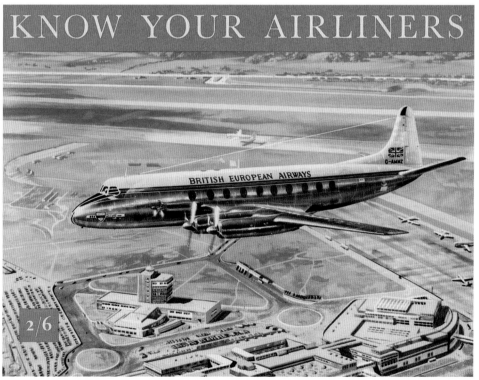

Covers of two books published in the 1950s. The text for Supersonic Aircraft *taxed Roy's technical know-how to the limit! John W.R. Taylor did the writing in* Know Your Airliners.

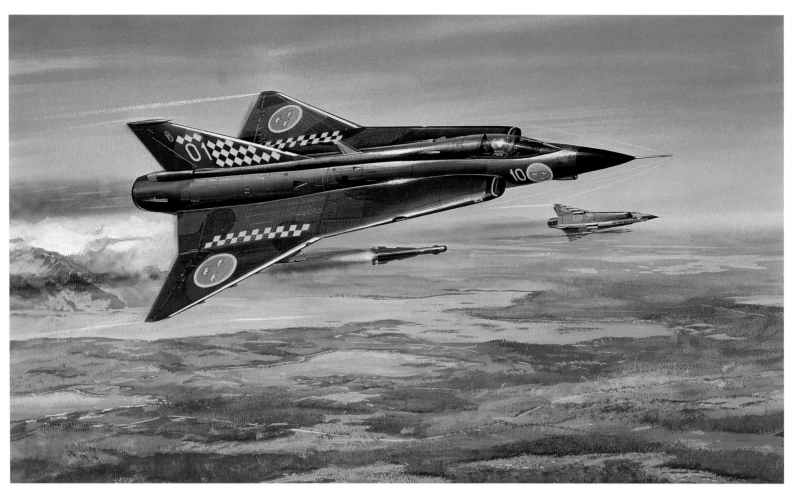

Another action box top for Airfix, the Swedish Saab 35 Draken. At this time, along with vehicles, figures and ships, Airfix produced a vast range of British and foreign aircraft kits in various scales, many still available today.

He undertook a variety of commissions, including a series of full-colour covers featuring racing cars for the institution that was *Eagle* – a publishing phenomenon that famously launched 'Dan Dare' and had spawned books and annuals. This contrasted nicely with covers for the rival boys' publication *Swift* featuring famous aeroplanes. For a while Roy worked flat out producing a new cover for each comic each week. 'They had to be at the printers – rushed up by train – no later than one minute before midnight,' he said. 'One minute past midnight would miss the deadline – the presses were rolling!'

Predictably, given the ever-volatile children's publishing business, editorial policy changed. First one then the other contract was discontinued. 'Suddenly, I was at a loose end!' Roy exclaimed. Books were still a source of income, but 'they were not money spinners', and could not be relied upon for regular income.

'One day, looking around Woolworths, I first noticed Airfix plastic construction kits.' These early replicas were available packaged either in illustrated boxes or in their famous plastic bags suspended from a brightly printed paper head. 'I knew that I could improve upon this artwork,' said Roy, 'and so I wrote off to the company.'

It transpired that Airfix's resident artist was elderly and unwell and soon a deal was struck and Roy was encouraged to gradually take over much of the firm's packaging artwork. The end result was, says Roy, 'a profitable and enjoyable ten years with Airfix which taught me a lot and, I am told, set new standards for box-top artwork. Not only for aircraft, but for some of their ships, cars, space vehicles and licensed James Bond replicas.' Roy even illustrated the packaging for the firm's legendary Boy Scout figure – today a real collector's item, since few were produced because of its unpopularity with young boys eager, it seems, for Spitfires and Messerschmitts!

The Airfix years hold particularly fond memories for Roy. All in all they provided a great variety of subjects to paint and were a marvellous continuous experience to hone his skills, completing the artist's transition from technical illustration to full-colour rendering. 'My last job for Airfix was in August 1974,' he told me. 'The number of new kits was declining and I had already redone a lot of their older kits as they were reissued and the work was beginning to tail off. It was obvious to me that I would have to look for other work elsewhere.'

'I had always been interested in fine art,' he continued, 'mainly the romantic periods of the late nineteenth and early twentieth centuries. I was particularly fond too of the work of Montague Dawson, who was a great contemporary marine painter. I had done some ships for Airfix and had had to mug up on the whole subject of marine technology, so I decided to have a try at one or two classic marine paintings. Airfix had given me ten years of very enjoyable work with a nice retainer and a great deal of financial security. As a "thank you" to their managing director the late John Gray, and also Charlie Smith, who was their chief buyer, I thought I would present them each with a painting of a marine subject. John Gray wrote me a very nice letter of thanks. In fact just before he died (early in November 2000) he told me that it was still taking pride of place in one of his rooms. Furthermore, soon after I had given Charlie Smith his picture he came back to me with a rather interesting story. Apparently, someone had come into his lounge where the picture was displayed, gazed at it intently and said, "Who's this man? I like his work." Charlie told him that this was the chap who was doing the Airfix box-top art work. "You mean he's doing your box tops, when with this quality of work he should be selling it in a gallery up in the West-End?" his guest exclaimed. Well, as Charles told me this, my ears pricked up. Maybe here was the new opportunity I was looking for!'

'So I began to look around the West End galleries and made some inquiries. All my research seemed to point towards the Malcolm Henderson Gallery in St James's Street, which specialized in maritime art. I had in any case made a long study of traditional marine art and was particularly interested in the naval vessels, tea clippers and great packets of the heyday of sail. I had spare time

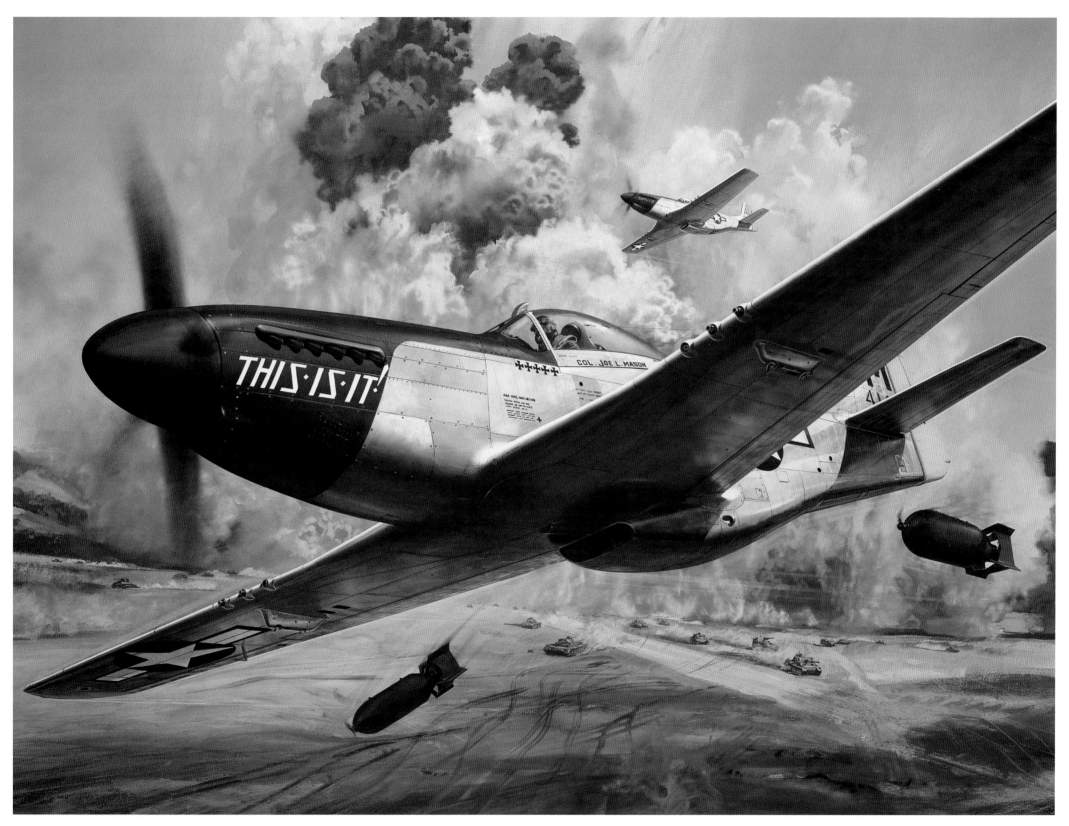

The superb Airfix ⅟₂₄ scale 'Superkit' aircraft range commenced in 1970 with the Spitfire Mk IA. Here is the artwork for the P-51 Mustang in the series.

1. BTH starter motor.
2. Detachable access panels to engine.
3. Outer engine cowling support pillars.
4. Air scoop directs air onto accessories gear box for cooling.
5. Support beam for outer engine cowling panels.
6. Screw jack raises and lowers hinged cowling panels via chain drive from winding handle (7).
8. Drive shaft to accessories gearbox via bevel box (9).
10. Engine mounting ring.
11. Struts incorporating turnbuckle adjustment raise cowling panels support beam, hinged at (12), for access to top of engine.
13. Accessories gearbox.
14. Dual generator and extra cooling duct.
15. Hydraulic reservoir.
16. Fire wall.
17. Access panel to hydraulic system ground connection. Graviner inertia switches, etc.
18. Air intake to oil cooler (19).
20. Air bled off to cool jet pipe bay beneath cockpit.
21. Access panel to oil system pipelines.
22. Front spar lower fixing point for tubular engine mounting (23) and assisted take-off hook (24).
25. Air storage bottle.
26. Bottles feed fire extinguisher system in engine, accessories, and jet pipe compartments, and gear in undercarriage well.
27. Bifurcated jet pipe exhausts on each side of fuselage.
28. Retracting gun-sight mounting.
29. Engine control box and cross shaft to starboard side of engine.
30. Secondary instrument panels flank main central blind flying panel.
31. Two-step rudder bar assembly.
32. Stick-type control column.
33. Structure stiffened for ejection-seat mounting.
34. Radio shelves.
35. Two accumulators.
36. Three oxygen bottles (two shown without mounting cable for simplicity).
37. Electrical panel.
38. Hatches for oblique cameras.
39. Idler levers carry tubular elevators and rudder control linkage.
40. Guard for control linkages, wiring, etc., and hand-hold for access to rear fuselage through radio hatch.
41. Reinforcing skin around camera ports.
42. Upwards identification lamp.
43. Downwards identification lamps.
44. Two hatches, slightly off-set each side of centre line, for vertical cameras.
45. Guard carries cable trimming controls across fuselage.
46. Control linkage compensating levers.
47. Tail-wheel retracting jack and door operating linkage.
48. Deck hook and operating jack.
49. Rear lamps.
50. Rudder trim tab.
51. Elevator spring tab (port) and trim tab (stbd.).

52. Undercarriage door hinge and operating jack.
53. Centre section cruciform structure.
54. Mounting beam for under-fuselage stores.
55. Main spar.
56. Centre-section diagonal spar.
57. Undercarriage operating jack.
58. Undercarriage leg hinge point.
59. Fairing door attaches to leg by sliding linkage.
60. Foot-step on to wing.
61. Linkage operates door over wing hinge members.

62. Wing folding operating jack.
63. Wing fold hinges.
64. Main flaps and linkage (65).
66. Outer plane air brake lock.
67. Outer plane air brake operating jack.
68. Small landing flap also operates as air brake (see diagram).
69. Spring tabs.
70. Trim tab (port only).
71. Navigation lamp.
72. Formation keeping lamp.
73. Identification lamp.

74. Wing tip can be manually folded.
75. Centre plane air brake and jack.
76. Fences prevent aileron buffeting when air brakes are extended.
77. Cooling air between double skinning prevents local heating from jet efflux.
78. 20 mm. cannon and ammunition bays.
79. Front fuselage fuel tank bay (flexible bag tanks are used).
80. Centre section fuel tank extends up between jet pipes.
81. Rear fuselage fuel tank bay.
82. Inner wing fuel tank bay.
83. Outer wing leading edges form integral fuel tanks.

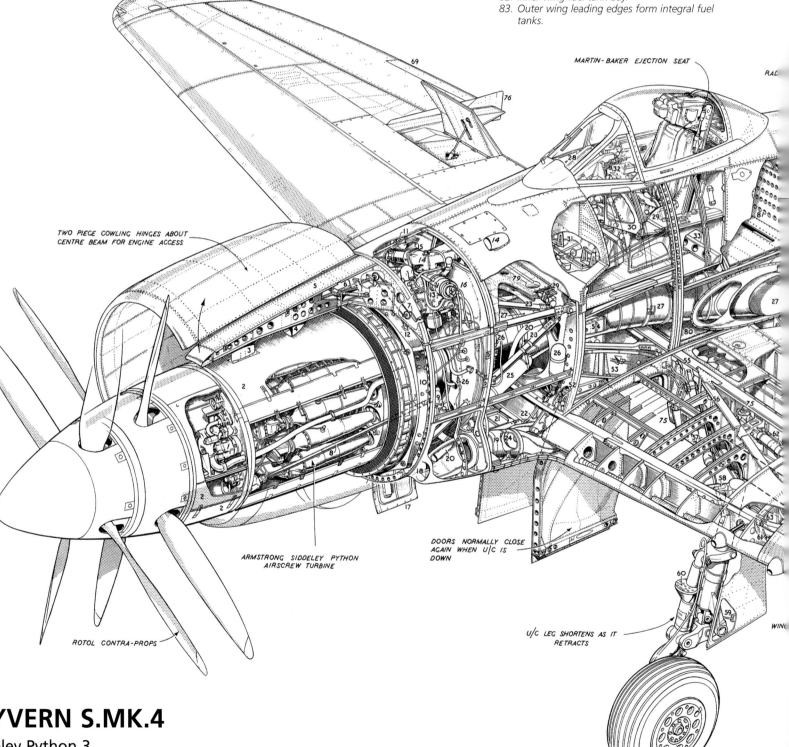

MARTIN-BAKER EJECTION SEAT

TWO PIECE COWLING HINGES ABOUT CENTRE BEAM FOR ENGINE ACCESS

ARMSTRONG SIDDELEY PYTHON AIRSCREW TURBINE

DOORS NORMALLY CLOSE AGAIN WHEN U/C IS DOWN

ROTOL CONTRA-PROPS

U/C LEG SHORTENS AS IT RETRACTS

THE WESTLAND WYVERN S.MK.4

One 4110 s.h.p. Armstrong Siddeley Python 3

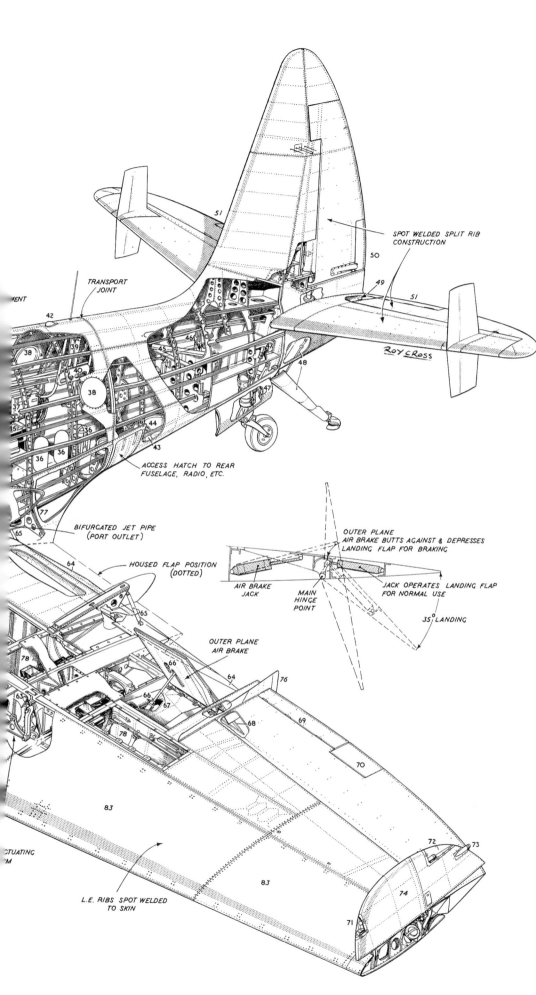

SPOT WELDED SPLIT RIB
CONSTRUCTION

TRANSPORT
JOINT

ROY CROSS

ACCESS HATCH TO REAR
FUSELAGE, RADIO, ETC.

BIFURCATED JET PIPE
(PORT OUTLET)

HOUSED FLAP POSITION
(DOTTED)

OUTER PLANE
AIR BRAKE BUTTS AGAINST & DEPRESSES
LANDING FLAP FOR BRAKING

AIR BRAKE
JACK

MAIN
HINGE
POINT

JACK OPERATES LANDING FLAP
FOR NORMAL USE

35° LANDING

OUTER PLANE
AIR BRAKE

L.E. RIBS SPOT WELDED
TO SKIN

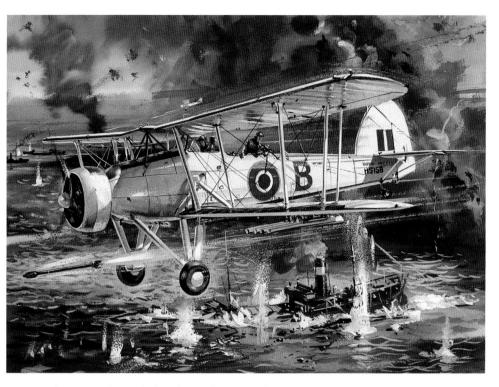

ABOVE: The original rough for the Airfix Swordfish box top.

and produced four or five traditional marine pieces in gouache and took them along to the gallery. Malcolm Henderson, the owner, seemed very interested and asked me to participate in a four-man show of marine paintings he was putting on. All my pictures sold. Thus began an association in the field of historical marine painting which has lasted to this day.'

'Eventually I faced the task of going to see John Gray and explaining to him that I would be leaving Airfix and that I was going to take up marine painting on a full-time basis. I think there was some consternation in the higher echelons there. I presume they thought I was there for good. In fact one upshot was that they immediately offered me a 25 per cent rise in my fee! Not surprisingly, this led me to think that I could have earned this for a quite a few years before. But my mind was made up. The work at Airfix was gradually diminishing, so I came to an arrangement by which I gave them six months' notice and helped them introduce a new artist, Ken McDonough, G.Av.A. to do the work. Eventually, I left and took up marine painting as a full-time occupation.' A year or two later Airfix was in deep trouble and languished in temporary liquidation until rescued by American multinational General Mills, owners of a UK subsidiary, Palitoy.'

'There is a sequel to all this. After twenty-five years concentrating on marine painting, I thought I had learned quite a bit and wanted to see how all the extra experience I had accumulated working in oils in the fine art field would influence my old love of creating aircraft paintings. My membership of the Society of Aviation Artists had lapsed long ago – as had the society itself although various members still kept the craft of aviation painting alive in the Kronfeld Club and subsequently the new Guild of Aviation Artists. Although the Guild was a derivative of the previous society, technically I was no longer a member and the then president of the Guild tactfully told me that I was not simply going to walk back into the association. I was quite happy to earn back my membership and during the following few years I displayed a number of new paintings – some of which are in this book – and, happily, eventually attained full membership of the Guild.'

Where does Roy prefer to paint – in or out of the studio? 'I am a studio painter because more often than not historical painting has to be done from the imagination,' he said. 'The old marine artists would often be aboard a small boat in the middle of a naval action – you can't do that with air combat or at 30,000 feet! So all mine are studio paintings, although I have enjoyed sketching "from life" at events organized by the Guild at aerodromes and aviation museums.'

'Generally,' he continued, 'I work in silence in the studio. You need to be thinking all the time. You aren't copying something that you can see – that's hard enough. Every stroke you make has to come from your imagination based on available reference. There are so many things to consider: for example you have to achieve a consistent light on your subject and think about its effect on the colours involved. Regarding aircraft you have to consider the curvature of the machine. Remember, other than a model, you haven't got the subject directly in front of you – except of course in a ground view on location which one can sketch. You might have photographs, which can be used for reference, although for obvious reasons you cannot copy them. You need to know where the highlights are to reveal the curvature of the aeroplane. A model is great for this – you can take it out in the sunlight or even direct a spotlight on to it and then, as you tilt the aircraft replica, you can understand the true profile of your subject and get a good approximation of where the highlights are. This is a technique I learned at Airfix. They rushed me new pressings from which I quickly assembled a rough model. This I could pose in any position to fill the rather awkward box-top format. I used to think this approach was unusual but have since observed models in other artists' studios

and learned that my "innovation" was far from unique. The American artist Maxfield Parish, for example, used to build detailed models of an idealized landscape often with buildings illuminated, to give him an approximation of scale and directions of the sunlight and shadows. And this was in the 1930s.'

Painting aircraft has certain similarities with portraiture and deciding on the most attractive attitude for an aircraft in flight has parallels with showing off a sitter's best features. Roy must consider such intangible niceties as the harmonious lighting on cloud and landscape as well as the plane, and considering that the audience for aviation art includes enthusiasts, experts and practitioners well versed in aeronautical matters, rendering accurate colours and markings is as important as the engineering detail. 'This is why my background in a manufacturer's technical department and long association with the aircraft industry are a considerable bonus,' said Roy.

'For Airfix at the beginning I did two or three pencil or charcoal roughs from which the management could pick their favourite composition, which I would subsequently follow with a larger colour visual.' Roy used a Grant enlarger and nowadays a photocopier to enlarge the basic image to full size. A cartoon in the traditional sense was created full-size on tracing paper with notations of colouring and markings.

'With an aeroplane the "feel" and "sit" have to be just right and correct in every technical detail. As with the rigging in a marine painting, I have a check-list of all the details such as trim tabs, aerials, access panels, control horns – any of which it is easy to bypass even in the final checking.' This is not as straight-forward as it might sound. If the aircraft is making a diving turn to port, for

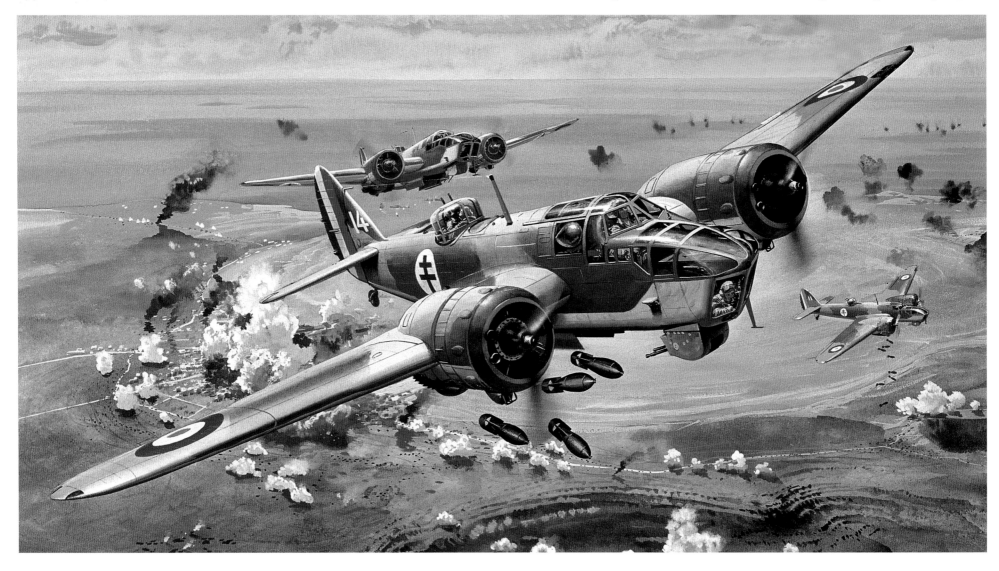

LEFT: The Bristol Blenheim Mk IV in action.

RIGHT: French jets from the 1950s: the SO 9000 Trident jet/rocket research aircraft; the Dassault Super-Mystère B1; and the Nord 1402 Gerfaut 1B.

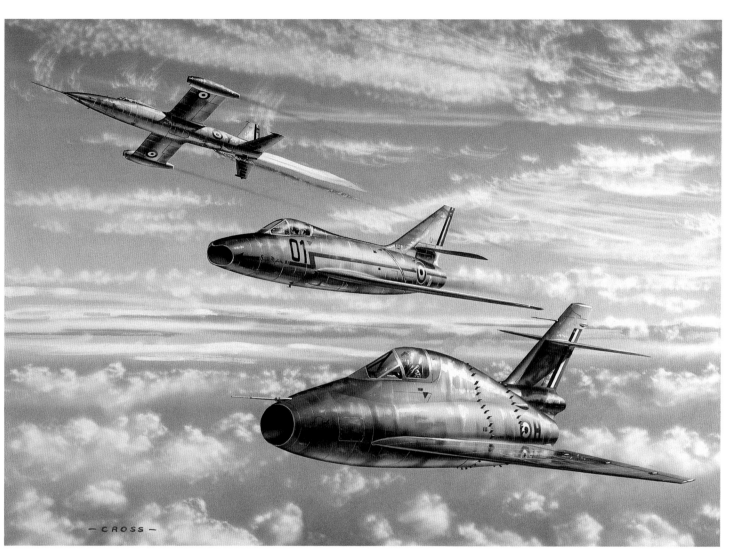

example, Roy has to ensure all the flying surfaces, ailerons, elevator and rudder are in the correct attitude. Imagine the pennants atop the mast of a sailing man'o'war flying in a contrary direction to a gale-force wind!

Finally, the cartoon is transferred to the canvas and painting can commence. Roy loosely blocks in the whole canvas, but he then goes on to finish the background, leaving the main subject detail until the last. He generally paints in oils. This medium has to be built up gradually in layers – 'a time-consuming process, but when it is finished all that remains is a final overall check for accuracy and then…it's off to the framers'.

Adept at using a variety of painting and drawing media, Roy is happy working with the most suitable material for the job – be it Indian Ink for line work (the discipline with which he began his career in art) or water- or oil-based paints. Gouache – a kind of thick, opaque watercolour – is a favourite, however, and some of his most famous paintings have been executed in this medium. Gouache is favoured amongst graphic designers and commercial artists commissioned by magazines and book publishers. It reproduces well and because of its opacity allows over-painting – the ability to be able to correct or amend details. It looks an easy medium, but first appearances can be deceptive. For example it changes colour as it dries (like acrylic), and is difficult to glaze or over-paint without activating the initial water-soluble layer.

Commercial watercolour boards are of differing quality and Roy told me that he had some special supports made up that featured pre-soaked and stretched Arches paper bonded to stiff board in readiness for his brushwork. 'The Arches paper is a favourite of mine. You can soak it and if you are very quick you can do a "wet-in-wet" painting and the gouache smoothes out beautifully.' Even on soaked paper speed is essential and Roy has several basic colours readymixed for the sky and clouds before he begins painting. Aviation artists want a soft impression of the sky, as distinct from the sharper detail of the aircraft and the foreground. And as we all know, an attractive skyscape is fundamental to the overall success of any portrayal of an aircraft in flight. To achieve a more subtle finish with gouache, a rapidly drying medium more associated with hard-edged depictions of flat areas of colour or tone, Roy was forced to adopt a very systematic approach to his painting. He actually managed to subdivide a large picture area into quarters and then tackled each successive section in rotation whilst keeping it all damp!

Working wet-in-wet means that Roy can quickly block in the background – often immediately capturing the elusive quality of the sky and clouds. He strives to get the sky right as soon as possible and prefers not to overwork or correct this important aspect of an aviation picture. 'It's best to do it first-off and not retouch it afterwards. If you are working wet-in-wet you find that it all flows in beautifully on a good paper. But later if you are still unhappy, you could rework it, perhaps by dampening the surface a bit with a diffuser and then retouching the sky.'

Although Roy can switch medium with ease, he is convinced that oil is best for really 'grand' canvases and for paintings more concerned with capturing an emotion or the transitory quality of light, rather than fine detail. 'Oil is the best possible medium for really big aviation paintings and, of course, the marine work I do now. However, recently I have also used artists' acrylics. They do everything that oils do – although they are more difficult to blend because they dry so fast.'

'Choosing to paint largely historical subjects make things difficult,' he said. 'Whereas many landscape artists can look out of the studio window and hopefully see an inspirational sky or shapely tree, an aeroplane or fully rigged packet ship is not immediately at hand!' He has consequently amassed an impressive reference library to help his research efforts and to ensure that specific details are as accurate as possible. Indeed, recently his aviation book collection alone was valued in excess of £12,000. His collection of maritime books and memorabilia is equally valuable, and, as you might expect, he also has a fine array of books about his favourite fine artists. There is also a huge amount of aviation reference material filed in steel cabinets by subject and manufacturer. Roy never knew what he would be commissioned to paint next so he had to keep records of almost every aeroplane that had flown. His archives are full of sketches and photographs of clouds recorded at different times of the day and a collection of air-to-ground images to help him vary his backgrounds.

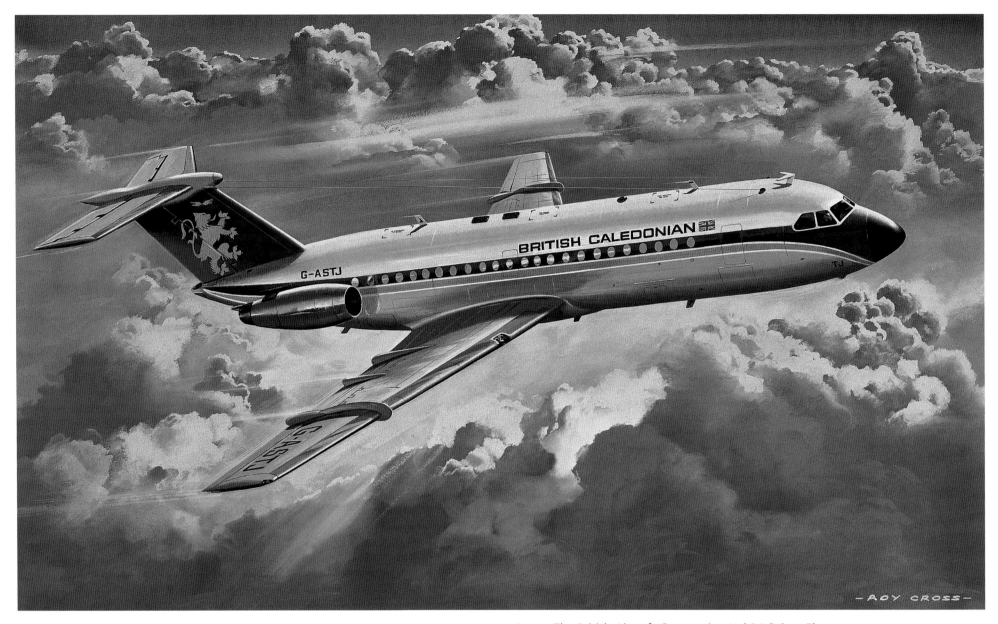

ABOVE: *The British Aircraft Corporation Ltd BAC One-Eleven.*

RIGHT: *A typical advertising painting, of the Handley Page Herald for Rolls-Royce, marked Roy's entry into the lucrative field of commercial artwork, only to be thwarted by decreasing business for the industry and probably the advance of cheaper colour photography. A byword of the day was 'Last in, first out!'*

'Occasionally when flying I would take my own air-to-ground photographs, and from all this can build up realistic but imaginative backgrounds to the main aircraft subjects.'

On the subject of computers and the facility to enlarge and reduce via scanners and electronic copiers, Roy has this to say: 'As technical artists in the old days we did everything by hand, but today I hear from illustrators working in the field of aviation publishing that a lot of computerization is involved. Jim Clark, for example, who was the doyen of cut-away artists, used to go down to the factory and sit there and sketch the whole thing on the spot! I used to compromise between having the (engineering) drawings and sometimes using photographs and sketching from "life" on location, going back home to do the main work, and finally going back to the factory to have it checked over by the technicians before the final execution.'

But there is one piece of modern machinery which has transformed his daily work and without which life would be that much more difficult: the photocopier! 'I've recently bought, at some expense, one of these copy machines which both enlarges and reduces,' he told me. 'I found this piece of kit paid for itself within a year and saved a lot of tedious labour. Now I can enlarge and reduce things and alter my composition by playing about with elements of a picture without too much effort.'

No stranger to the technical side of graphic equipment, having been trained to use the airbrush and Grant enlarger (a very robust and purely mechanical contraption largely superseded by today's electronic copiers), Roy prefers to rely on his intuitive finesse with such simple resources as the pencil and paint brush. There is no substitute for traditional drawing skills and many a painting has been let down because of a poorly executed composition. Roy recalled the days immediately after the Second World War when, as a technical artist he was encouraged to learn the airbrush. 'As soon as I had the money, I bought an airbrush for my own use. My first airbrush was a DeVilbiss Aerograph. I found this piece of equipment essential for the tone drawings I was then producing.'

I wondered if Roy ever experienced periods when it was difficult to continue or even finish a painting. Did he ever experience 'artist's block' – moments when his artistic muse simply abandoned him? 'I don't believe in artist's block,'

was his forthright answer. 'Although a blank page or canvas can be quite intimidating you will have worked out your ideas previously on a combination of sketches or artist's roughs, well before you even touch the canvas. No, it's a job of work – a "nine-to-five" job if you are going to make a living out of it. I don't believe in "blocks" and I don't believe in discarding a half-finished painting, because that's simply a waste of time! I can't afford the time to throw anything away. Everything has to be well planned in advance so that it is always brought to completion.'

Roy has few regrets about missing out on a formal art education in his youth. 'So many people tell me I would have learned nothing really useful for my particular field, and in fact I did go part-time to Camberwell School of Arts and Crafts and, a little while later, St Martins, but in some ways I do regret not completing a proper academic art course. This would have enabled me to learn earlier about the history of art and about individual artists and maybe I would have caught-on about certain techniques sooner.'

'I don't claim to be the best aviation artist in the business,' he reflected as he reviewed half a lifetime's work, 'and the complexities of modern technical illustration have gone beyond my current capabilities, but I have always tried to explore new techniques and media.' For sheer variety of illustration in all media, all of it top class, the contents of this book I think reveal a unique talent. Few aviation artists can claim to progress from accomplished technical illustration in various media, via colour advertising work, to a rewarding career in the field of high-class traditional fine-art painting. Roy Cross has achieved this enviable hat trick and readers of this book must surely agree that, especially with his latest aviation art, he has gone from strength to strength.

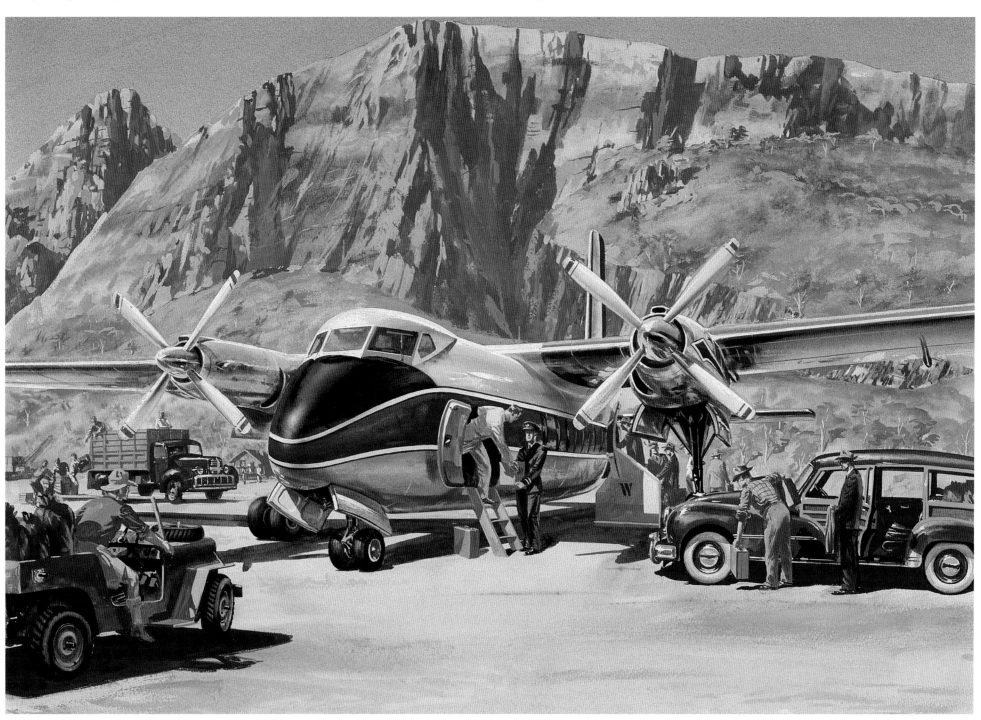

The Gallery

Captions by the artist

I decided to adopt a chronological approach as the most logical way of grouping together, in a single gallery, the large number of aircraft illustratons I have completed down the years. The individual paintings were not created in such an orderly procession of course! Some date back over fifty years and others were completed quite recently. I think arranging them as I have serves two purposes: the reader can view half a lifetime's aviation art, and also learn a little about the development of aviation from the earliest days of flying to the present. The previous pages reveal the development of my art from line and technical illustration, which at one time seemed to be the height of my ambition, to colour illustration for books and advertising.

This orderly approach has the odd hiccup, for which I beg to be excused, and there were obvious gaps, which I attempted to fill with new pictures and sketches. Of course there are countless aeroplanes I should like to have included – types that appeal to the artist, such as the famous Fairey III series of rugged biplanes, beauties such as the de Havilland DH 91 Albatross and Lockheed Constellation, oddities like the DH 5 and plain uglies like the Avro Bison, ungainly in flight but still an honest and workmanlike machine, built through no fault of its own to a convoluted specification and intended low cost. I confess to a nostalgic regard for those old biplanes, many before my time, which epitomise for me the adventure and romance of flying and spurred me on to draw them in the first place.

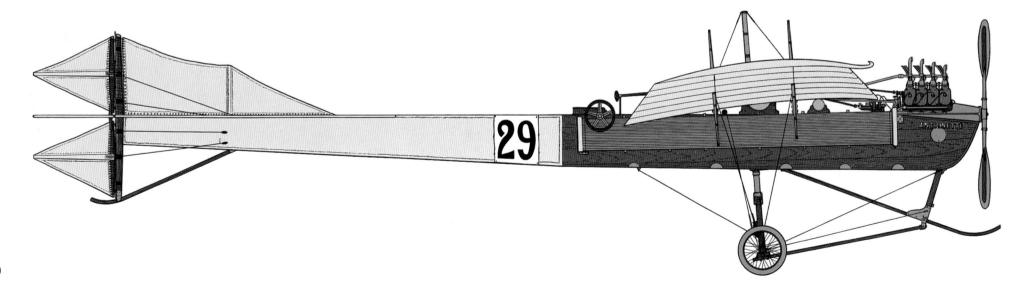

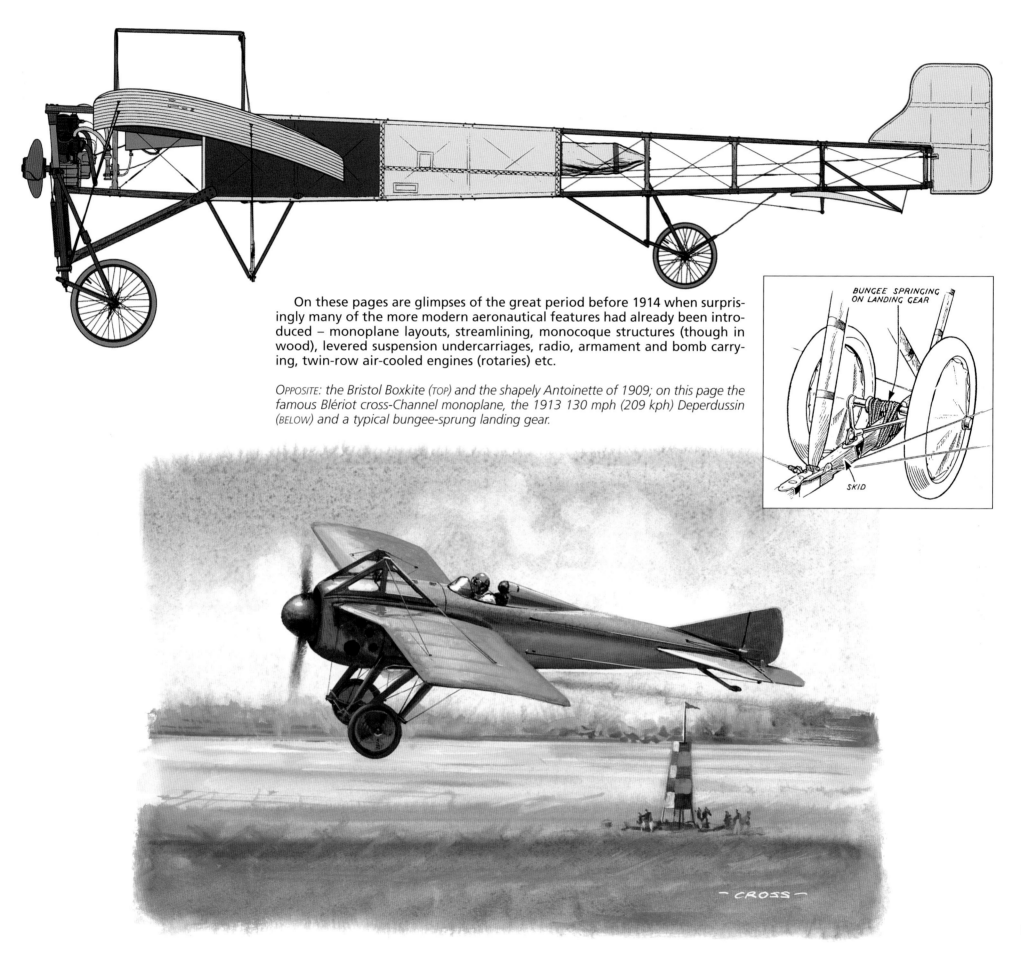

On these pages are glimpses of the great period before 1914 when surprisingly many of the more modern aeronautical features had already been introduced – monoplane layouts, streamlining, monocoque structures (though in wood), levered suspension undercarriages, radio, armament and bomb carrying, twin-row air-cooled engines (rotaries) etc.

OPPOSITE: the Bristol Boxkite (TOP) and the shapely Antoinette of 1909; on this page the famous Blériot cross-Channel monoplane, the 1913 130 mph (209 kph) Deperdussin (BELOW) and a typical bungee-sprung landing gear.

BUNGEE SPRINGING
ON LANDING GEAR

SKID

– CROSS –

31

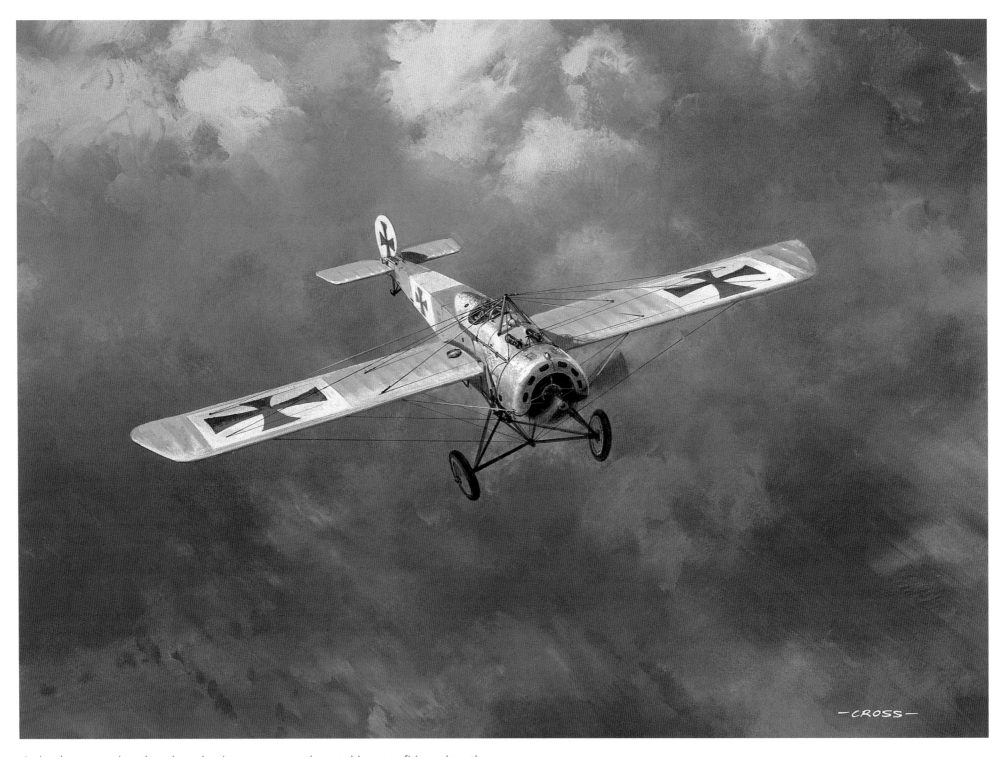

A simple cam and push-rod mechanism to prevent the machine-gun firing when the airscrew obstructed the muzzle, rather than great aerodynamics, made the Fokker E-type monoplane perhaps the most efficient fighting aeroplane of 1915 and introduced a new era of air combat. Here the great Oswald Boelcke is aloft in his twin-gun E-IV.

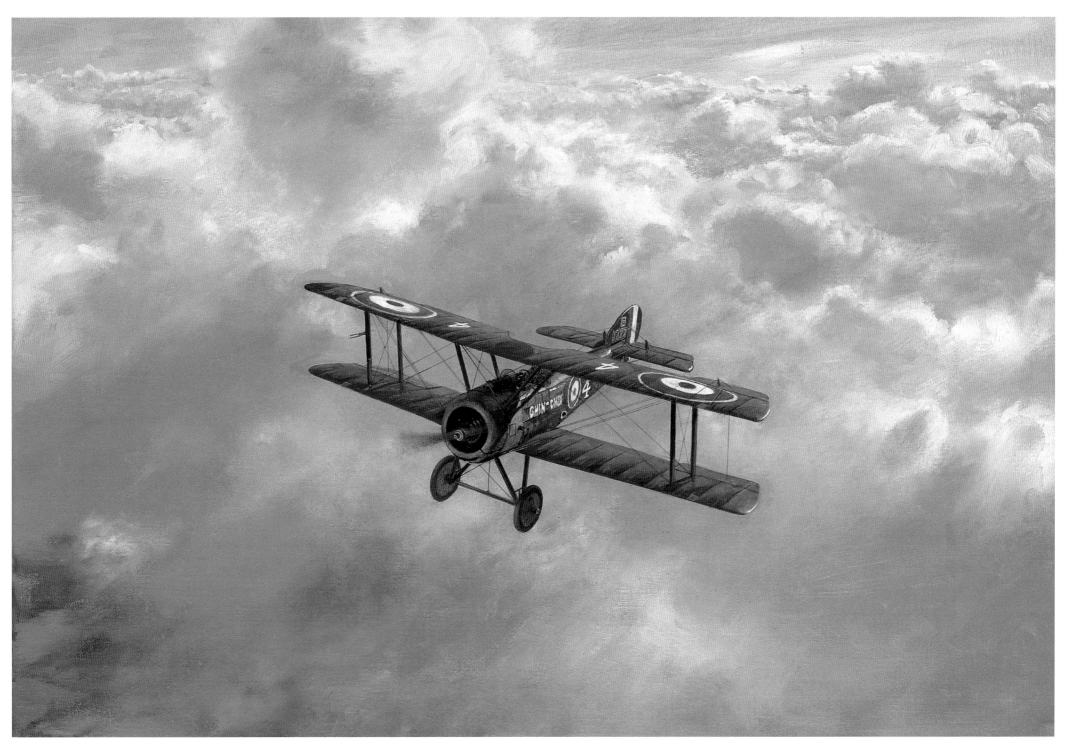

In The Clouds Remember *Major Oliver Stewart labelled the Sopwith Pup 'the perfect flying machine, without superior', and despite only having a single machine-gun and coming into the battle late in the day, it was a worthy adversary of the Fokker E-type monoplane and later German fighters. It was powered by 'the finest rotary ever made' to quote Oliver Stewart again, the 80 hp Le Rhône.*

RIGHT: The famous Sopwith Camel.

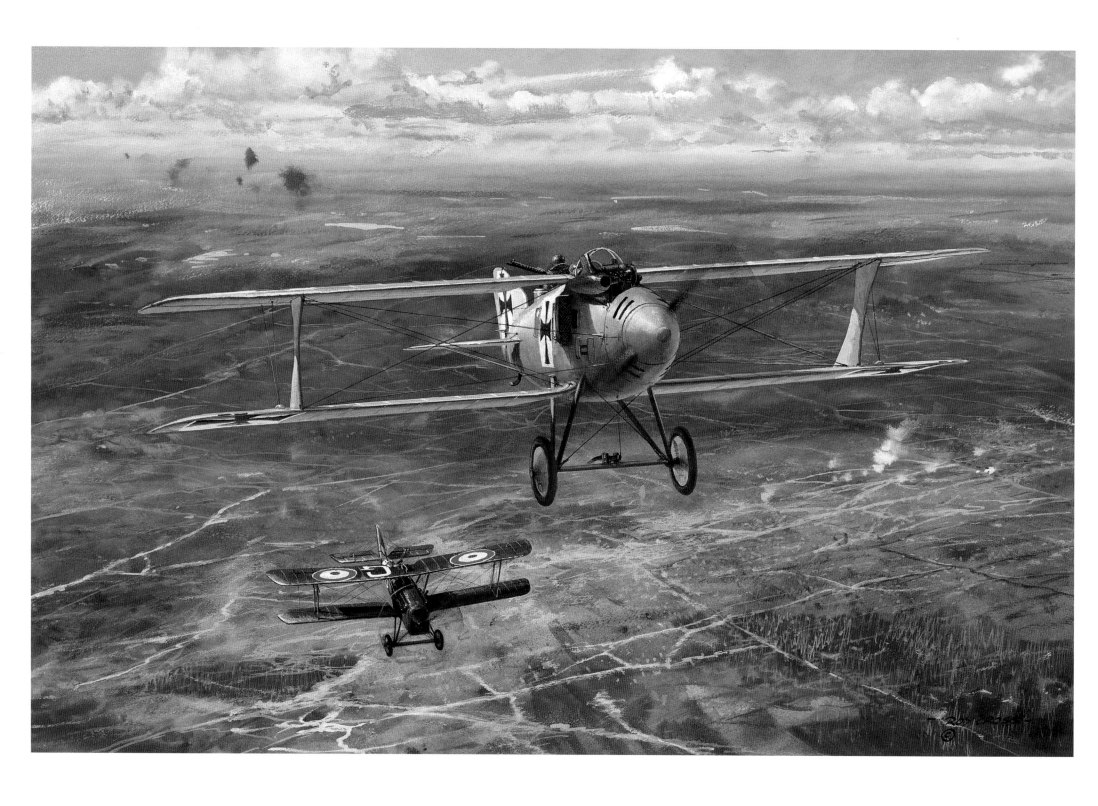

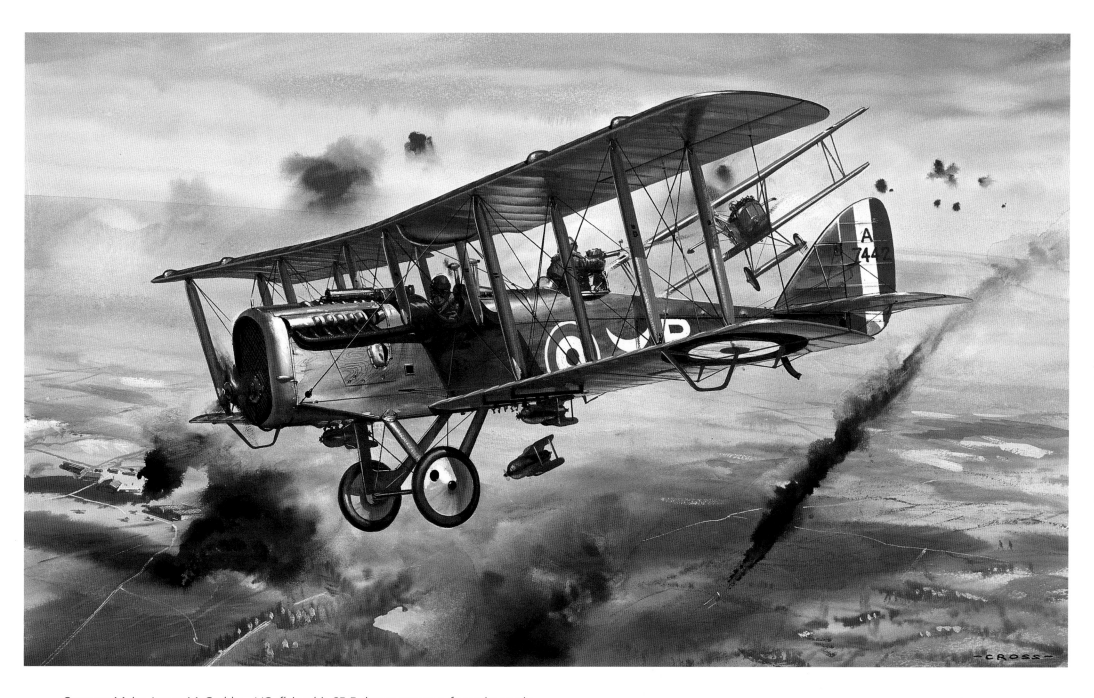

Opposite: *Major James McCudden, VC, flying his SE 5 demonstrates a favourite tactic, creeping up to an unsuspecting adversary's blind spot beneath the tail (Roland C II).*

Above: *The DH 4 long-range day bomber introduced in 1917. It was hoped that a 136 mph (219 kph) top speed and 22,000 ft (6,096m) ceiling afforded by the powerful Rolls-Royce Eagle engine, plus an excellent outlook for pilot and observer, would provide comparative immunity from German fighters during deep penetrations over enemy lines. A derivative, the 1918 DH 9A, gave sterling service with the Royal Air Force as late as 1931.*

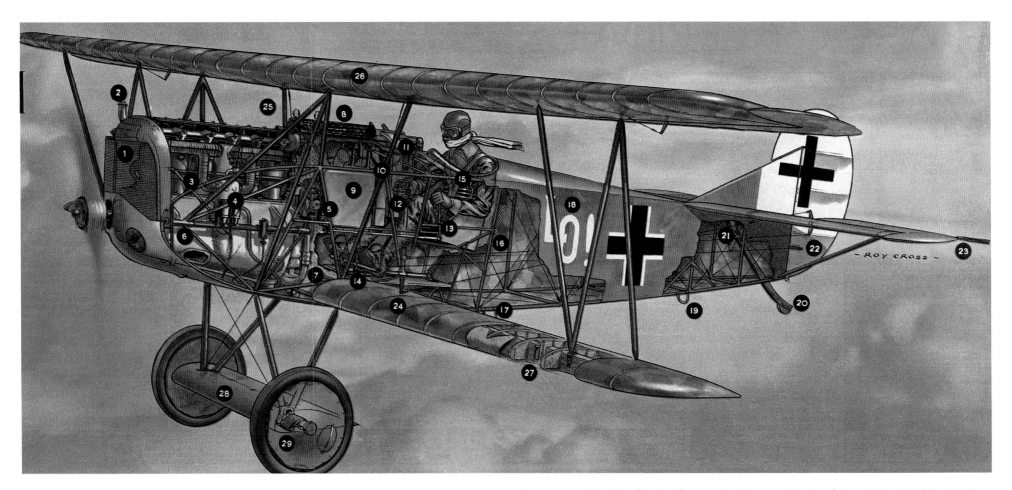

A cut-away drawing for the famous boy's paper Eagle of Ernst Udet's Fokker D VII fighter.

BELOW: One of the plates from Early Aeroplanes of the Albatros D V flown by Leutnant Karl Thom of Jasta 21 in 1917.

OPPOSITE: The Austrian 'Red Knight' Hauptmann Godwin Bromowski flying his Albatros D III over the Italian front with fellow ace pilot Oberleutnant Frank Linke-Crawford.

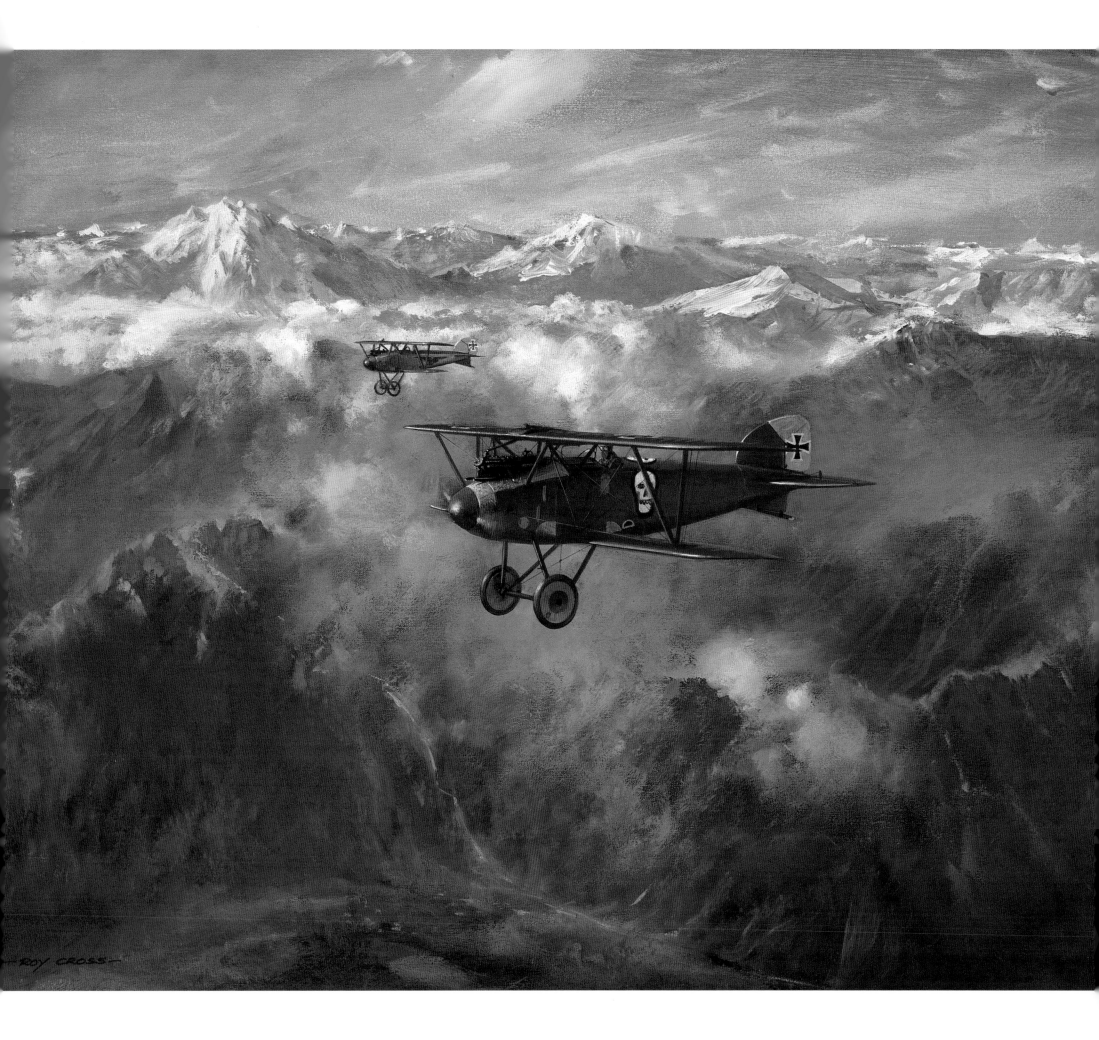

Opposite: A Curtiss JN-4A used by Aerial Fighting Squadron No.1 RFC, a training unit in Canada 1917–18. Jennys were also made or assembled by Canadian Aeroplanes Ltd and renamed Canucks.

The perfect training aircraft; the Avro 504 (*this page*) and the Curtiss Jenny (*opposite*). The first 504 appeared in 1913 powered by an 80 hp Gnôme rotary engine and in various updated versions served with the Royal Air Force and in civilian and service roles worldwide right up to the 1930s. At one time the Americans even considered it as a replacement for the Jenny, their standard trainer developed from the Model J of 1914 vintage, itself the work of a British engineer employed by pioneer Glenn H. Curtiss.

Above: a unique high-visibility colour scheme on a 1918 504K home-establishment trainer, while more usual schemes are shown in the painting *below*.

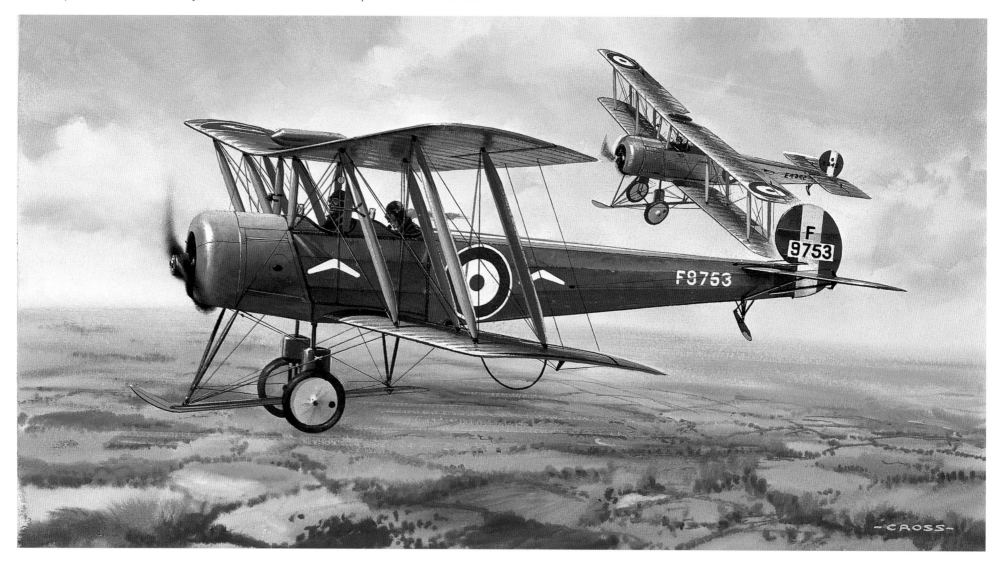

38

— ROY CROSS —

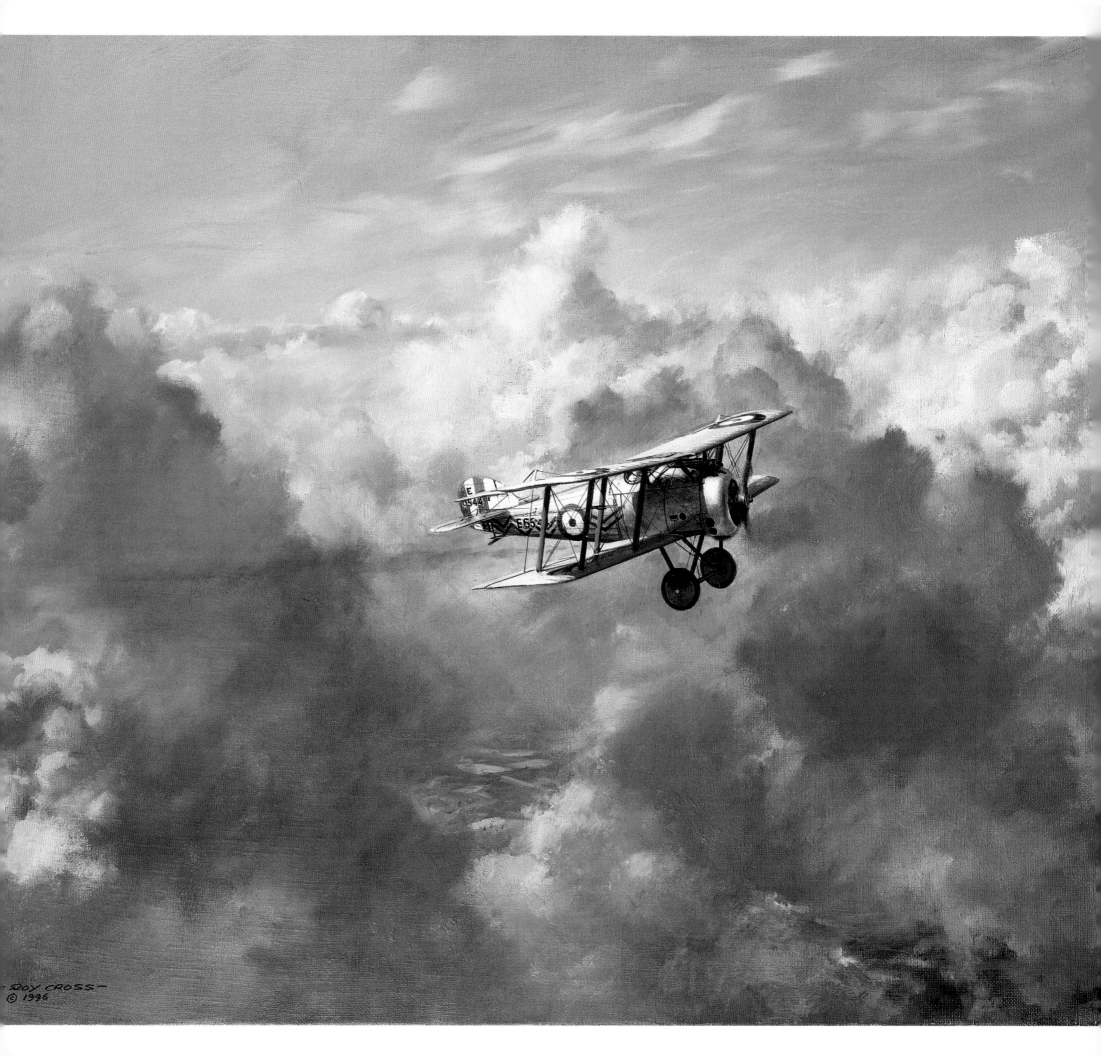

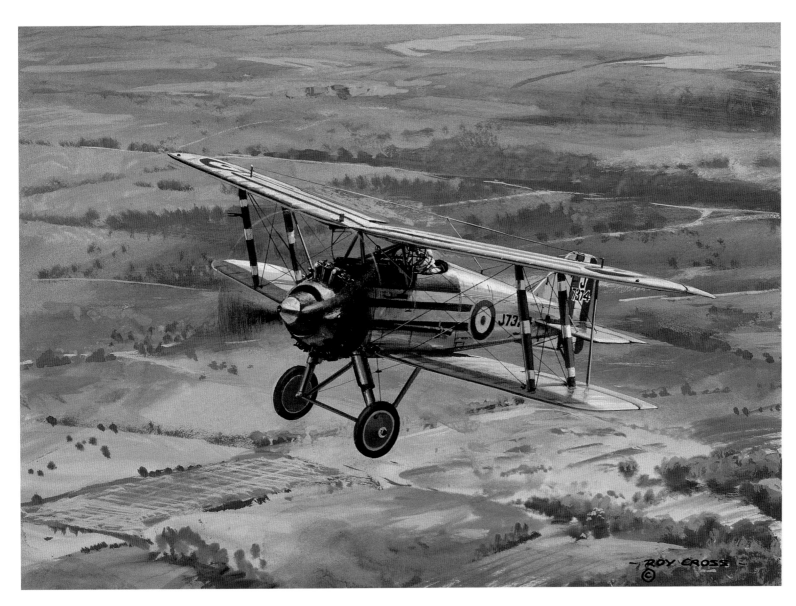

Mid-twenties RAF fighters improved little upon the SE 5 and Camel of the war period and indeed the Gloster Grebe (LEFT) was designed by the same engineer, H.P. Folland, who created the SE 5. The Armstrong Whitworth Siskin (BELOW) was ordered into production at about the same time as the Grebe and had a certain rugged, ungainly charm which is most appealing. The Grebe has the markings of No. 25 Squadron and the Siskin those of No. 41 Squadron, RAF.

OPPOSITE: During the late 1950s I had a spell at St Martin's School of Art in the hope of learning about the mysteries of oil-painting technique. The genesis of this painting occurred in a quiet corner of the classroom there, ignored by tutors and students alike, who had quite other interests. Years later I came across the unfinished skyscape and popped in this Sopwith Snipe, a type that bridged the last years of the Great War and the early post-war era of a decimated RAF. This is a Snipe belonging to No. 17 Squadron RAF c.1925.

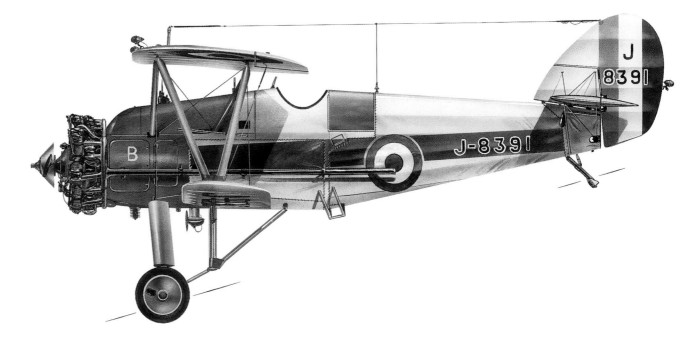

41

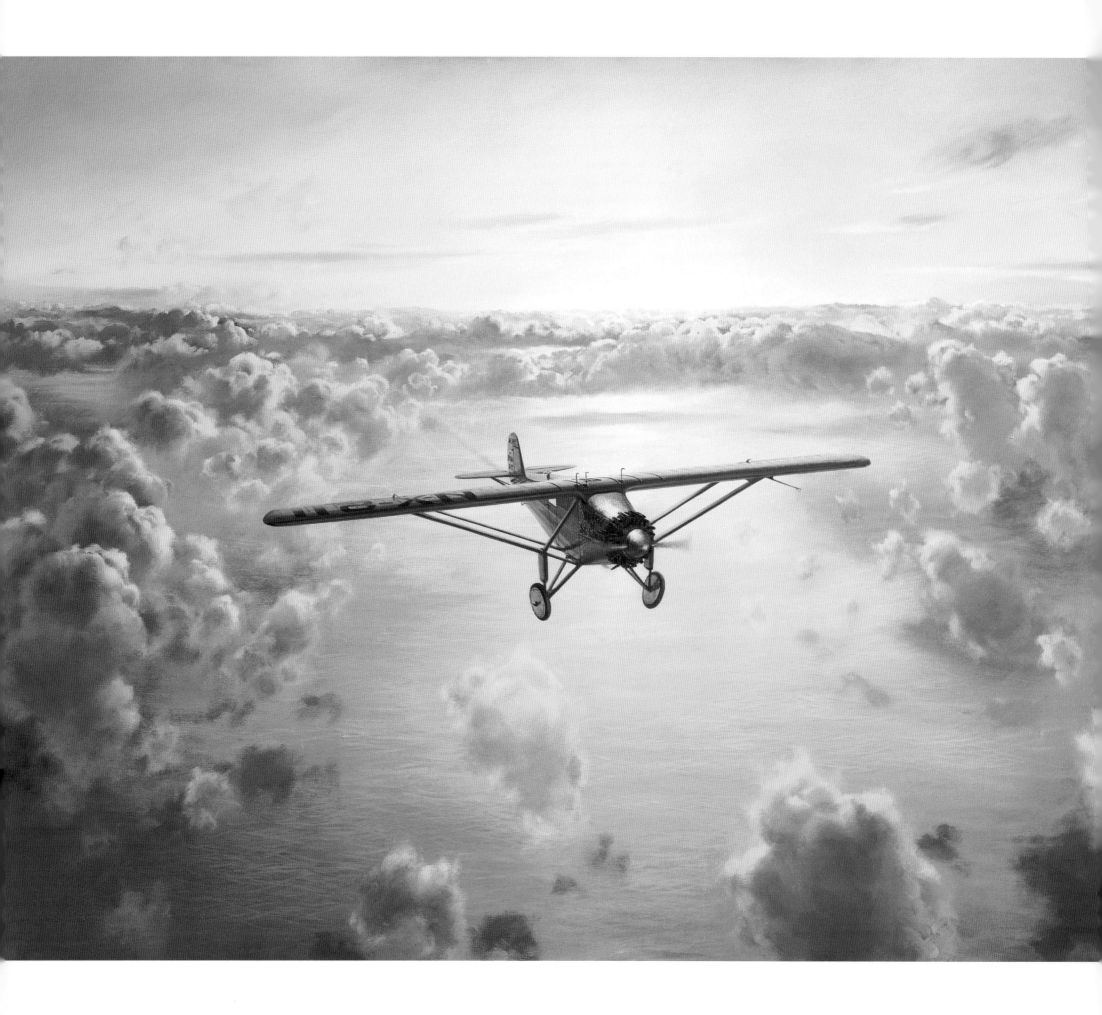

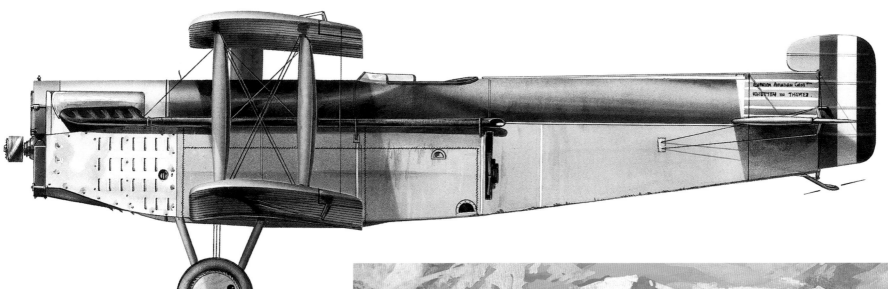

Great Flights

ABOVE: Famous pilot and designer Harry Hawker and navigator Lieutenant-Commander K. Mackenzie Grieve modified a post-war five-passenger Eagle-powered Sopwith transport for their unsuccessful attempt at a non-stop west–east crossing of the Atlantic in 1919.

RIGHT: The DH 88 Comet, winner of the 1934 MacRobertson England–Australia Trophy race.

BELOW: Charles E. Kingsforth-Smith had his eye on a pioneering flight across the Pacific Ocean as early as 1921, an ambition he finally achieved in 1928 in the Whirlwind-powered Fokker tri-motor Southern Cross.

OPPOSITE: An impression of Charles Lindbergh's lonely first solo flight across the Atlantic in 1927 in the Ryan NYP (220 hp Wright Whirlwind engine) named Spirit of St Louis.

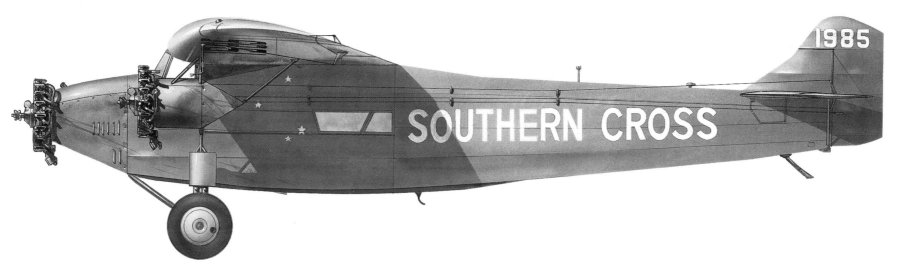

An artist's delight! During the late 1920s and early 1930s, Hawker Aircraft had produced a series of service aircraft of notably fine lines, making them among the prettiest of their day. Most of them used Rolls-Royce in-line Vee engines that allowed a shapely, streamlined nose while well-staggered wings gave an eager, thrusting appearance that promised high performance. The two-seat Hart light bomber of 1929–30 spawned a whole line of similar aircraft adapted for various duties with the RAF and Fleet Air Arm. In the foreground above is the Demon two-seat fighter derivative of 1933 (No. 29 Squadron), formating on a float-equipped ship-board Osprey fighter-reconnaissance machine, a type which initially entered service with the Fleet Air Arm in 1932.

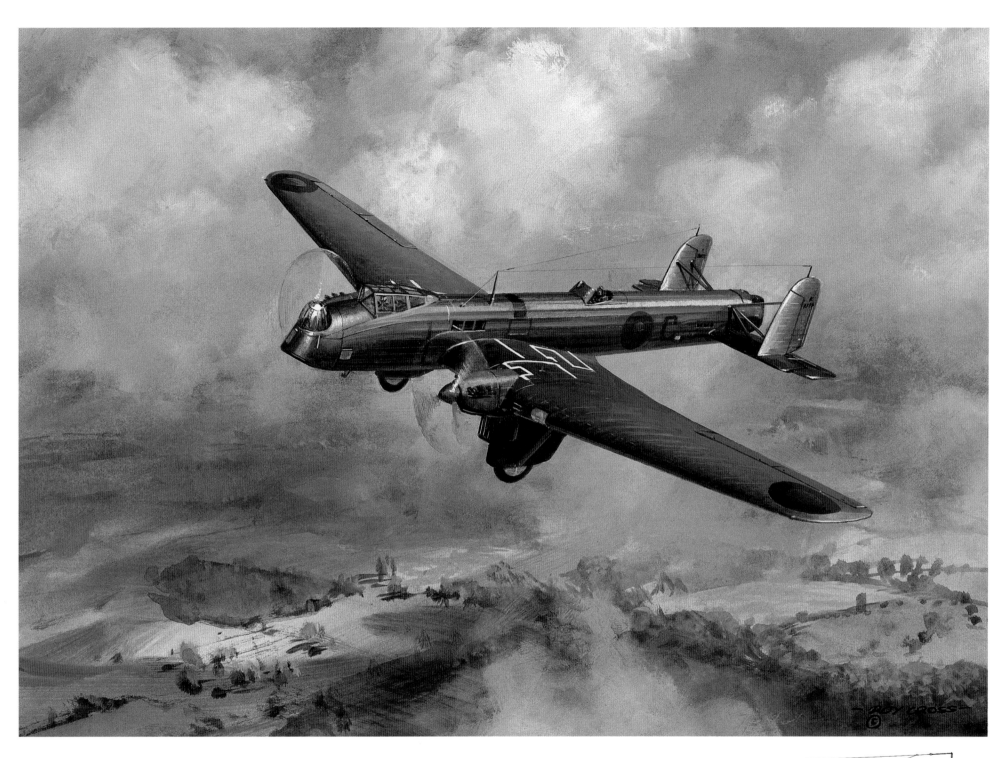

ABOVE: Limits to the performance potential of the biplane layout had long been foreseen, and as early as 1927 Fairey Aviation Ltd, for one, was thinking in terms of a monoplane design, to bomber specification B19/27. But it was not until 1936 that the developed machine actually entered service with a single full RAF squadron (No. 38) as the Hendon night bomber, already outdated as a result of Air Ministry indecision and newer specifications.

RIGHT AND AT THE BOTTOM OPPOSITE:
Speed personified; the single-seat Hawker Fury II, here shown in the markings of No.25 Squadron, RAF.

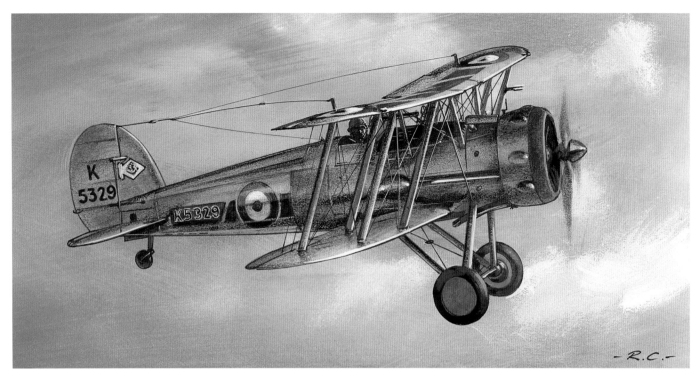

I intended to submit the painting opposite of a No. 72 Squadron Gloster Gladiator Mk I to the annual exhibition of the Guild of Aviation Artists some years ago, but immediately prior to the show I was somewhat nonplussed to discover an advertisement for a superb limited edition print of the Gladiator in a rather similar attitude, the artist being Roy Huxley, a full member of the Guild. Since the possibility of mine being the second of two similar pictures in the same exhibition did not appeal, it was withheld and appears here for the first time!

The Gloster Gauntlet (above) originated from the same 1927 specification – for a fast-climbing single-seat interceptor fighter with a climb to 20,000 ft (6,096 m) in under twelve minutes – which resulted eventually in the Hawker Fury. Gloster's SS 19B (the Gauntlet) stemmed from the SS 18 and SS 19 series fitted with various air-cooled radial engines, as distinct from the Fury with its Rolls-Royce in-line Vee engine. Interestingly, the SS 19 featured six-gun armament, for the Air Ministry, belatedly, were thinking in terms of increased fire power, already common in foreign fighters, to counter the bomber threat. Strangely, the service Gauntlet reverted to twin Vickers gun armament, but with a 223 mph (359 kph) maximum speed and a climb to 30,000 ft (9,144 m) in 21.2 minutes (Gauntlet I), it usefully improved upon the performance of the 174 mph (280 kph) Bristol Bulldog IIA, which it replaced in squadron service from 1935.

The improved Gladiator was the last biplane fighter to serve with the RAF and featured single-bay instead of twin-bay wings, single-strut landing gear with Dowty internally sprung wheels, four-gun armament and eventually an enclosed cockpit for the pilot. This streamlining and the more powerful 856 hp Bristol Mercury IX engine raised the top speed to 246.5 mph (396.6 kph).

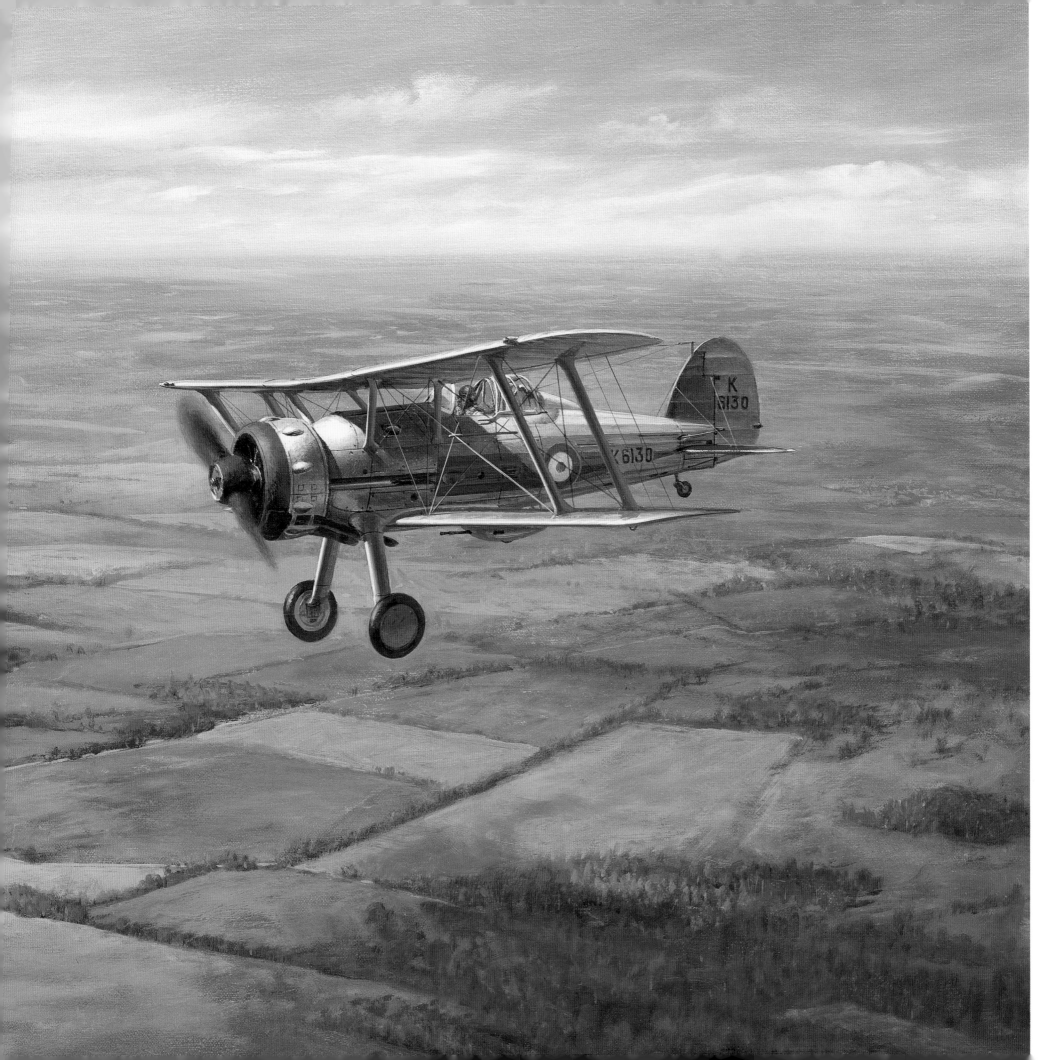

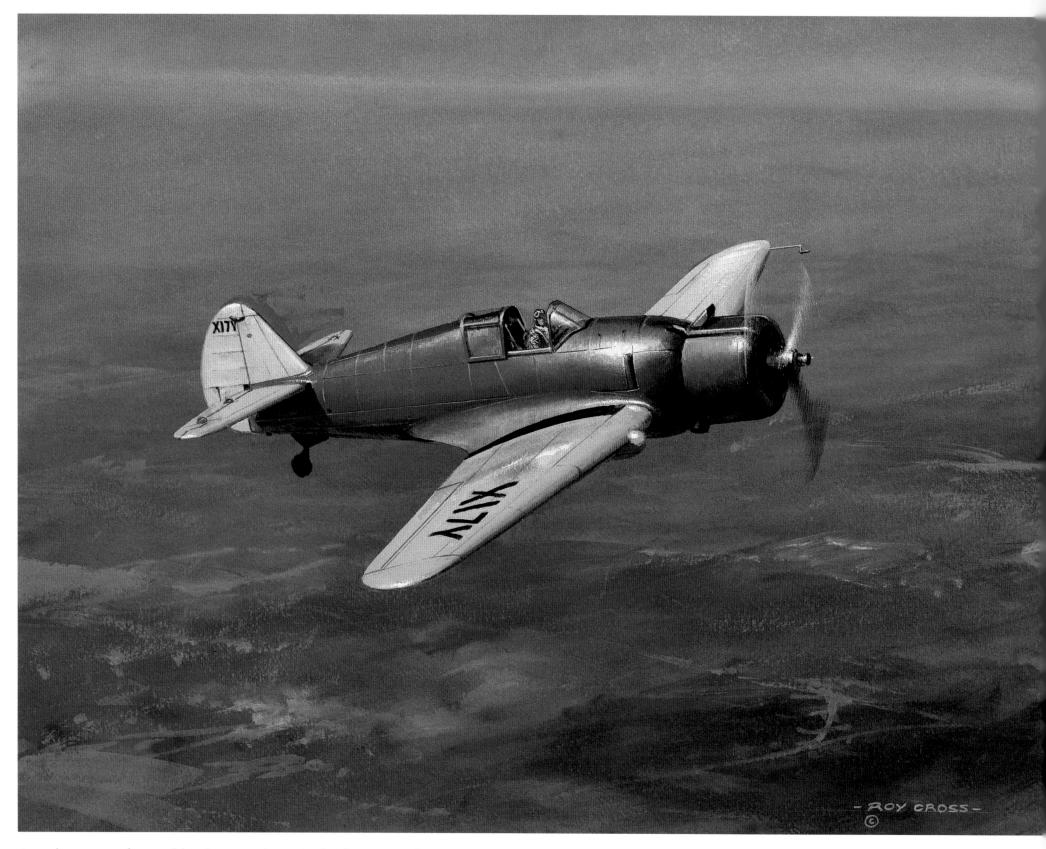

- ROY CROSS -
©

Aeroplanes manufactured by the USA always had a fascination for me as a youngster, not least because of their colourful paint schemes, as witness the picture above. Identification of the aeroplane depicted puzzled more than one of the enthusiasts I showed it to until I mentioned the Curtiss P-36 (Mohawk). It is in fact the prototype Model 75, looking unfamiliar and out of proportion with a tightly cowled, small-diameter twin-row Wright R-1670 radial engine. Four-gun armament was intended and the developed Model 75A and the contemporary Seversky P-35 marked the evolution of US single-seat fighter design from biplanes (Curtiss Hawks and Boeing P-12s/F4Bs) to modern monoplane configurations.

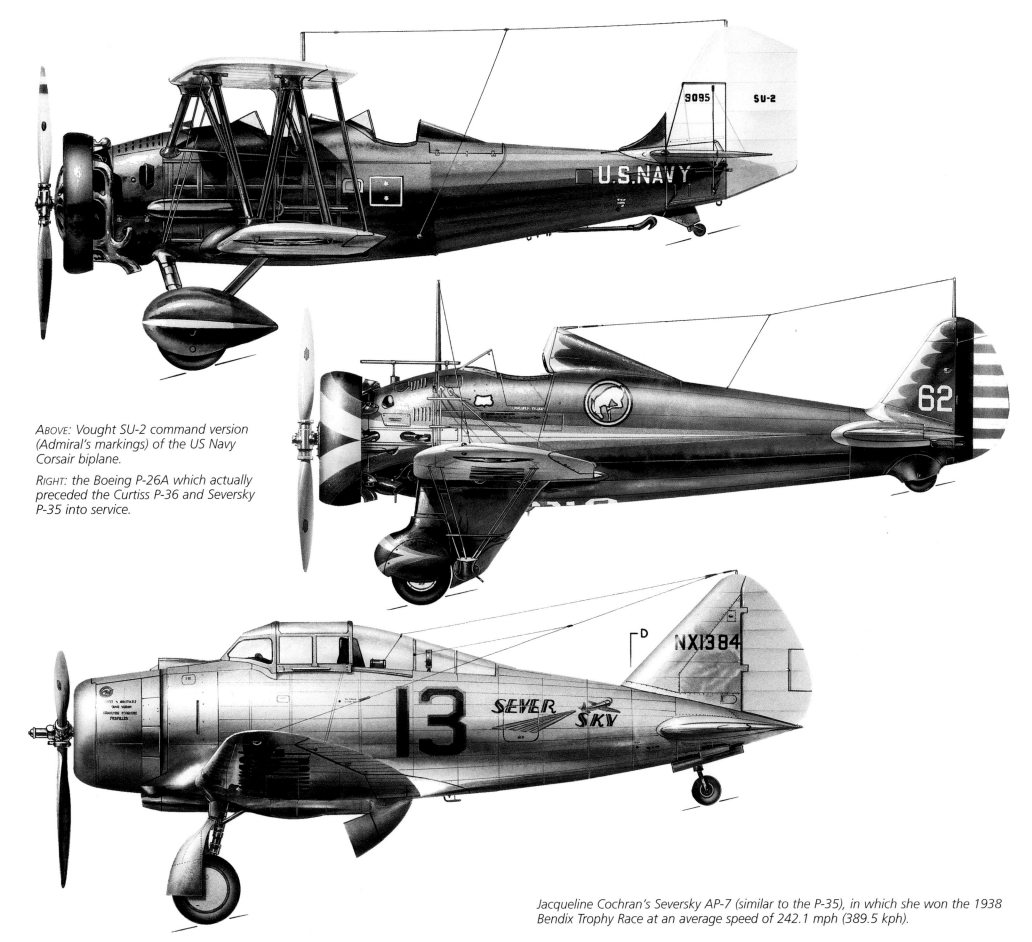

ABOVE: Vought SU-2 command version (Admiral's markings) of the US Navy Corsair biplane.

RIGHT: the Boeing P-26A which actually preceded the Curtiss P-36 and Seversky P-35 into service.

Jacqueline Cochran's Seversky AP-7 (similar to the P-35), in which she won the 1938 Bendix Trophy Race at an average speed of 242.1 mph (389.5 kph).

More colourful pre-1941 US markings. Outdated by later versions, this Boeing F3B-1 in a special blue and silver command scheme was allocated to the Commanding Officer of the aircraft carrier USS Lexington.

A fairly advanced naval carrier-borne monoplane, with folding wings and retractable undercarriage at the time of its first flight in 1935, the Douglas TBD Devastator became the standard torpedo-bomber for the US Navy until the Grumman Avenger was introduced. Although they played their part, most Devastators were lost during the decisive Coral Sea and Midway naval air battles against the Japanese in 1942.

The first service version of Consolidated Aircraft Corporation's PBY long-range patrol bomber in the colourful pre-war markings of the US Navy. The red engine cowling leading edges denote the leader of the first section of the squadron as shown by the red fuselage stripe and white-outlined Vee on the mainly yellow wing-top surface. The squadron is VP (patrol)-12.

PBYs demonstrated their long-range capabilities with a formation delivery flight of less than 22 hours, San Diego to Hawaii, January 1937, and went on to serve worldwide right through and after the war with American, British and other air forces in various versions totalling over 3,200 machines.

The menace of the Luftwaffe. *LEFT: Heinkel He 51 ground attack aircraft in Spain. RIGHT AND BELOW: Accurate and terrifying attacks by Junkers Ju 87 Stukas aided the rapid advances of the German army during the early part of the Second World War, while the Ju 88 in many forms became the Luftwaffe's best medium/dive bomber and heavy fighter.*

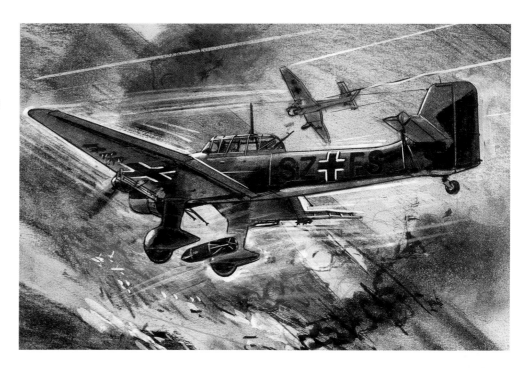

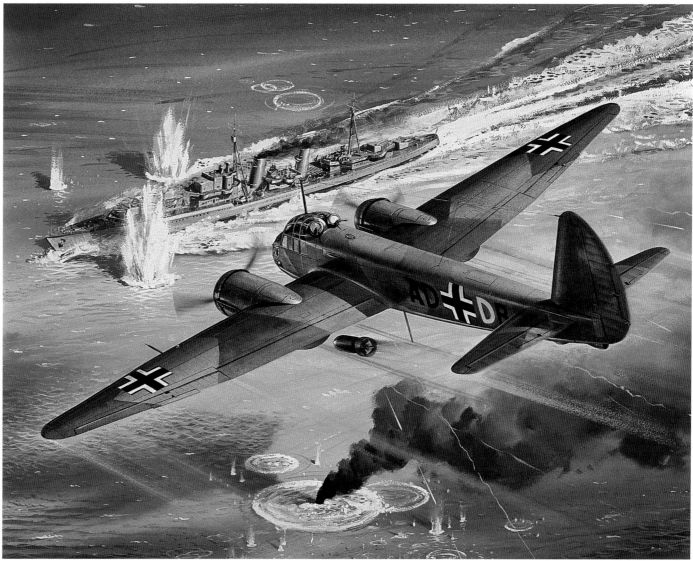

Sidney Camm, Hawker's Chief Designer, had discussed with the Air Ministry a monoplane version of the successful Fury in August 1933, and a year later an official specification was issued incorporating Camm's latest developed design proposals based on the new Rolls-Royce PV 12 engine, which promised a speed of 320 mph at 15,000 ft. Whereas Supermarine's racing seaplane experience dictated stressed-skin construction, Camm saw little reason to change from the fabric-covered metal structure developed to a high degree in his series of production biplanes for the RAF. The Hawker system of tubular metal frame construction was sturdy and easy to repair, and of course extensive factory facilities already existed to speed the new machine into production.

Air Ministry proposals for eight-gun armament were incorporated into the new Hurricane design and the prototype flew on 6 November 1935. Tested at the Aeroplane and Armament Experimental Establishment (AAEE), Martlesham Heath, it achieved a maximum speed of 315 mph (507 kph) at 16,200 ft (4,938 m) and 282.5 mph (454.5 kph) at 30,000 ft (9,144 m) and climbed to 10,000 ft (3,048 m) in three minutes fifty-three seconds, 20,000 ft (6,096 m) in eight minutes thirty seconds and 30,000 ft (9,144 m) in eighteen minutes ten seconds. The best climb rate was 2,950 ft (899 m) per minute at 7,600 ft (2,316 m) and the service ceiling was over 30,000 ft (9,144 m). The Hurricane thus beat its forebear the Fury on its own ground, climbing ability, and in most other respects was incomparable, to be bettered shortly only by the Spitfire.

Despite the great promise of the Hurricane, a lengthy period was to elapse before the first production models were available. Delay was fraught with danger because it was evident on the latest information from abroad that German air rearmament aimed at an eventual first-line strength of 4,000 planes.

In view of the urgency Hawker started on production drawings for the Hurricane nearly three months before the first order, for fully 600 machines, was received on 3 June 1936. Little more than a year later the assembly lines were operating and the first Hurricane to come from them flew on 12 October 1937 and the second six days later. By the following February the first Hurricane squadron, No. 111 at Northolt, was equipped with a full complement of sixteen machines and the pilots were getting used to a class of performance quite different from that provided by the biplane Gauntlets they had just relinquished.

RIGHT: Hurricane Is of No. 238 Squadron, September 1940, the near machine flown by P/O Bob Doe, DFC and Bar, with 14 victory swastikas painted beneath the cockpit canopy.

BELOW: The prototype Hurricane, first flown in late 1935.

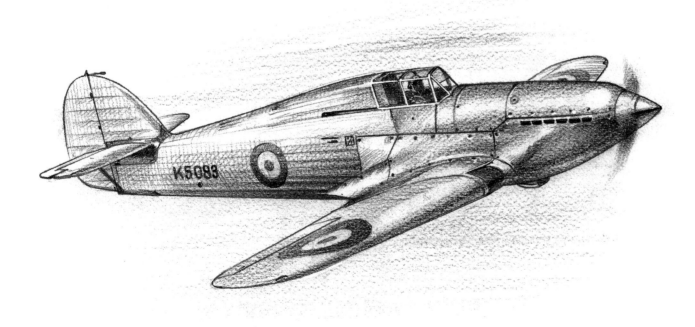

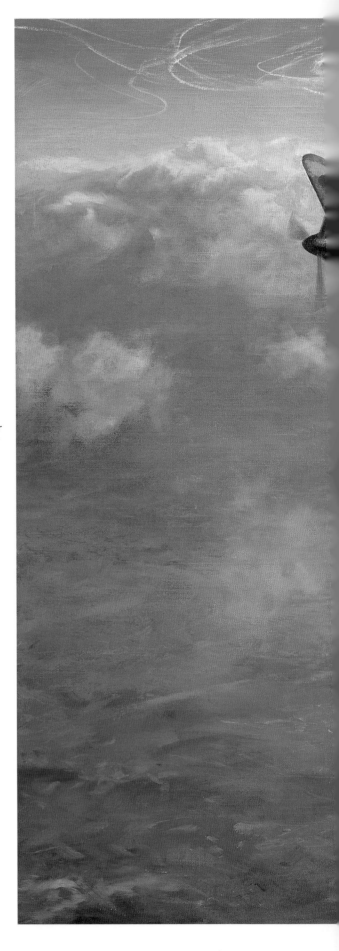

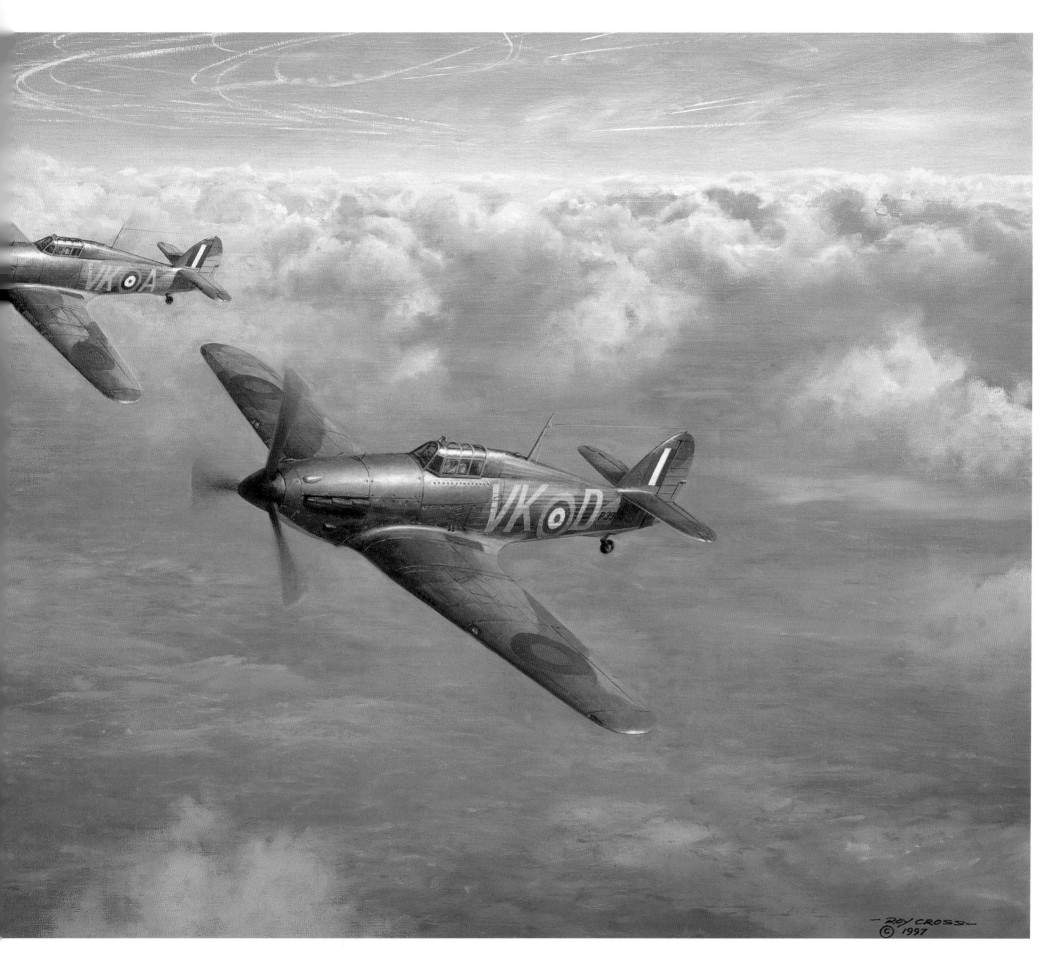

Roy Cross
© 1997

Spitfire Gallery

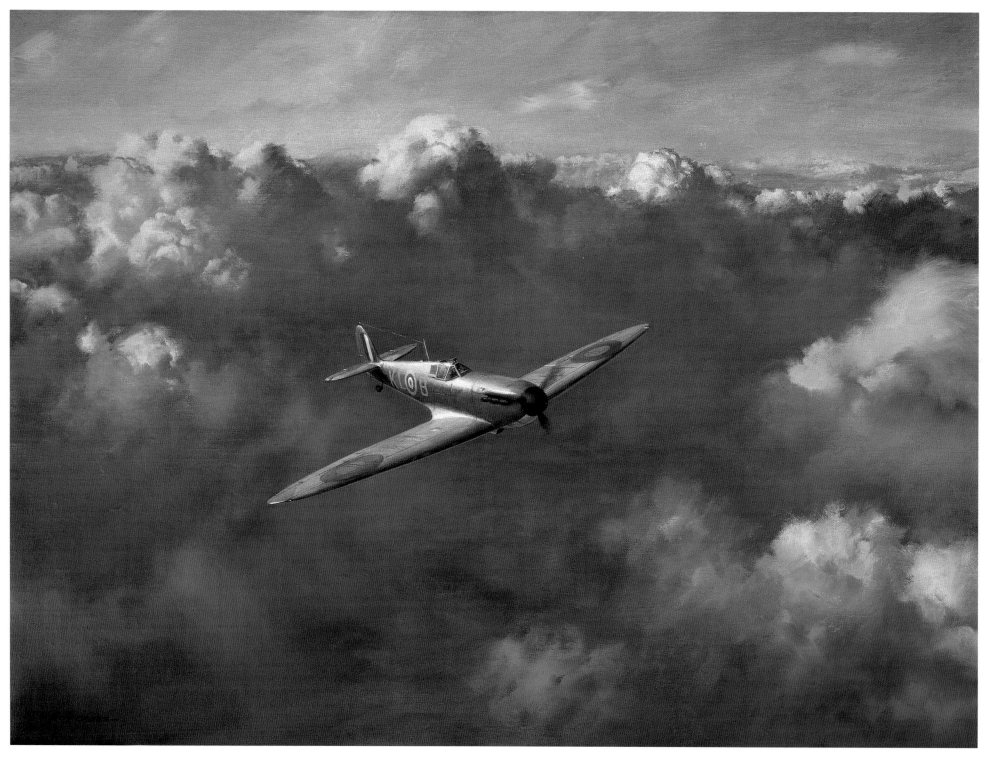

Seeing Gerald Coulson's aviation art was one of the several factors which prompted me to attempt colour work, in gouache and eventually oils, back in the 1950s, and I know that he will not mind me borrowing the idea of a Spitfire Gallery from the fine book of his artwork originally published in 1991.

I just happen to have done more illustrations and paintings of the Spitfire than any other aeroplane!

ABOVE: *The Spitfire I of P/O Al Deere, No. 54 Squadron, 1940.*

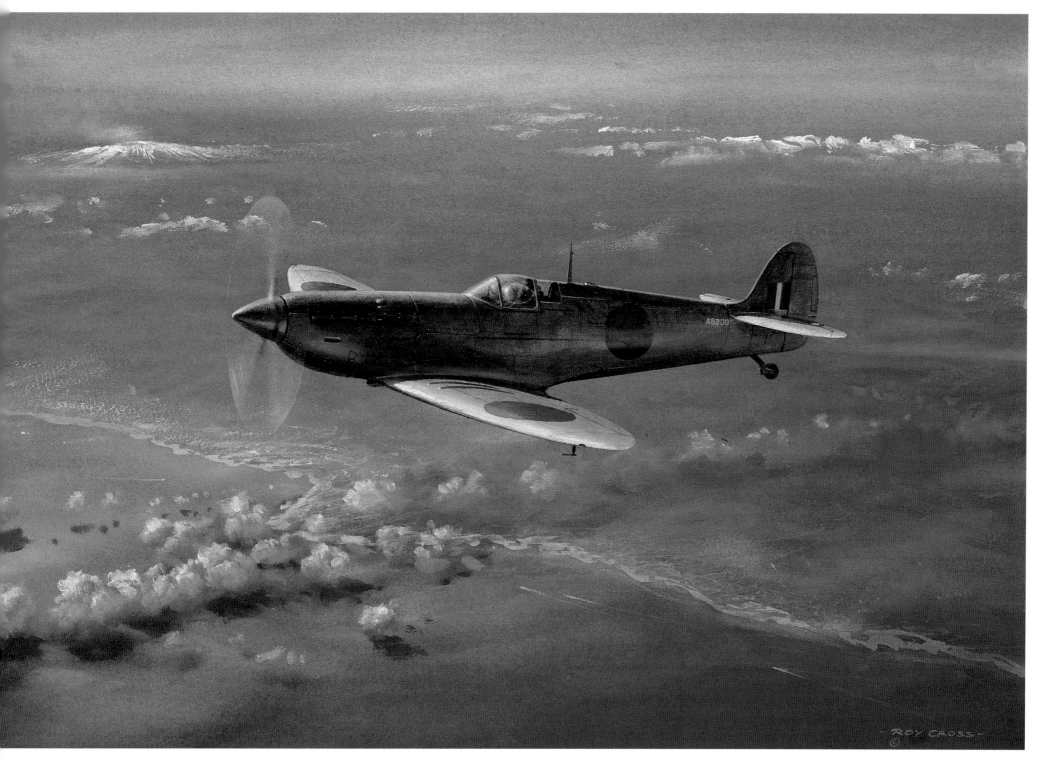

A tribute to the Spitfire and other pilots and crews of the Allied photographic reconnaissance units who flew alone for long periods and at extreme altitudes, usually unarmed, over enemy territory to bring back vital intelligence. Here a Spitfire PR Mk IV cruises at 25,000 ft over Sicily.

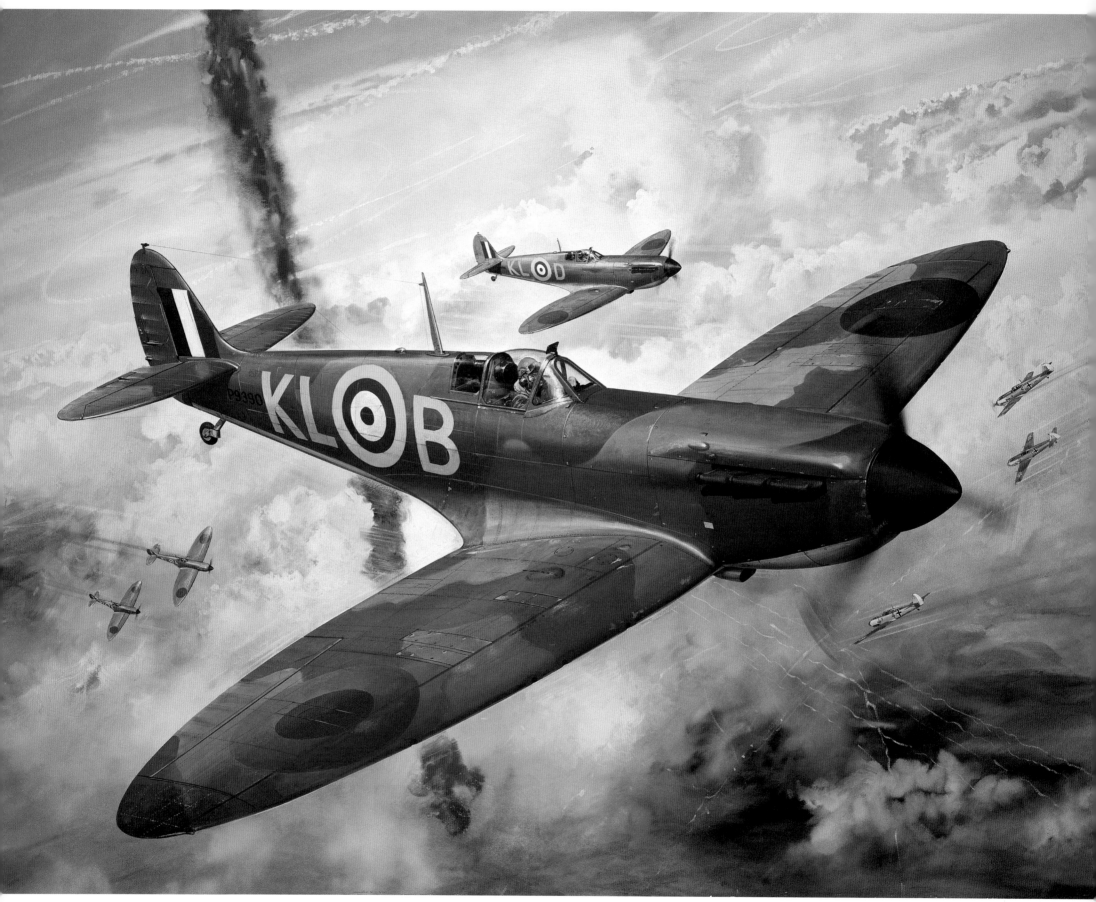

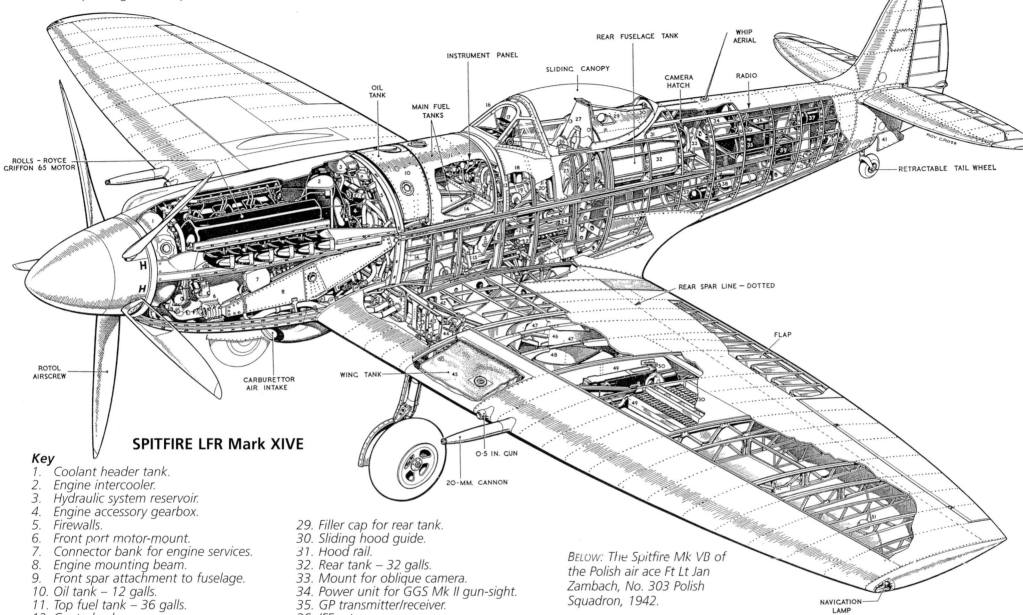

OPPOSITE: A special painting to mark the introduction of the first Airfix ¹⁄₂₄ scale 'Superkit' of the same Spitfire I as reproduced on page 56. The mood however is entirely different since with this painting Airfix required all the excitement of the 1940 air battles.

ROLLS – ROYCE GRIFFON 65 MOTOR

ROTOL AIRSCREW

CARBURETTOR AIR INTAKE

OIL TANK

MAIN FUEL TANKS

INSTRUMENT PANEL

SLIDING CANOPY

REAR FUSELAGE TANK

CAMERA HATCH

WHIP AERIAL

RADIO

ROY CROSS

RETRACTABLE TAIL WHEEL

REAR SPAR LINE – DOTTED

FLAP

WING TANK

0·5 IN. GUN

20-MM. CANNON

NAVIGATION LAMP

SPITFIRE LFR Mark XIVE

Key

1. Coolant header tank.
2. Engine intercooler.
3. Hydraulic system reservoir.
4. Engine accessory gearbox.
5. Firewalls.
6. Front port motor-mount.
7. Connector bank for engine services.
8. Engine mounting beam.
9. Front spar attachment to fuselage.
10. Oil tank – 12 galls.
11. Top fuel tank – 36 galls.
12. Control column.
13. Connector bank for fuel-tank gauges.
14. Bottom fuel tank – 48 galls.
15. Rudder pedals.
16. Bullet-resisting screen panel.
17. Gyroscopic gun-sight.
18. Radio control box.
19. Throttle with gun-sight range twist-grip control.
20. Bomb switches.
21. Seat armour.
22. Fuel cock for rear tank.
23. Pilot's main switch panel.
24. Elevator and rudder trim wheels.
25. Crowbar to assist breaking out of cockpit if trapped inside.
26. Pilot's seat.
27. Head armour protection.
28. Back armour integral with seat unit.

29. Filler cap for rear tank.
30. Sliding hood guide.
31. Hood rail.
32. Rear tank – 32 galls.
33. Mount for oblique camera.
34. Power unit for GGS Mk II gun-sight.
35. GP transmitter/receiver.
36. IFF set.
37. Oxygen bottles.
38. Pneumatic storage bottles.
39. Accumulator.
40. Ballast weights.
41. Tail wheel fairing door.
42. Undercarriage operating jack.
43. Undercarriage pivot attachment members to spar.
44. Chain and sprocket linkage to pilot's undercarriage control.
45. Port wing tank – 12¾ galls.
46. Wheel well.
47. Wing ribs cut away to take wheel depth.
48. Oil and engine radiator (intercooler and engine on starboard side).
49. Browning 0.5 in gun and ammunition box.
50. Cannon feed and ammunition box.
51. Downward identification lamp.

BELOW: The Spitfire Mk VB of the Polish air ace Ft Lt Jan Zambach, No. 303 Polish Squadron, 1942.

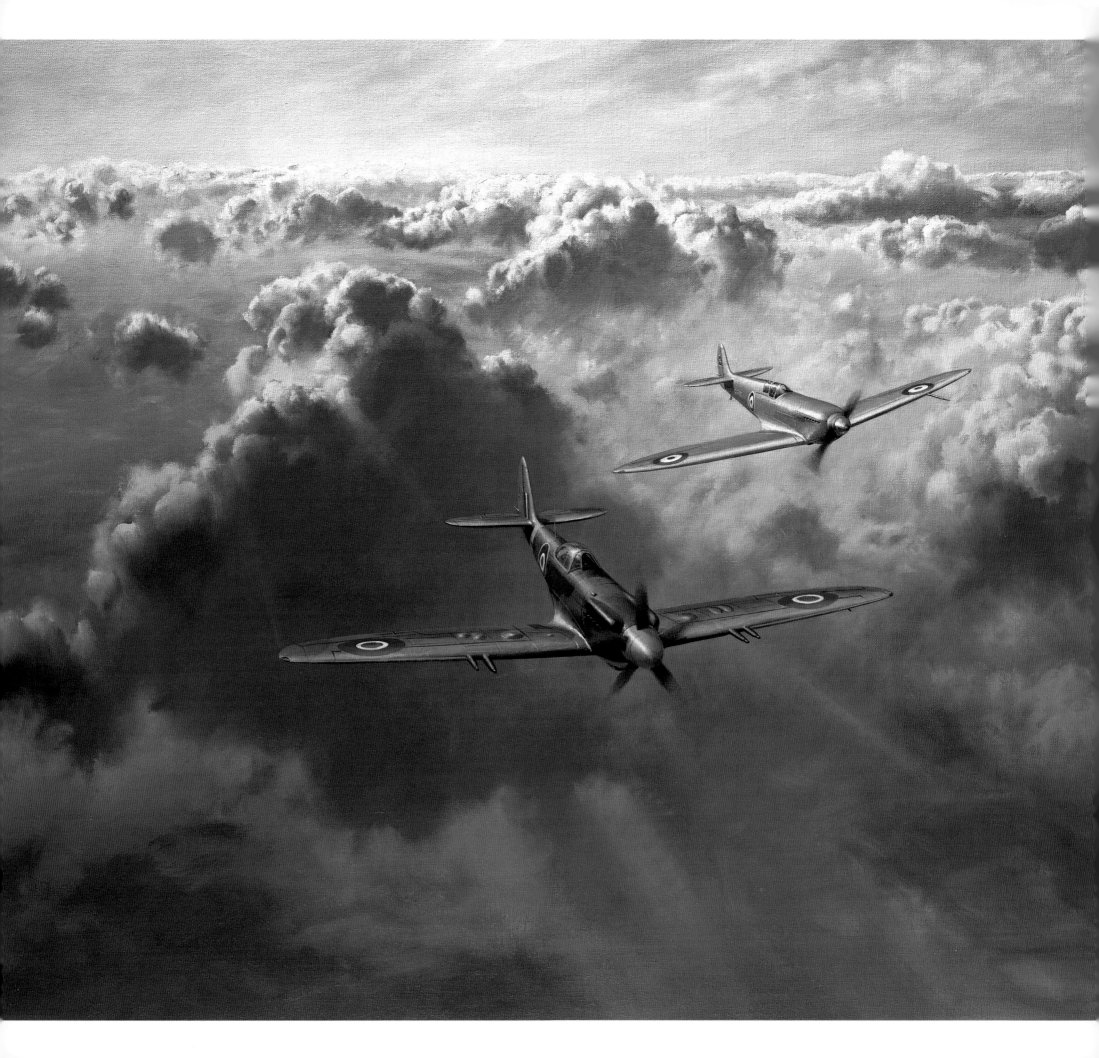

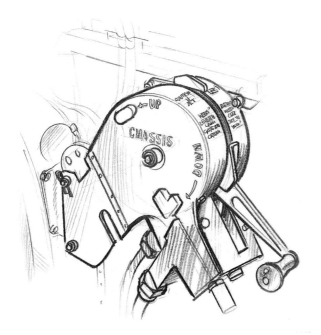

Opposite: The last and the first: a Spitfire Mk.24 of 1946 in the foreground flanked by the original prototype of 1936. The painting is allegorical; the prototype was destroyed in 1939 but the idea was to convey the whole period of Spitfire development in one picture; a feat that in this case a photograph could not do. This is where the artist scores over the photographer, although I am well aware how the photographic/electronic image can be manipulated. The sketches (this page) were done 'from life' of the Spitfire's undercarriage retraction control, signalling switchbox and the 20 mm (0.78 in) Hispano cannon installation (B wing).

Key
(1) magazine trigger release; (2) magazine retaining strap; (3) magazine impeller; (4) empty shell chute; (5) three access panels in wing top surface.

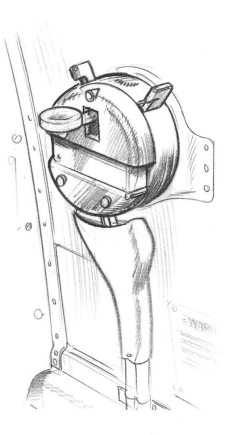

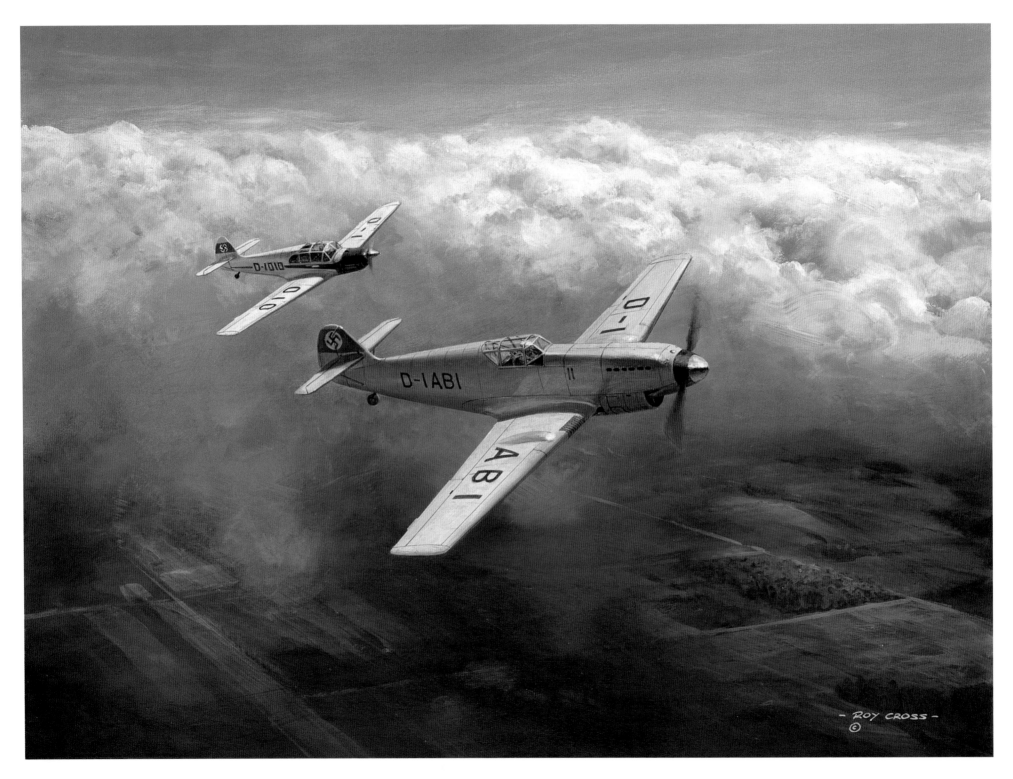

- ROY CROSS -

The famous Messerschmitt Bf 109 and the Spitfire were closely matched during the Battle of Britain and both manufacturers vied with each other throughout the war to keep technically in advance of their rival. Regarding ease of mass production, the 109 was well ahead, with over 33,000 being made with far less call upon industrial capacity compared with the Spitfire. Although more practical in that sense, for the artist the 109 loses out decisively as regards the sheer beauty of line. The prototype Bf 109VI flew well before the Spitfire, in May 1935, and is depicted above, powered ironically with a Rolls-Royce Kestrel upright Vee engine, for the new German Junkers Jumo and Daimler-Benz lightweight aero-engines were behind schedule. Formating on the 109 is a civil Messerschmitt Bf 108 Taifun which pioneered many of the structural features and manufacturing techniques carried over so successfully to the 109. The developed Bf 109E of 1940 appears opposite top, the cut-away drawing being of the slightly more elegant F1 version.

62

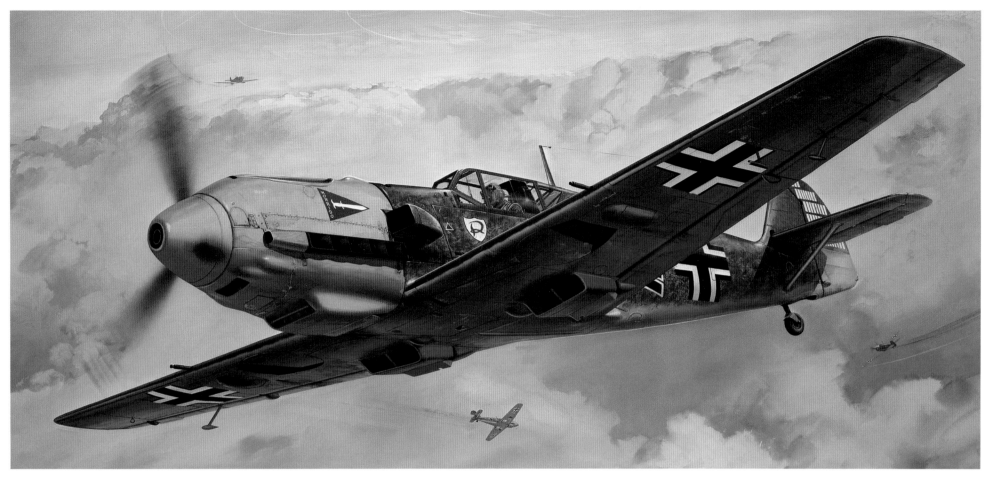

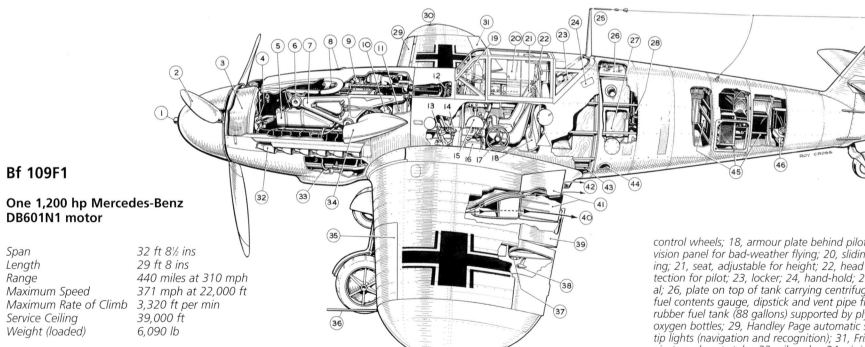

Bf 109F1

One 1,200 hp Mercedes-Benz DB601N1 motor

Span	32 ft 8½ ins
Length	29 ft 8 ins
Range	440 miles at 310 mph
Maximum Speed	371 mph at 22,000 ft
Maximum Rate of Climb	3,320 ft per min
Service Ceiling	39,000 ft
Weight (loaded)	6,090 lb

Key

1, 20-mm MG 151 cannon blast tube; 2, VDM airscrew, diameter 9 ft. 8½ ins.; 3, oil tank. Coolant pumped through the cylinder blocks flows into the external vapour separating swirl chambers (4), the vapour returning to the coolant header tanks (5), on each side of motor; 6, anti-vibration pad on forged magnesium alloy engine-bearer (7);8, two synchronised 7.9 mm MG 17 guns; 9, gun interrupter gear; 10, supercharger; 11, MG 17 ammunition box; 12, instrument panel; 13, rudder pedal; 14, MG 151 cannon lies between cylinder blocks and fires through airscrew hub; 15, throttle; 16, engine-priming fuel tank and hand pump for starting; 17 flap and tail trim control wheels; 18, armour plate behind pilot; 19, hinged direct-vision panel for bad-weather flying; 20, sliding glass panel in hooding; 21, seat, adjustable for height; 22, head and neck armour protection for pilot; 23, locker; 24, hand-hold; 25, radio mast and aerial; 26, plate on top of tank carrying centrifugal immersed pump, fuel contents gauge, dipstick and vent pipe fittings; 27, self-sealing rubber fuel tank (88 gallons) supported by plywood box; 28, three oxygen bottles; 29, Handley Page automatic slat (open); 30, wing-tip lights (navigation and recognition); 31, Frise-type aileron; 32, ejector exhaust stubs; 33, oil cooler; 34, air intake for supercharger; 35, port leading-edge slat shown closed; 36, pitot head; 37, aileron hinge and (38) mass balance; 39, outer flap section; 40, main air flow through wing radiator; 41, air flow exit flaps; 42, boundary layer air flow; 43, reinforced tank base; 44, foot-step; 45, radio hatch and installation; 46, master compass; 47, semi-retractable tail wheel; 48, elevator with small trimming tab adjustable on the ground; 49, horn-balanced rudder.

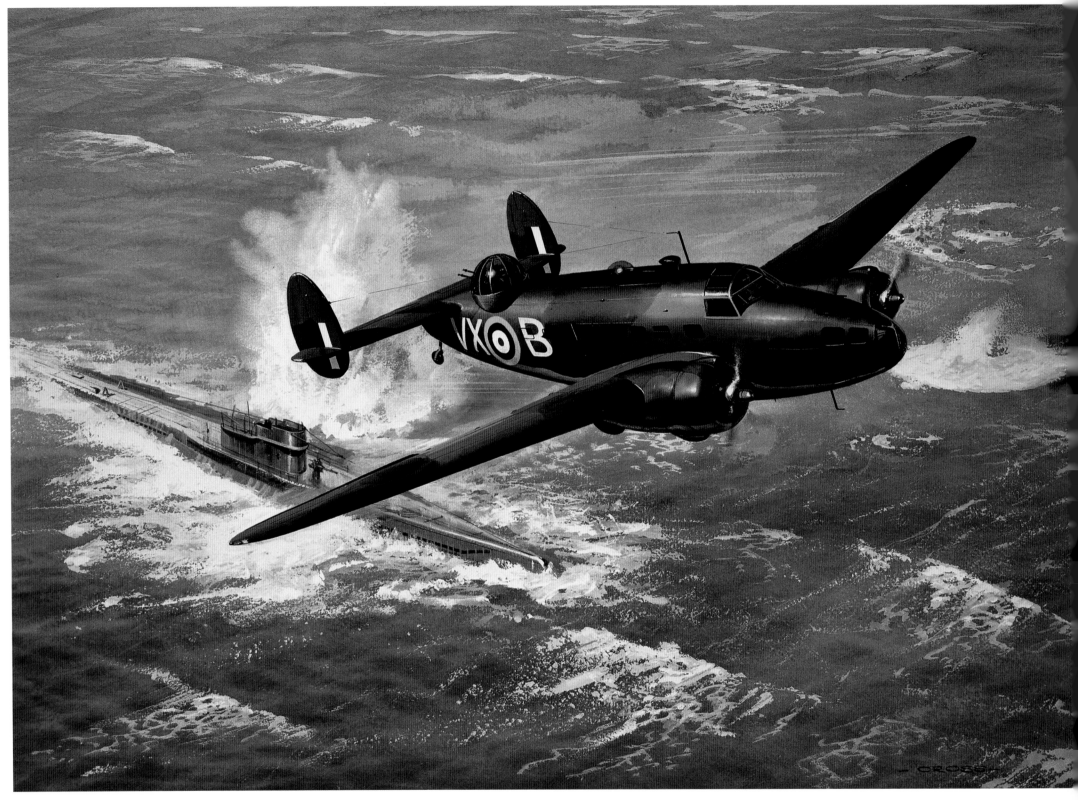

From airliner (the Model 14 Super Electra) to Coastal Command maritime reconnaissance and back to transport-communications duties, the Lockheed Hudson was one of the first aircraft ordered from America by the British Purchasing Commission in 1938, a total of 2,539 variants eventually being supplied. The drawings opposite were worked up from sketches done on the spot at Hendon RAF aerodrome in 1943 and appeared in the July 1943 issue of the ATC Gazette.

The cut-away drawing opposite is of the Hudson III transport, which differed from the standard operational aircraft only in such details as the removal of the Boulton Paul two-gun turret, and of certain equipment in the rear cabin to make way for six seats (see 17). A wide variety of equipment was carried on the various models of the Hudson in service with the RAF, but the layout of the drawing above was common to most, except for the above-mentioned modifications to the transport version.

OPPOSITE TOP: A USAAF A-29 version.

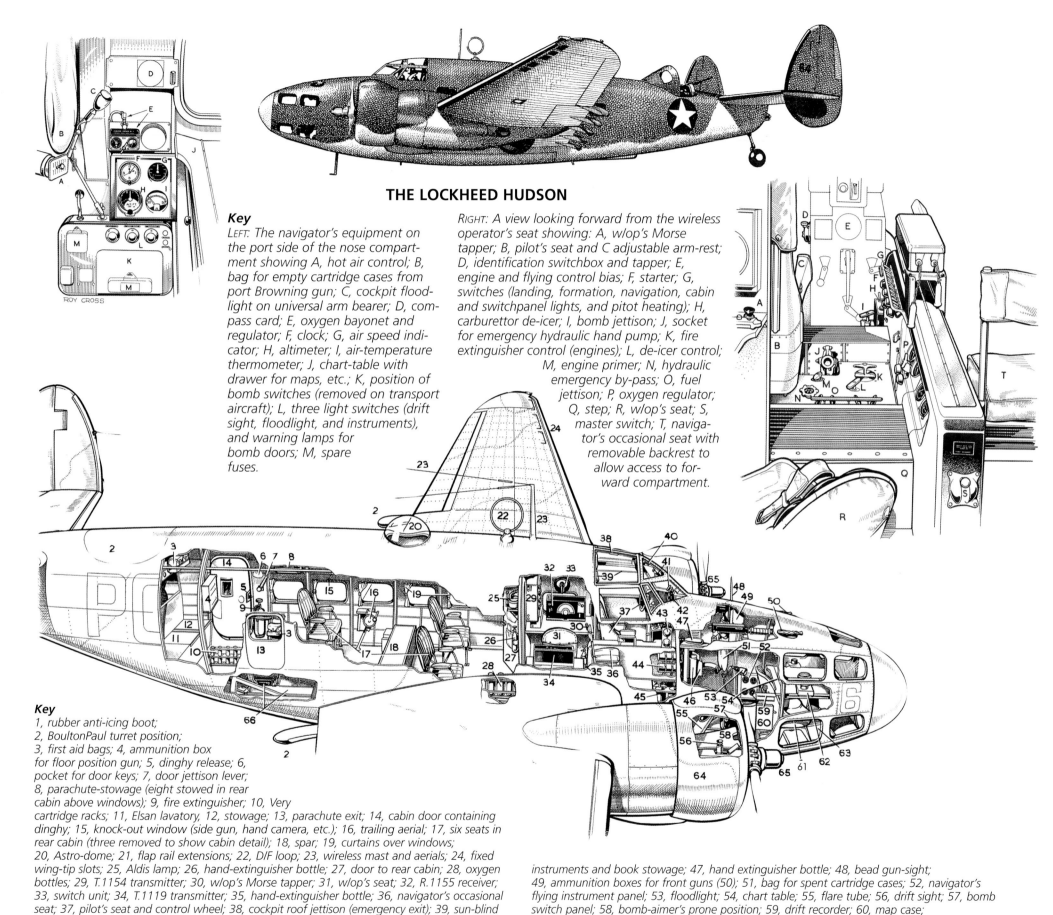

THE LOCKHEED HUDSON

Key

LEFT: The navigator's equipment on the port side of the nose compartment showing A, hot air control; B, bag for empty cartridge cases from port Browning gun; C, cockpit floodlight on universal arm bearer; D, compass card; E, oxygen bayonet and regulator; F, clock; G, air speed indicator; H, altimeter; I, air-temperature thermometer; J, chart-table with drawer for maps, etc.; K, position of bomb switches (removed on transport aircraft); L, three light switches (drift sight, floodlight, and instruments), and warning lamps for bomb doors; M, spare fuses.

RIGHT: A view looking forward from the wireless operator's seat showing: A, w/op's Morse tapper; B, pilot's seat and C adjustable arm-rest; D, identification switchbox and tapper; E, engine and flying control bias; F, starter; G, switches (landing, formation, navigation, cabin and switchpanel lights, and pitot heating); H, carburettor de-icer; I, bomb jettison; J, socket for emergency hydraulic hand pump; K, fire extinguisher control (engines); L, de-icer control; M, engine primer; N, hydraulic emergency by-pass; O, fuel jettison; P, oxygen regulator; Q, step; R, w/op's seat; S, master switch; T, navigator's occasional seat with removable backrest to allow access to forward compartment.

ROY CROSS

Key

1, rubber anti-icing boot; 2, Boulton Paul turret position; 3, first aid bags; 4, ammunition box for floor position gun; 5, dinghy release; 6, pocket for door keys; 7, door jettison lever; 8, parachute-stowage (eight stowed in rear cabin above windows); 9, fire extinguisher; 10, Very cartridge racks; 11, Elsan lavatory, 12, stowage; 13, parachute exit; 14, cabin door containing dinghy; 15, knock-out window (side gun, hand camera, etc.); 16, trailing aerial; 17, six seats in rear cabin (three removed to show cabin detail); 18, spar; 19, curtains over windows; 20, Astro-dome; 21, flap rail extensions; 22, D/F loop; 23, wireless mast and aerials; 24, fixed wing-tip slots; 25, Aldis lamp; 26, hand-extinguisher bottle; 27, door to rear cabin; 28, oxygen bottles; 29, T.1154 transmitter; 30, w/op's Morse tapper; 31, w/op's seat; 32, R.1155 receiver; 33, switch unit; 34, T.1119 transmitter; 35, hand-extinguisher bottle; 36, navigator's occasional seat; 37, pilot's seat and control wheel; 38, cockpit roof jettison (emergency exit); 39, sun-blind and rails; 40, compass wedge plate; 41, cockpit floodlight; 42, dashboard; 43, carburettor temperature gauges; 44, flares; 45, three oxygen bottles; 46, drift sight, navigation

instruments and book stowage; 47, hand extinguisher bottle; 48, bead gun-sight; 49, ammunition boxes for front guns (50); 51, bag for spent cartridge cases; 52, navigator's flying instrument panel; 53, floodlight; 54, chart table; 55, flare tube; 56, drift sight; 57, bomb switch panel; 58, bomb-aimer's prone position; 59, drift recorder; 60, map case; 61, navigator's sliding seat; 62, compass; 63, optically flat bomb-aimer's window; 64, Wright Cyclone engine; 65, three-bladed, hydromatic airscrews; 66, retractable floor-gun position.

The painting opposite of the Curtiss P-40 commemorates the squadron, No. 414, I visited as a young cadet at Croydon in 1942. Consequently, the P-40 is one of my favourite aeroplanes, featured in a number of drawings including that of the USAAC P-40 above and the Tomahawk IIB below in the markings of the American Volunteer Group in China, the original Flying Tigers. In essence the P-40 was a P-36 airframe fitted with a water-cooled in-line Allison V-12 engine instead of the air-cooled radial, the streamlining and extra power increasing the top speed from 313 mph/504 kph (P-36A) to 342 mph/550 kph (XP-40). The Allison Division of General Motors Corporation had made a comparatively recent appearance as an aircraft engine manufacturer (1931) concentrating on liquid-cooled Vee power units, which were well developed abroad by manufacturers such as Rolls-Royce. These were judged to confer more streamlined nose lines and thus, intrinsically, more speed, power for power, than the radial engine with its built-in head resistance. Increasing power boosted the P-40's top speeds to 362 mph/582 kph (E), and 364 mph/586 kph (F with Packard-built Merlin engine), but that was about the limit of the airframe's potential, not least because of the large drag-inducing chin air intake on the production versions.

Nevertheless, the P-40's variants, 13,738 of which were made, served in virtually all the allied air forces in all theatres.

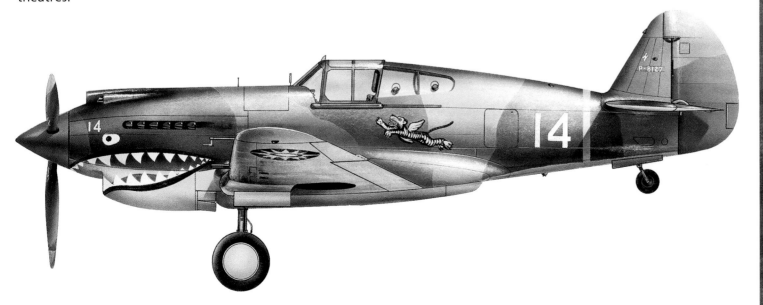

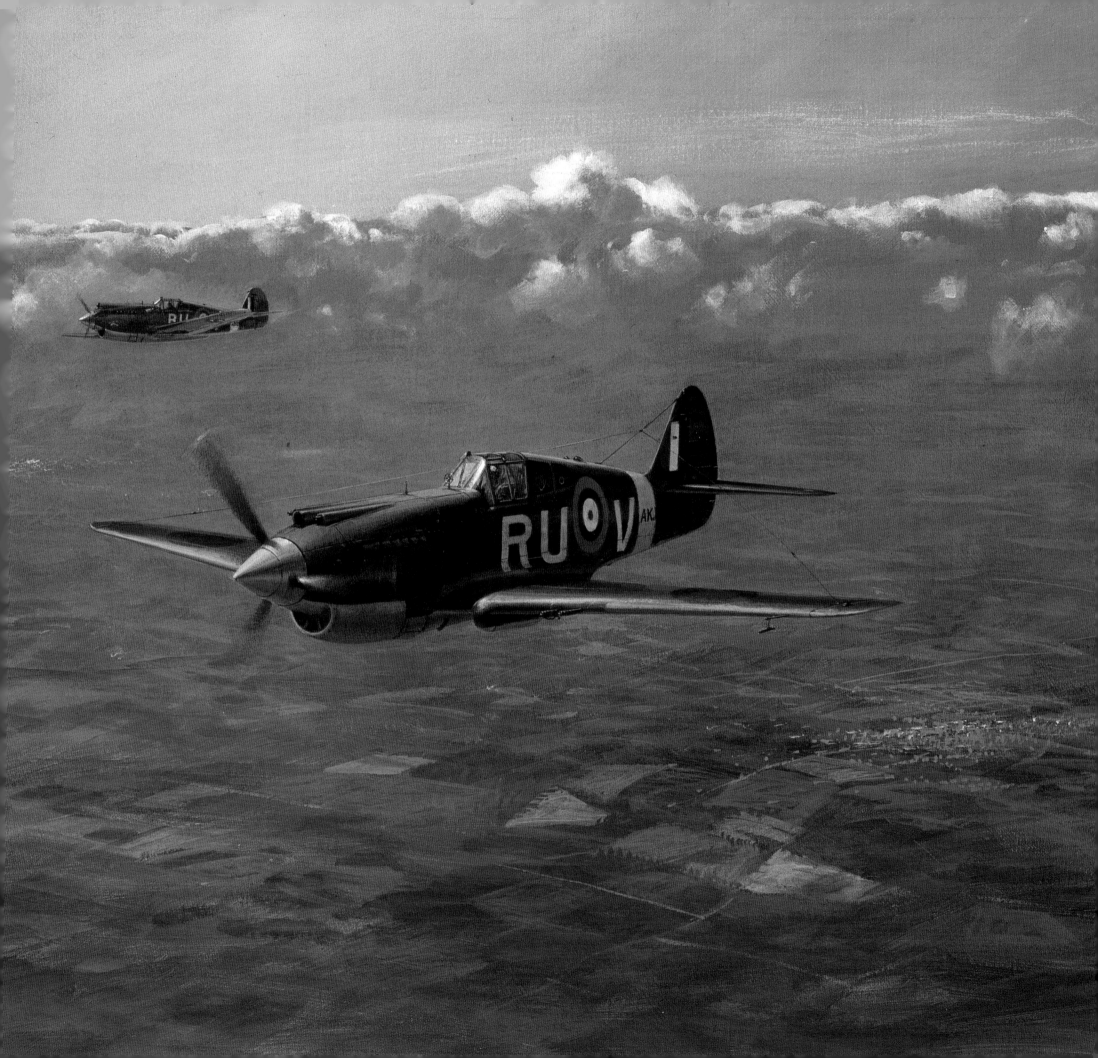

The Focke-Wulf Fw 190; a state-of-the-art single-seat fighter when it appeared in 1941, with heavy armament and a powerful closely cowled twin-row radial engine of 1,760 hp, giving a top speed of 395 mph (635.5 kph). The drawings and captions are from an early 1944 article in the *ATC Gazette*.

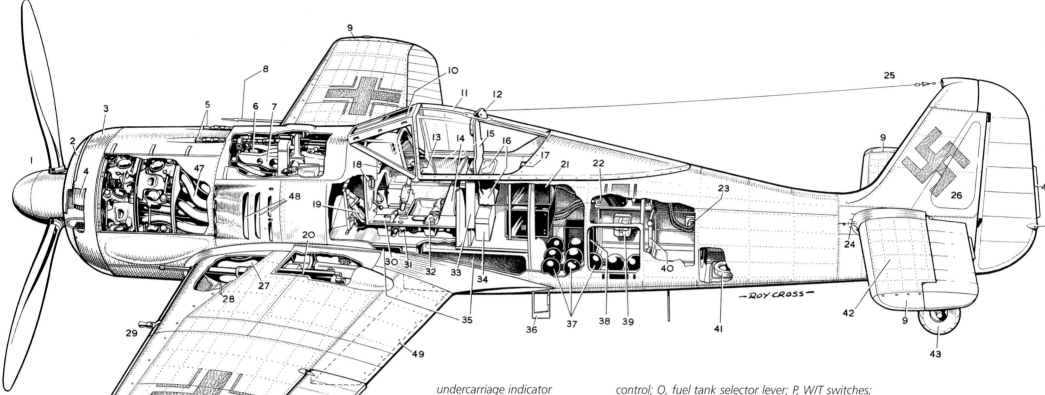

Key

1, Variable-pitch VDM metal airscrew; 2, nose-ring of 5-mm armour; 3, oil tank (10 gallons), protected by 3-mm armour; 4, annular oil tank and oil cooler; 5, two synchronised 7.92-mm guns; 6, hot air pipe for gun and ammunition heating; 7, gun-mounting; 8, pitot head; 9, detachable wing-tips; 10, bullet-proof windscreen; 11, sliding access hood (cannot normally be opened in flight, but may be jettisoned in an emergency); 12, aerial pulley (as hood slides back, slack of antennas is taken up over pulley, so keeping antennas taut); 13, sliding hood operating winch; 14, pilot's seat with 8-mm armour back; 15, 14-mm head armour; 16, ditty bag; 17, hood-jettison cartridge (breaks tubular guide and thus destroys hood anchorage); 18, double instrument panel; 19, rudder pedal actuates brakes; 20, Mauser 20-mm cannon synchronised to fire through the airscrew; 21, radio transmitter and receiver; 22, electrical distributor panel; 23, external power-supply socket for engine starting, or testing instruments and services on the ground; 24, tail-plane incidence gauge; 25, radio antennas; 26, access door to tail wheel retraction mechanism; 27, port wheel in 'up' position; 28,

undercarriage indicator (actually indicating wheels in 'down' position); 29, Oerlikon Ff 20-mm cannon, one in each wing; 30, port switch panel (flaps, U/C, etc); 31, warning horn; 32, priming pump and tank for engine starting; 33, 8-mm back armour; 34, accumulator; 35, two fuel tanks of 115 gallons total capacity; 36, retractable footstep; 37, three oxygen bottles, each consisting of three connected spheres; 38, engine-driven radio generator; 39, first-aid package; 40, starting handle in stowed position; 41, Patin master compass; 42, adjustable tailplane; 43, semi-retractable tailwheel; 44, navigation light; 45, trimming tabs on rudder and on elevators; 46, aileron trimming tab; 47, exhaust pipes; 48, exit louvres for engine cooling air; 49, port split flap (shown dotted).

RIGHT: This drawing of the interior of the Fw 190A cockpit emphasizes the neat layout.

A is the pump and tank for engine priming; B, W/T plug connector for pilot's helmet earphones; C, W/T volume control and 'on-off' switch; E, tailplane incidence button-switches (press one to make aircraft nose-heavy and the other to make it tail-heavy); F, tailplane incidence indicator; G, flap and H, undercarriage switches; I, indicator lights for flaps and U/C; J, throttle lever with thumb-switch for manual control of airscrew pitch; K, main cut-out; L, selector switch, manual or automatic control of airscrew pitch; M, magneto switch; N, instrument light dimmer

control; O, fuel tank selector lever; P, W/T switches; Q, release clip to allow removal of port switch-board; R, throttle damper; S, control column; T, pilot's seat and, U, harness. Switches on the starboard side include those for bomb release, gun cocking, engine starting, master switch, navigation lights, instruments and W/T; a map case and scribbling block are provided, and on the cockpit wall is the sliding hood winch and hood jettison lever.

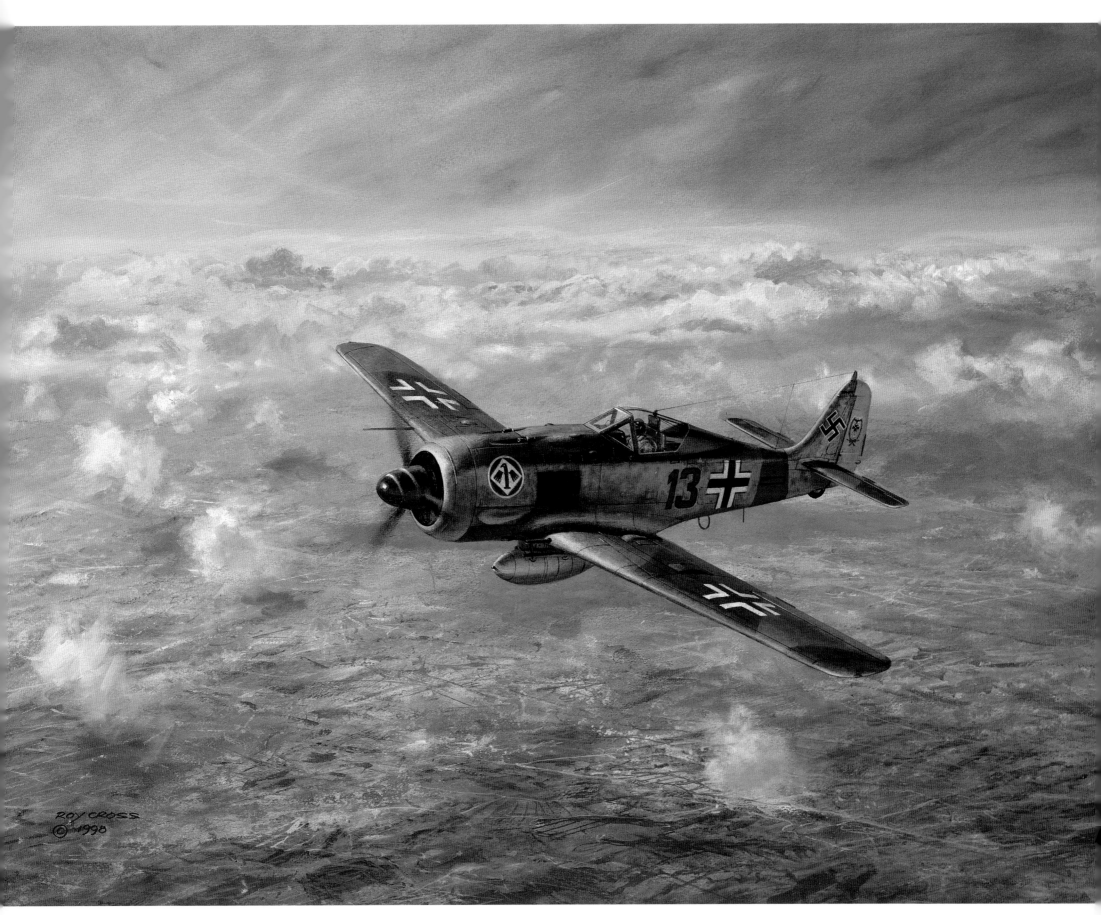

Colourful markings on the Fw 190A of Major Heinz Bär, JG1,1944.

A few years ago during a visit to The Aviation Bookshop, the enthusiast's Mecca in Holloway Road, north London, I was asked by the present proprietor, Dave Hatherell, if I would do a picture for him of the Bristol Beaufort. Why the Beaufort? Well, his father had been a crew member during the particular incident Dave wished me to portray. In 1941 the Beaufort squadrons were operating against various enemy coastal targets and shipping. On 23 July 1941, Dave's father, Frederick, wireless operator with Beaufort L9891, and the rest of No. 22 Squadron departed Thorney Island to mount an attack on the battleship *Scharnhorst*, which had left its moorings at Brest.

Twelve Beauforts flew to St Eval, each loaded with full fuel, torpedo and – so as to be self-sufficient on the detachment – three ground crew, plus crates of spares and ammunition.

Later in the day photo-reconnaissance located the battleship at La Pallice, behind torpedo nets. No. 22 Squadron was therefore recalled to Thorney Island, leaving at 20:45 hours.

Beaufort L9891 had been airborne about twenty minutes when it suffered engine failure. The Beaufort Mk I's single engine capacity being what it was, the pilot did extraordinarily well to fly it down for a crash landing. Alas, as it came down, it went through a low stone wall which demolished the airframe, save for the starboard wing. The site was Tolborough Tor, near Codda on the southern slope of Brown Willy, Bodmin, Cornwall. On board were:

- *Pilot*: 86646 Pilot Officer George Donald Worth (Don) Rogers. Seriously injured. Returned to operations with the Strike Wings 1944. Living Isle of Wight 2002.

- *Observer*: 1161855 Sergeant Alfred (Peter) Hills. Seriously injured. Returned to ground duties. Died Winchester 1990.

- *Wireless Operator*: 952737 Sergeant Frederick Sidney (Fred) Hatherell. Shaken and bruised. Returned to operations 1941. Died Barnet 2001.

- *Gunner*: 952969 Sergeant John Francis (Frank) McGee. Badly shaken and bruised. Returned to operations 1941. On first operation missing over Nantes, France, 2 December 1941. Commemorated on Panel 47 of The Runnymede Memorial.

- *Ground Crew*: Leading Aircraftman C.E. Angus, Leading Aircraftman A. Fleming, Corporal J.S. Laker.

Fred's recollection is of wandering around the wreckage to be confronted by a farmer touting a shotgun. Rescue was co-ordinated by an AA patrolman and the crew were taken in a convoy of vehicles to Launceston Cottage Hospital.

Don, the most seriously injured, was pronounced dead and left whilst efforts were taken to treat the others. He was later told of a young VAD nurse being sent to look at him, so as to have experience of seeing a corpse. She fled in terror when she discovered him breathing.

I decided to depict the aeroplane just before the accident, and it was a real pleasure to meet Fred and in a sense share the whole experience and partake in a piece of history. We had checked markings and codes to get the painting as accurate as possible and I had just about finished in the studio when Dave rang me up to say, 'By the way, it was a beautiful cloudless day.' I had put in the nice cloudscape as seen opposite! Contemplating the alterations involved, I decided that I rather liked the painting myself and was loath to let it go. So I reckoned it would be almost as quick to do a completely new picture, minus the clouds. So there are now two versions in existence, the one here remaining in my possession. And if you count too many faces peering out of the aeroplane, remember there were also ground crew aboard!

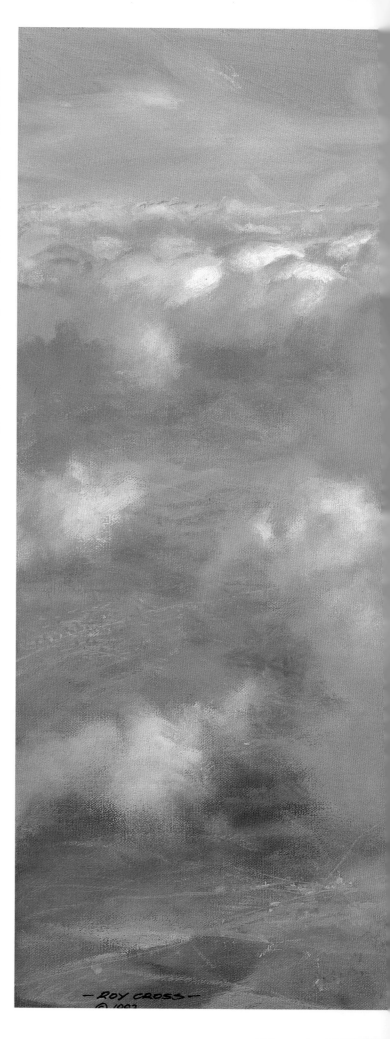

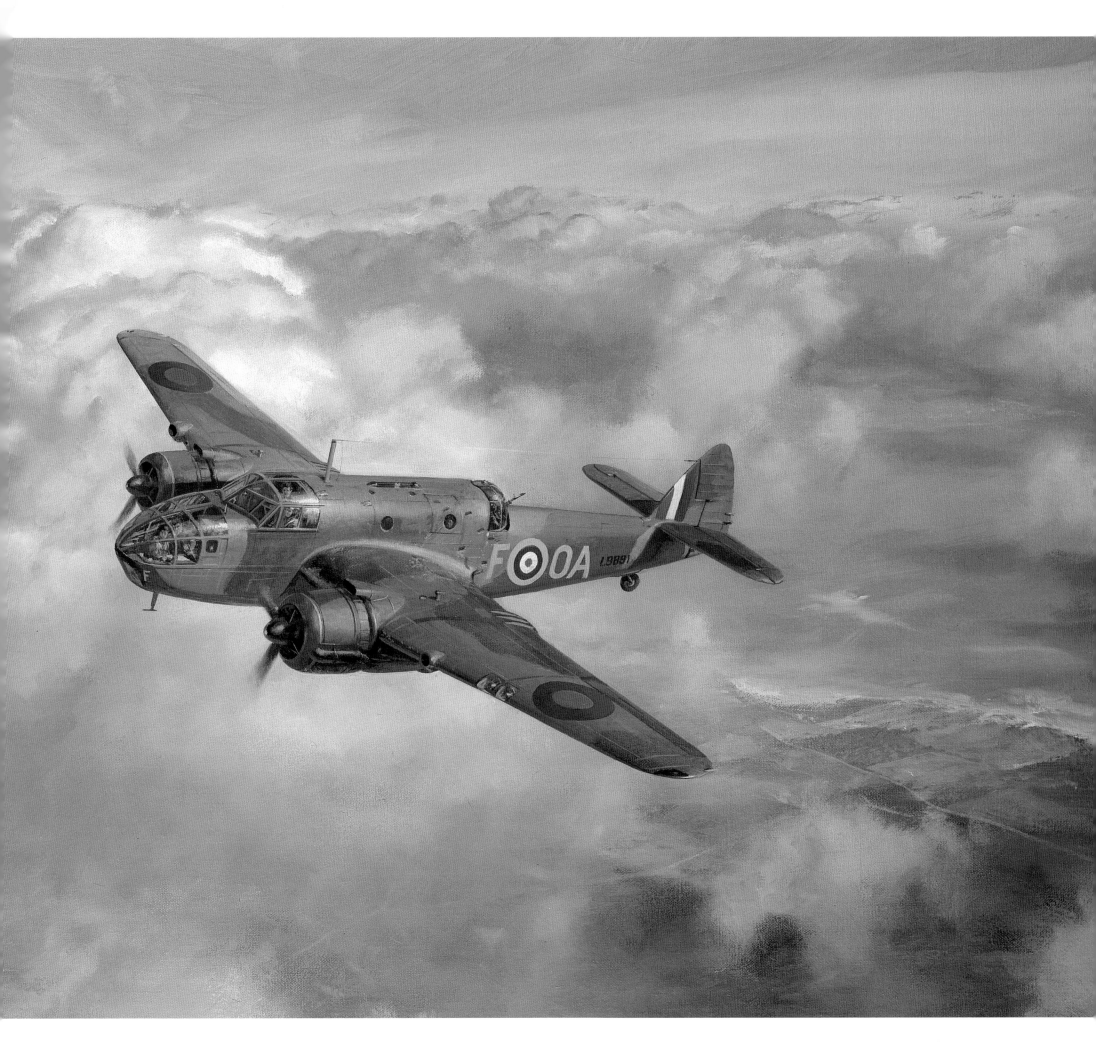

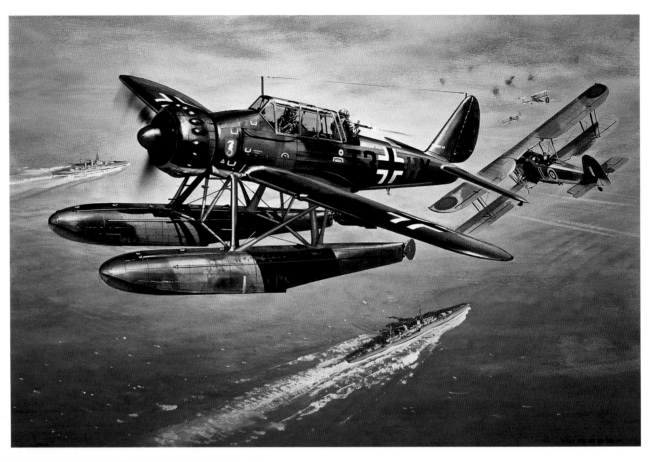

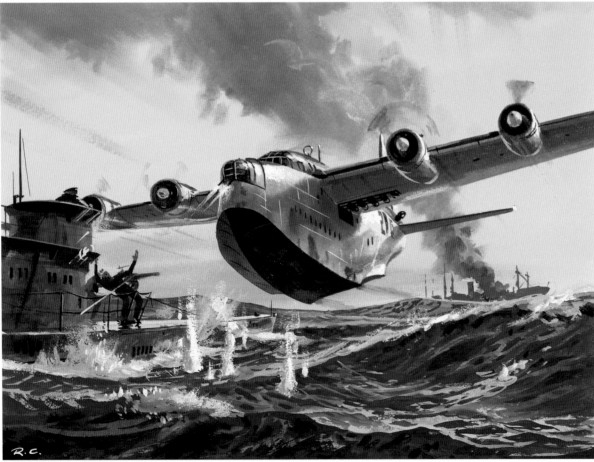

ABOVE: *the Arado Ar 196 ship-board reconnaissance floatplane, which served aboard many famous German warships such as* Scharnhorst, Gneisnau, Tirpitz *and* Bismarck.

LEFT: *This all-action scenario was one of two 'roughs' done for the box-top illustration for the superb Airfix model of the Short Sunderland. The management chose the other, less sensational view, and this illustration joins the many pencil and colour ideas which were never translated into finished artwork.*

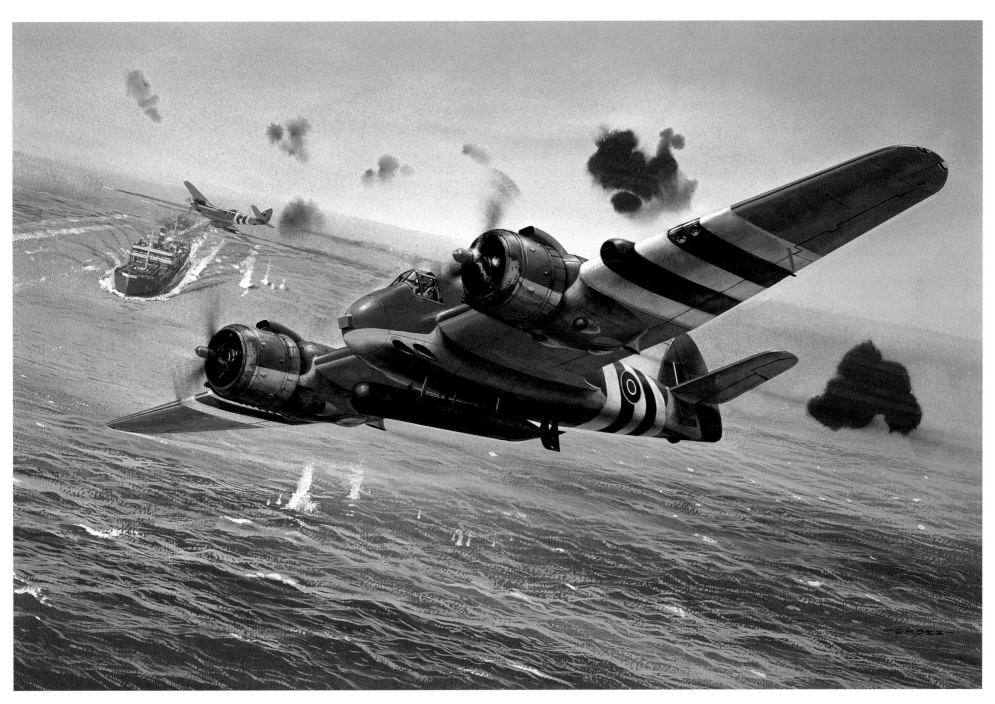

Seen here in its torpedo bomber and rocket-firing roles, the Bristol Beaufighter was developed from the Blenheim and Beaufort and played a successful role first as a radar-equipped night fighter, as a long-range strike fighter in the Middle East and as a heavy specialized attack/torpedo bomber in the European theatre and the Far East.

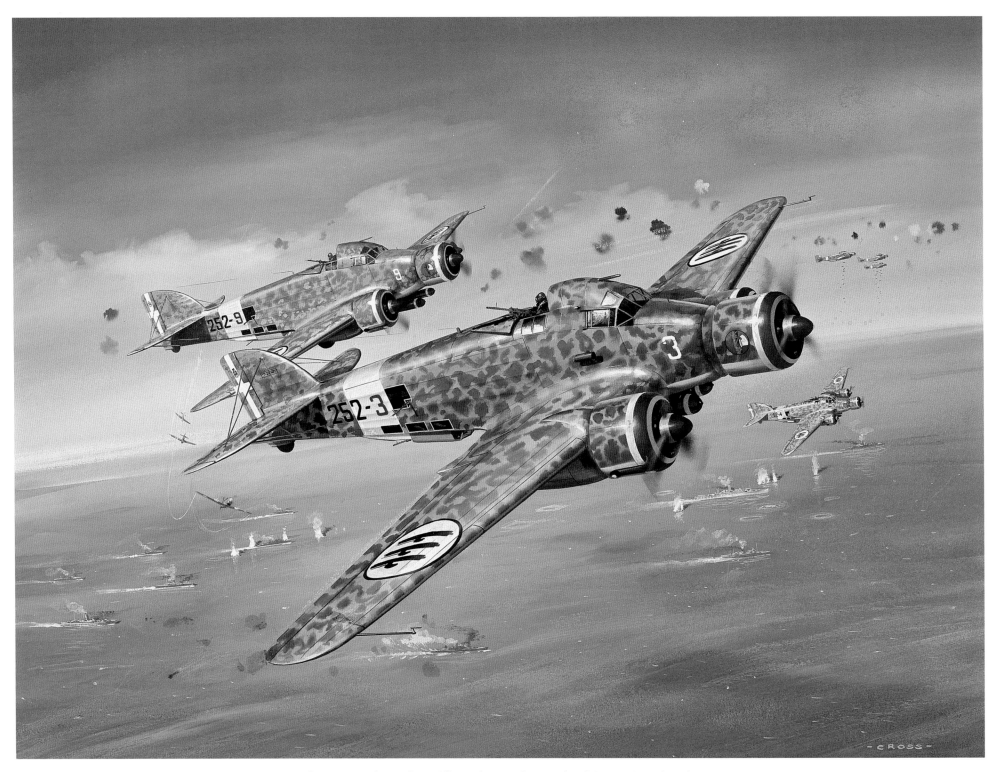

Originally conceived as a fast airliner, the Savoia-Marchetti SM 79 Sparviero became the standard long-range bomber of the Italian Air Force, blooded during the Spanish Civil War and equipping eleven bomber groups as Italy entered the Second World War. The tri-motor layout was particularly favoured by the Italians and over 1,200 were built, including the SM 79-II version here carrying two torpedoes.

Avro's Faithful Annie, the Anson, served for some twenty years with the Royal Air Force, initially as a coastal reconnaissance aircraft, and then as a crew trainer (armament, radio, navigation), light transport, air ambulance, communications aircraft and general squadron hack. Over 11,000 were built, including many civilian versions and a considerable number in Canada. Here is the Anson Mk I going about its instructional duties.

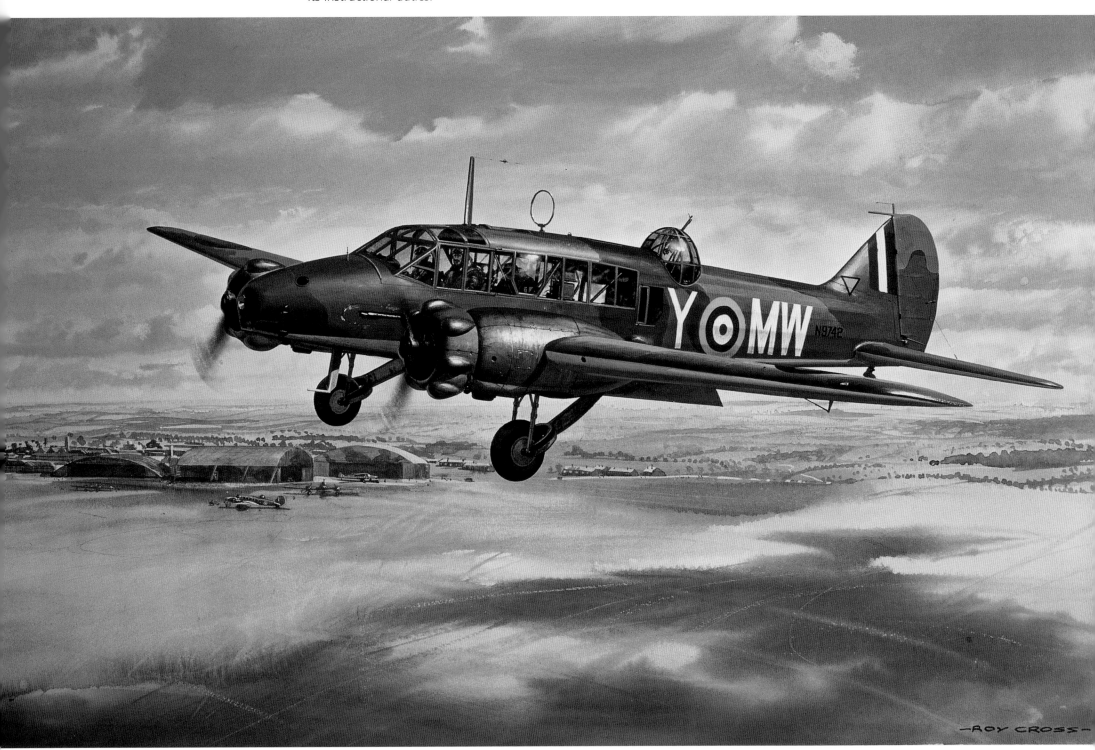

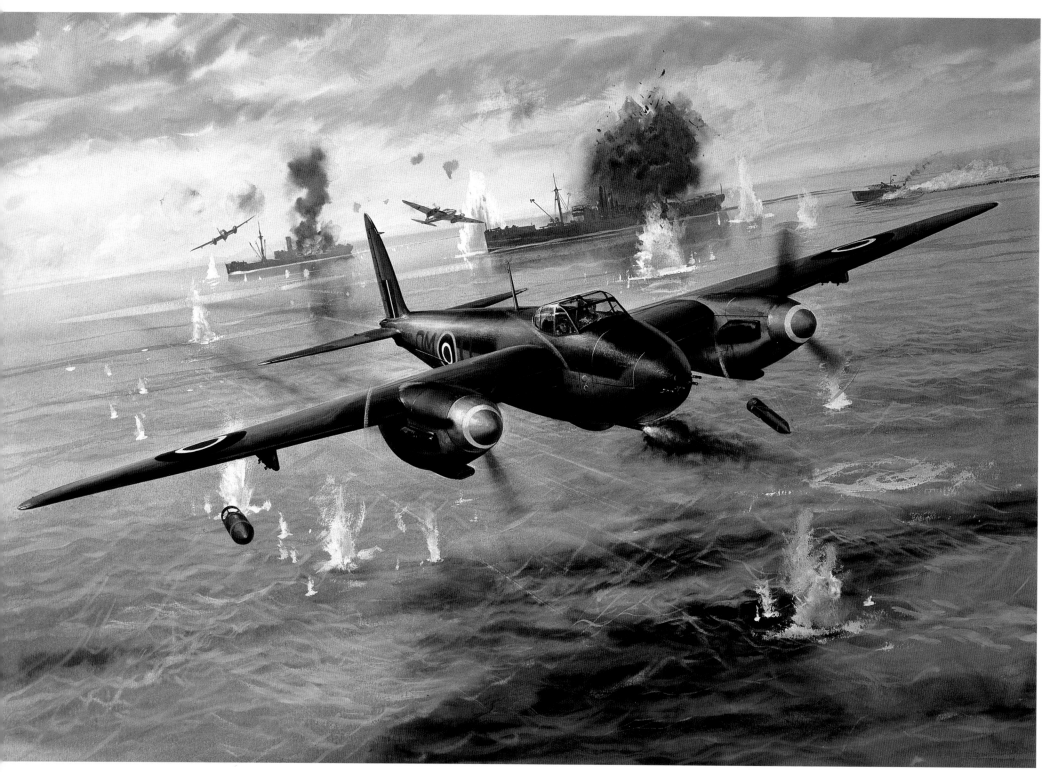

One of the de Havilland Mosquito's numerous war-time duties was as an anti-shipping strike/fighter with Coastal Command. Here is a Mk XVIII armed with a 75 mm (3 in) Molins quick-firing cannon, armament soon to be replaced by eight 60 lb (27 kg) rocket projectiles.

One of the most versatile aircraft types of the war period, the Mosquito is shown RIGHT in its PR Mk XVI photo-reconnaissance colour scheme.

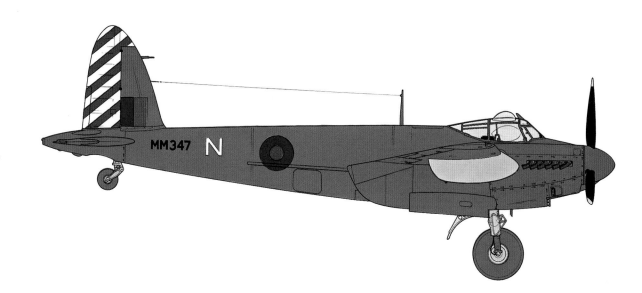

BELOW: The initial submission illustration for the Airfix OO-H0 aircraft refuelling set issued in 1970.

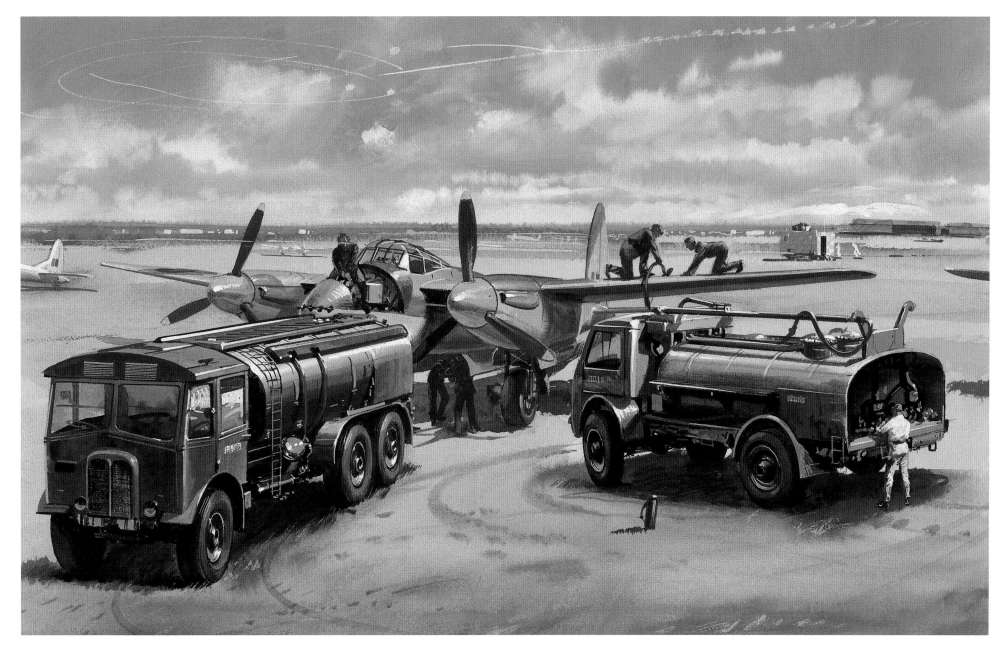

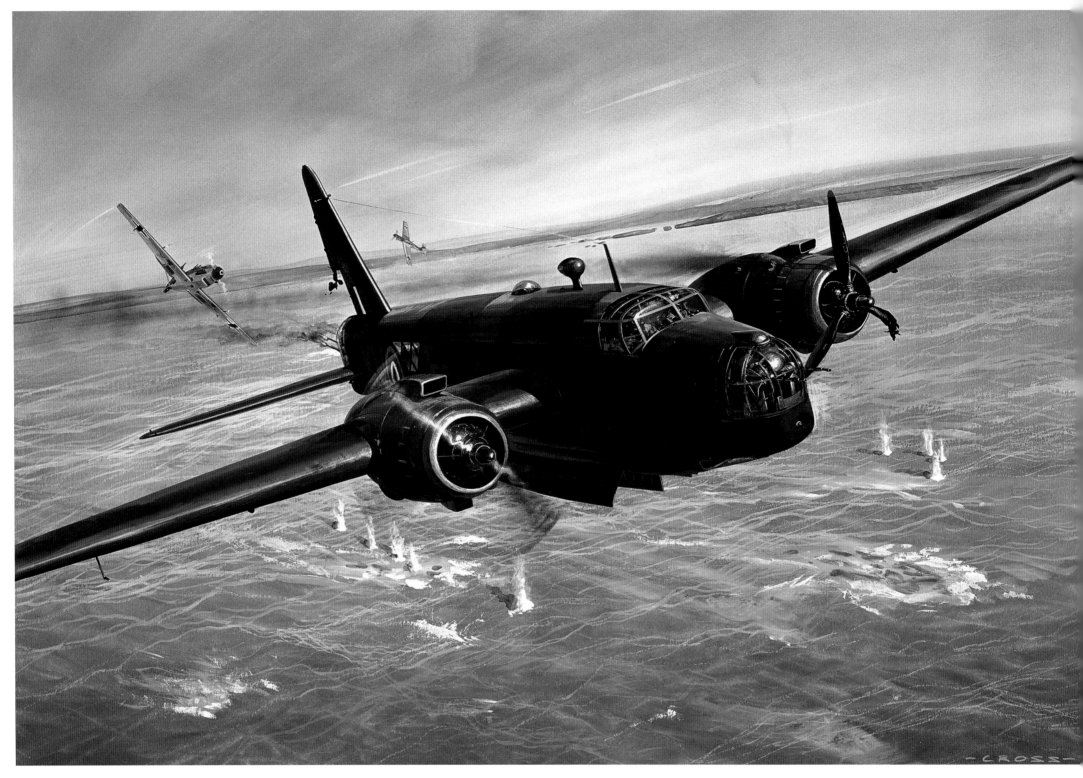

The painting above attempts to depict one of the early wartime raids on the German coast by Vickers Wellingtons of RAF Bomber Command during which disastrous losses were suffered. Eventually the Wellingtons were switched to the night-bombing role and with the Armstrong Whitworth Whitleys and Handley Page Hampdens pioneered the night-time assault on Germany.

Soon the Wellingtons were reinforced with the first of the RAF's four-engined heavy bombers to enter service, the Short Stirling. The high mid-wing design resulted in a hallmark of the Stirling, its tall, gawky undercarriage which initially gave trouble in service.

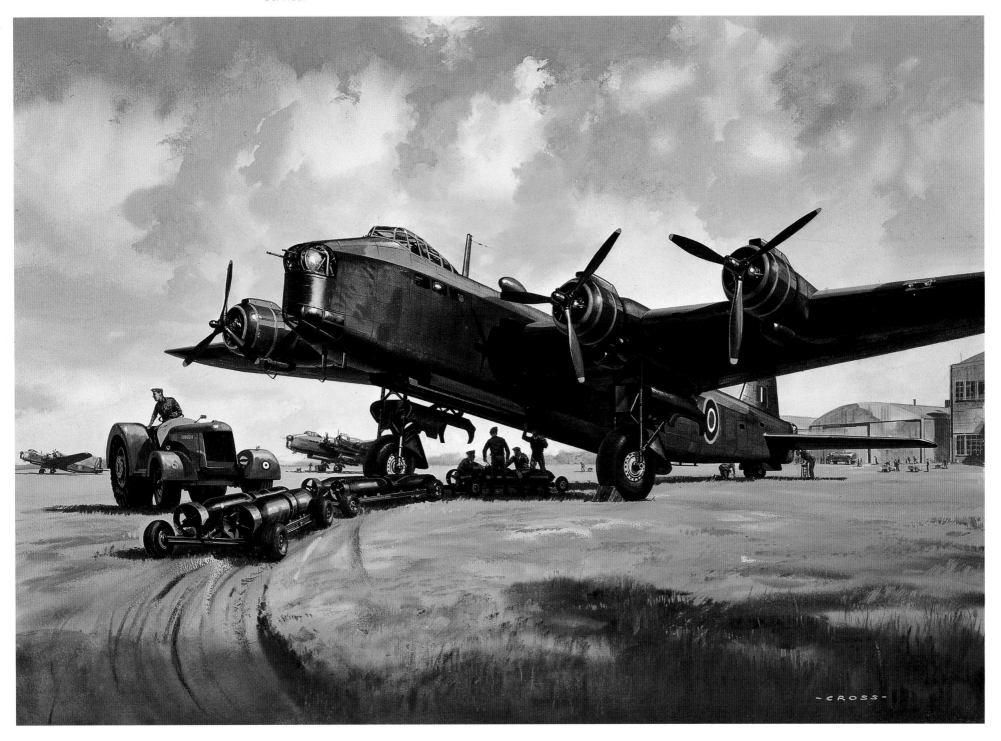

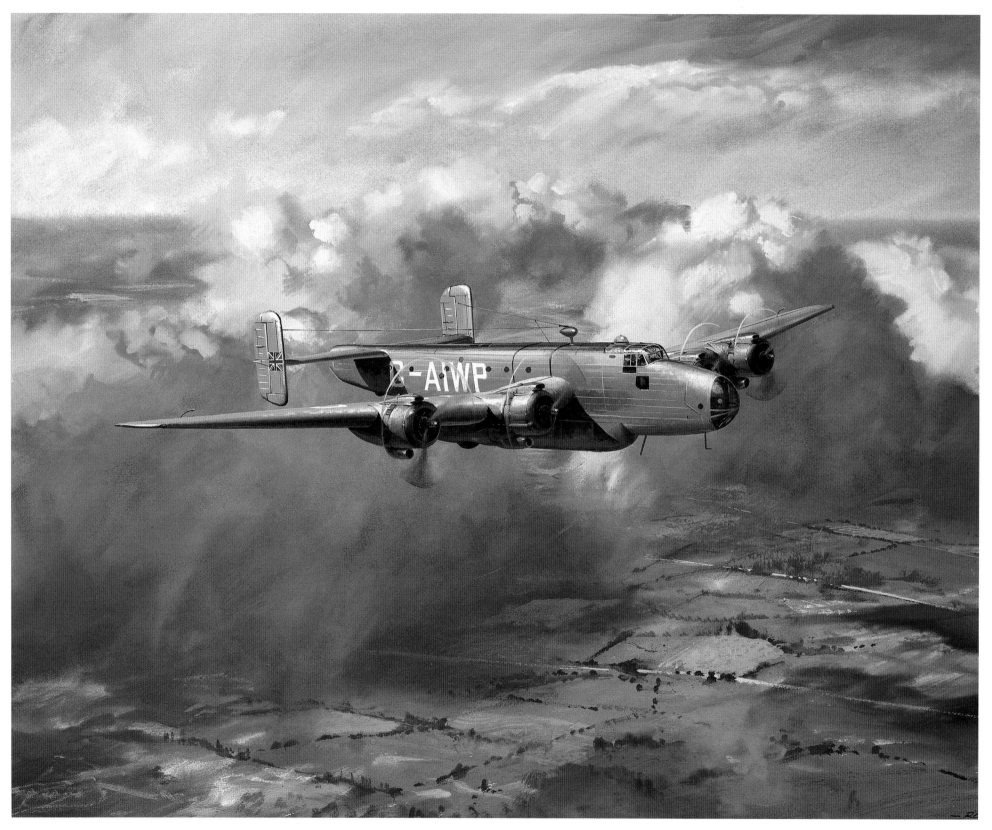

The second of Bomber Command's 'heavies' was the Handley Page Halifax but, somewhat out of sequence, the painting above is of the C VIII civilianized version with all gun turrets removed, a freight pannier in place of the bomb bay and eleven passenger seats (or ten stretchers) plus six crew bunks. This one was operated after the war by London Aero and Motor Services Ltd, and the similar Halton was used by BOAC as a ten-seat airliner.

The box-top illustrations for Airfix were meant to convey to the customers all the excitement of the aircraft in action to encourage them to reach into their pockets. Here, a stricken Avro Lancaster returns to base after a raid on Germany.

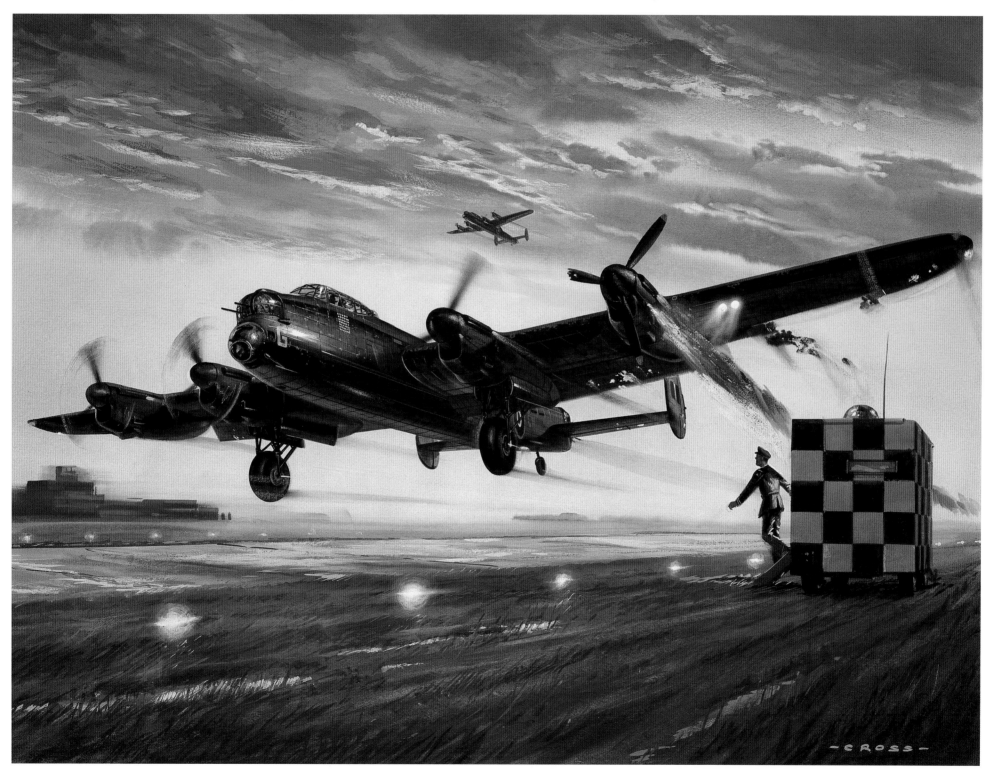

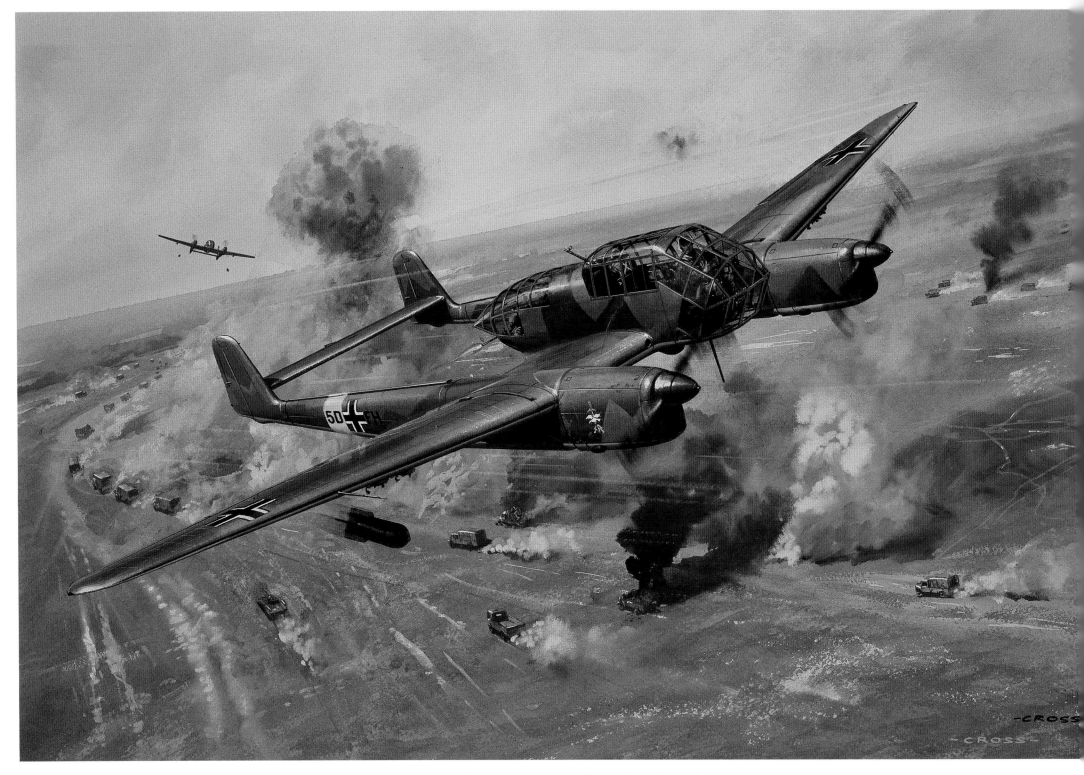

Another action painting, of the German Focke-Wulf Fw 189 Owl, also known as the
Flying Eye because of the insect-like multi-faceted forward cabin and the extensive
view it gave to the crew. It was intended to augment the Henschel Hs 126 short-range
reconnaissance and army co-operation high-wing monoplane.

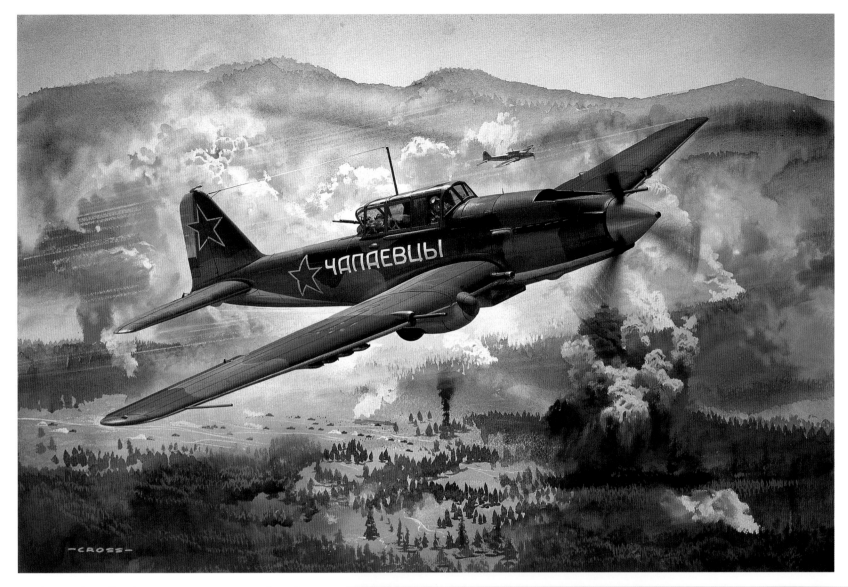

Like the Luftwaffe, the Soviet Air Force was largely dedicated to support of the ground forces, and one of the finest ground-attack aircraft on any side was the Ilyushin Il-2 Shturmovik. It was designed to operate very close to the ground, well within the range of small-arms fire, and had a front fuselage which was in effect an armoured shell to protect the engine and crew. Heavy cannon and machine-gun armament was augmented with rockets and bombs.

ABOVE: The Il-2 type 3.

RIGHT: The Yakovlev Yak-9 was the main Russian fighter in the later war years, this version being the long-range D model.

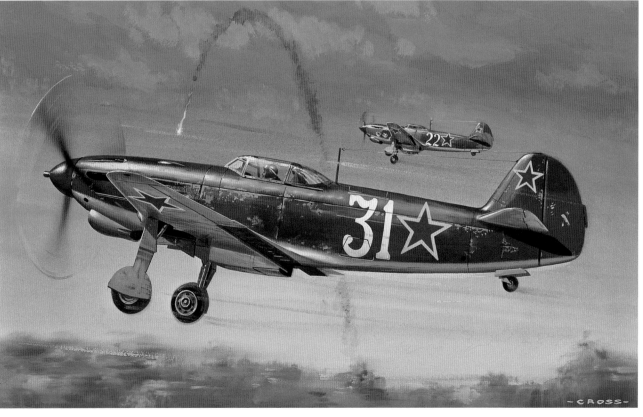

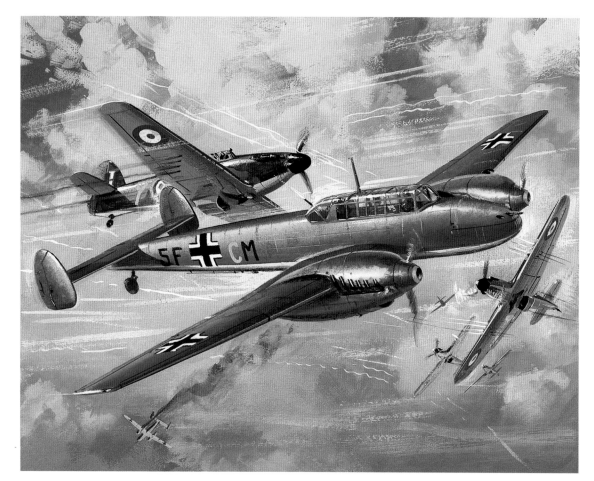

The Messerschmitt Bf 110, seen here in 1940 D form, dates from a 1934 concept for a twin-engined long-range destroyer/reconnaissance aircraft; employment as a light bomber and a night fighter was also foreseen. As with most of the new German types, it was designed for mass production with a structure in detail much like that of the Bf 109. Engines for the D model were the excellent Daimler-Benz DB 601A inverted V-12s giving 1,100 hp and a top speed approaching 350 mph (563 kph). As a bomber escort during the Battle of Britain it was less than successful despite its speed, and increasingly was used as a night fighter as well as in the day fighter-bomber role.

The Bv141 was contemporary with the Focke-Wulf Fw 189 and required for similar duties with emphasis on optimum view from the cabin for reconnaissance. Blohm und Voss came up with a rather ungainly asymmetric single-engine design, despite which it apparently flew well, as ascertained by Ernst Udet himself. The pilot's view to starboard must have been excellent but the view to port seems restricted by the jutting engine cowl and tail boom.

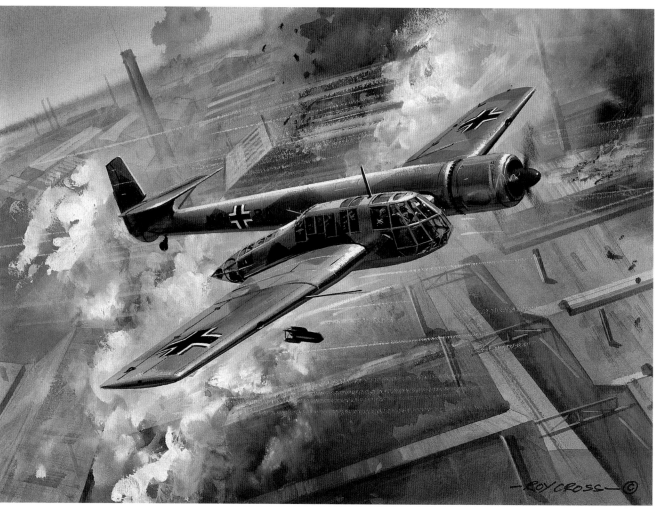

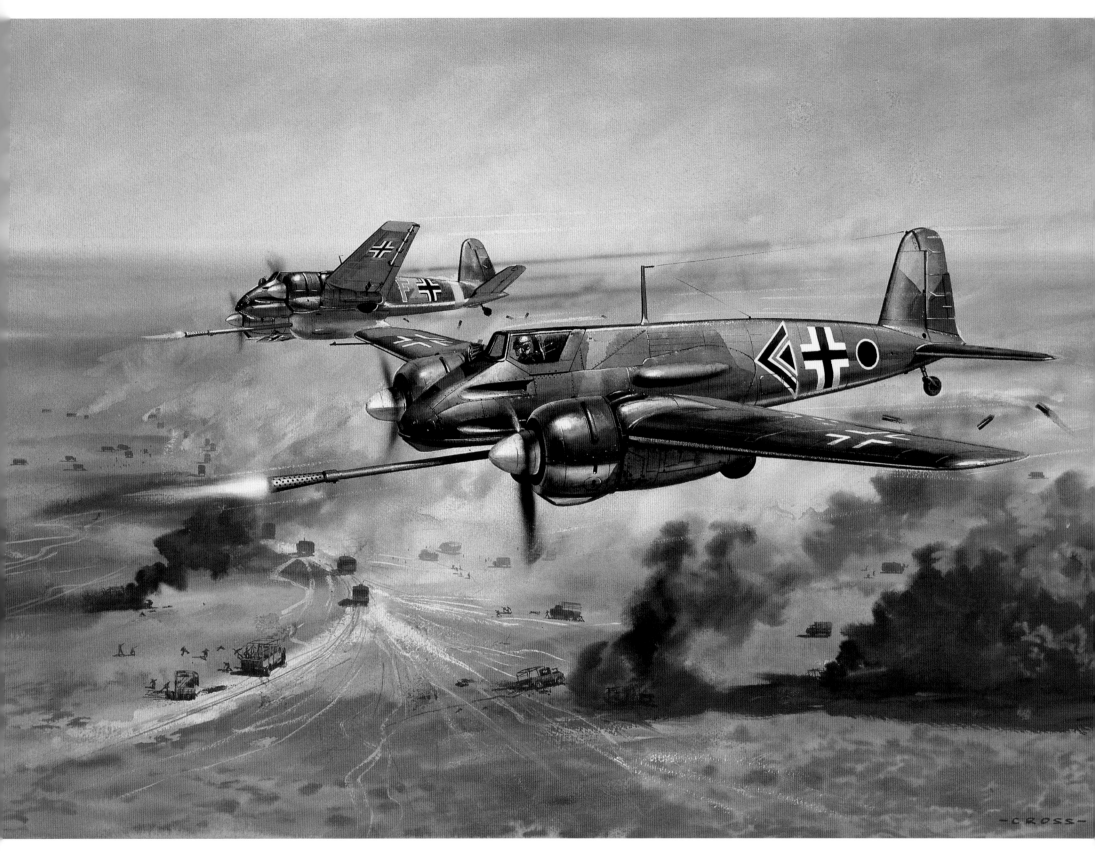

Armoured low-level ground attack aircraft had been used in the First World War and so it was no surprise that the Luftwaffe, with its primary role as air support for fast-moving ground forces, should formulate a requirement for a heavily armed and armoured low-level attack bomber. The hordes of excellent Soviet tanks and Il-2 ground-attack aircraft which were encountered as the eastern war progressed emphasized the need for such an aircraft as the Henschel Hs 129, but German pilots were unenthusiastic about the aeroplane and it was produced in tiny numbers compared with the Shturmovik. The Hs 129B version (above) mounted a huge 12-shot 75 mm (3 in) anti-tank cannon which was effective against even the latest Stalin tanks.

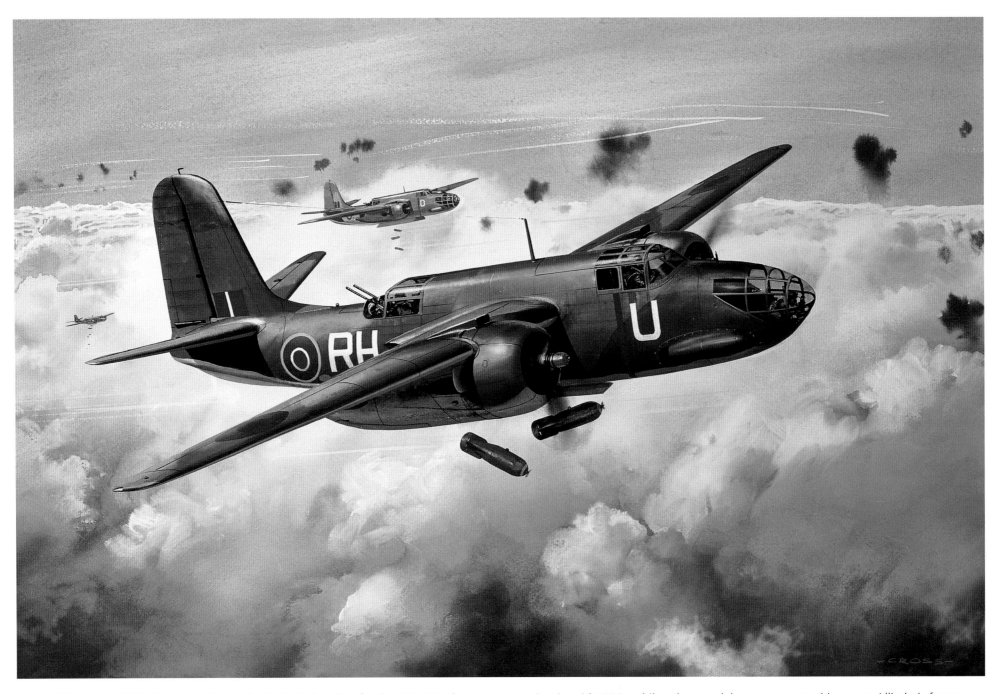

Derived from the 1938 Douglas twin-engined attack bomber for the USAAC, the much revised DB-7 was initially ordered by the French Purchasing Commission, desperate in 1939 to find new modern equipment for its air force in the face of the threat from the expanding Luftwaffe. Few of the initial orders reached the French, however, before the disastrous defeat of 1940 and the remainder (plus additional orders) were taken over for use by the Royal Air Force, initially as the Havoc I night fighter/intruder and then as the Boston light bomber.

The Army Air Corps was also expanding and orders were placed for the A-20

version in mid-1939, while other models were operated by most Allied air forces, including the Soviet's, the final number built totalling nearly 7,500.

ABOVE: a Boston Mk III of No. 88 Squadron, RAF.

OPPOSITE: The heavier Martin B-26 medium bomber was notable for its streamlined shape and, later on, its rugged reliability. At the same time it was berated for its high wing loading and fast landing speed, which initially caused many landing accidents and unpleasant epithets from the crews.

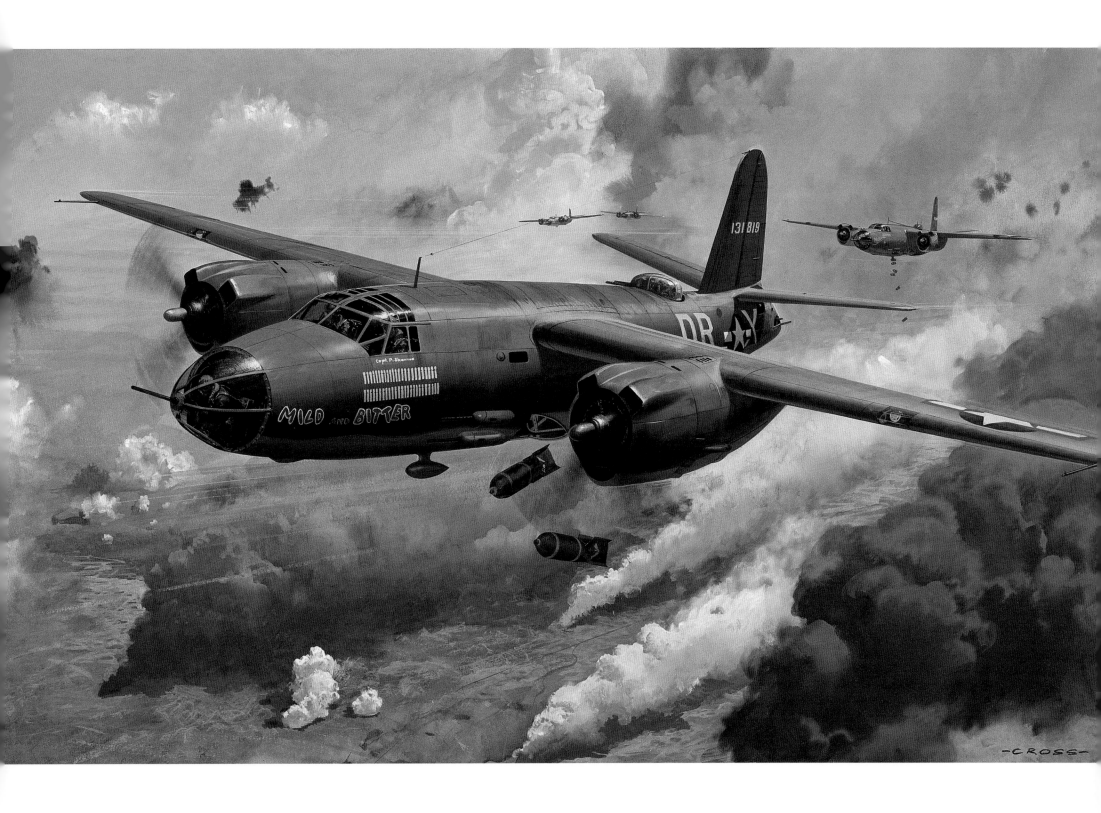

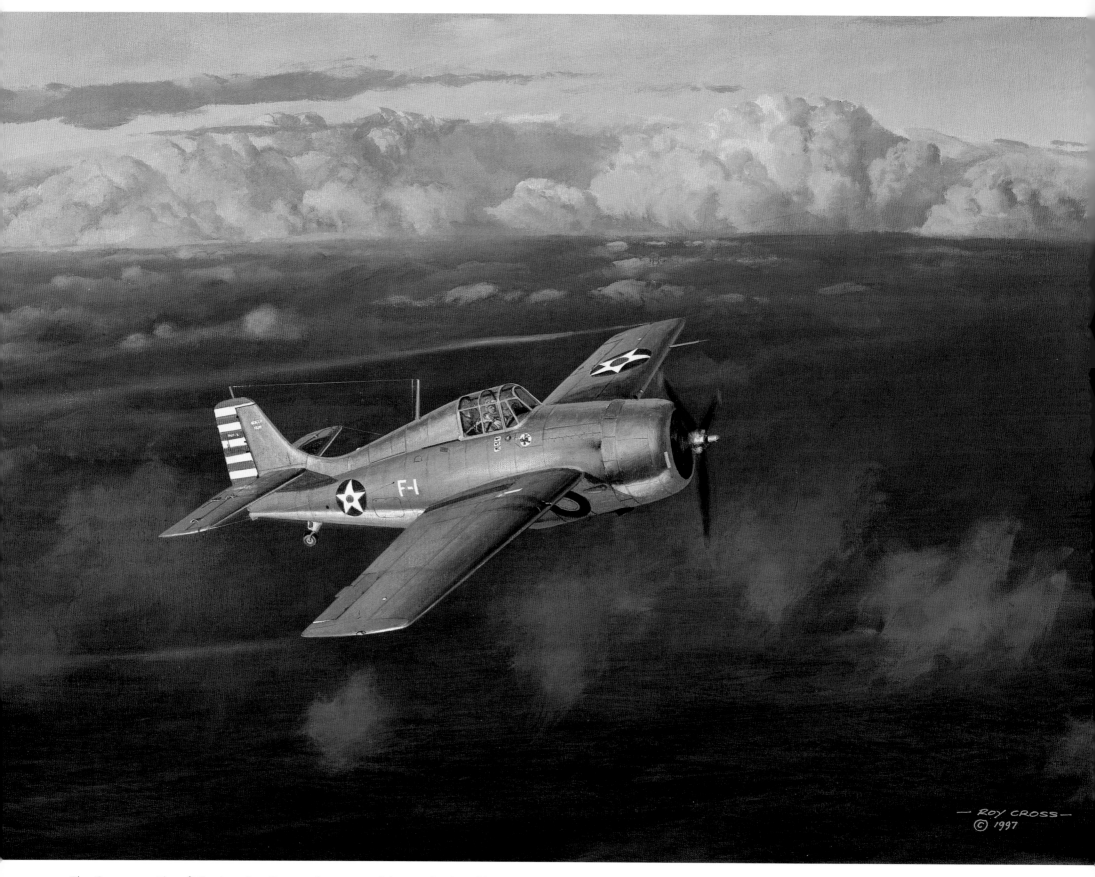

ROY CROSS
© 1997

The Grumman Aircraft Engineering Corporation was well known for its tubby carrier-borne biplane fighter aircraft for the pre-war US Navy, and their first monoplane, the F4F Wildcat, was also somewhat portly but served the navy well in the early air battles with the Japanese, and indeed later with the Royal Navy as the Martlet. This is the F4F-3 piloted by Lt John J. Thach, CO of VF-3 aboard the USS Lexington, April 1942.

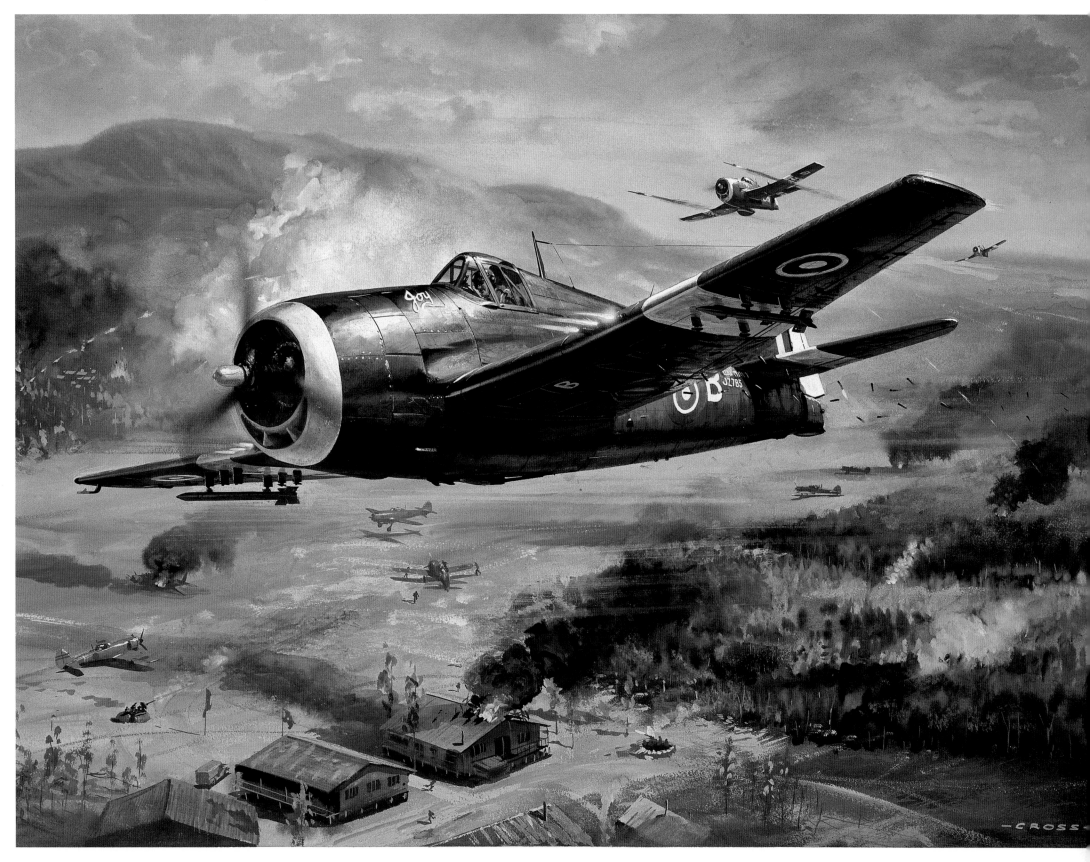

Structure weight was whittled down drastically in the Wildcat's successor, the F6F Hellcat, with a 2,000 hp Pratt & Whitney Double Wasp radial engine giving a much improved 375–80 mph (603–11 kph) top speed. Standard armament was six 0.5 in (12.7 mm) machine-guns in the wings, later increased to two 20 mm (0.79 in) cannon and four 0.5 in (12.7 mm) machine-guns to counter the cannon armament of Japanese naval fighters. 12,275 Hellcats were built by late 1945, when production ceased. Above is a Royal Navy Hellcat II in action in the Far East.

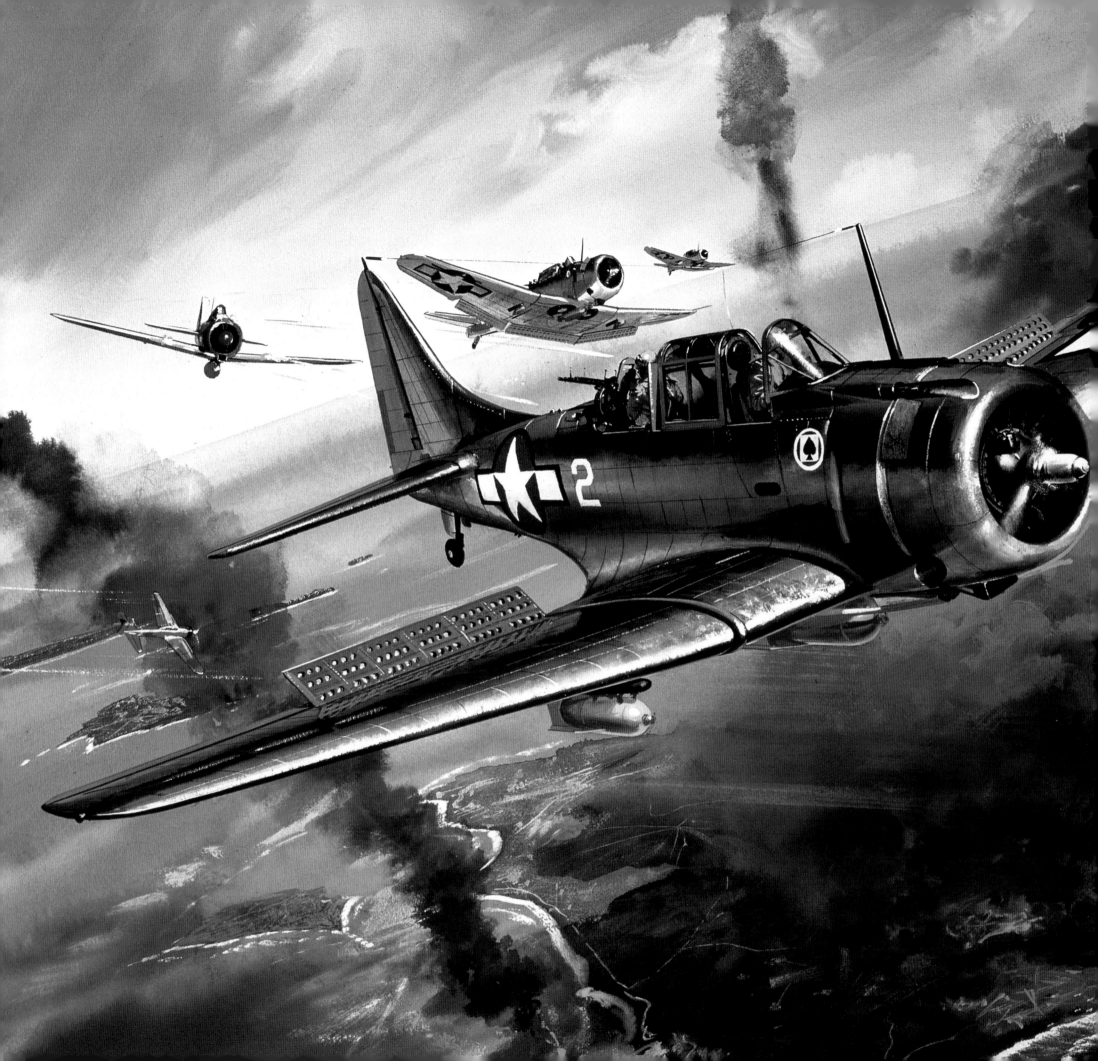

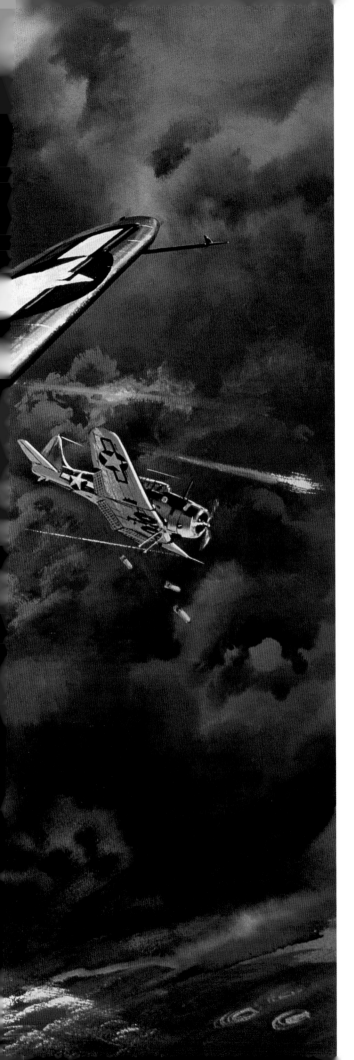

The scourge of the Japanese naval and land forces throughout the Pacific were the carrier-based Douglas Dauntless dive bomber, LEFT, and the Grumman Avenger torpedo bomber, BELOW. Pin-point dive bombing was developed during the First World War and, particularly against naval vessels, by the US Navy Air Arm long before the advent of the Ju 87 Stuka. The main Japanese naval casualties in the decisive battles of the Coral Sea and Midway were caused by Navy and Marine Corps Dauntless SBDs which bombed despite appalling casualties with catastrophic results for the Japanese. In the painting can be seen the distinctive perforated air brakes deployed as the machine prepares to commence its dive, the under-fuselage fork which swings the bomb down and clear of the airscrew upon release, and the armoured twin-gun observer's position. The markings are of the Ace of Spades Marine squadron VMSB-231, 1944.

The Avenger carrier-borne torpedo bomber was a turret-armed three-seater with wings folding and twisting back along the fuselage sides in the same way as those of the Wildcat fighter, for stowage below decks. Internal capacity for the torpedo or bombs resulted in a deep belly ending in a ventral gun position for the navigator, the radio operator manning the enclosed single-gun rotating powered turret. The white tail and right wing flashes signify the USS Yorktown, CV-10, as the parent vessel.

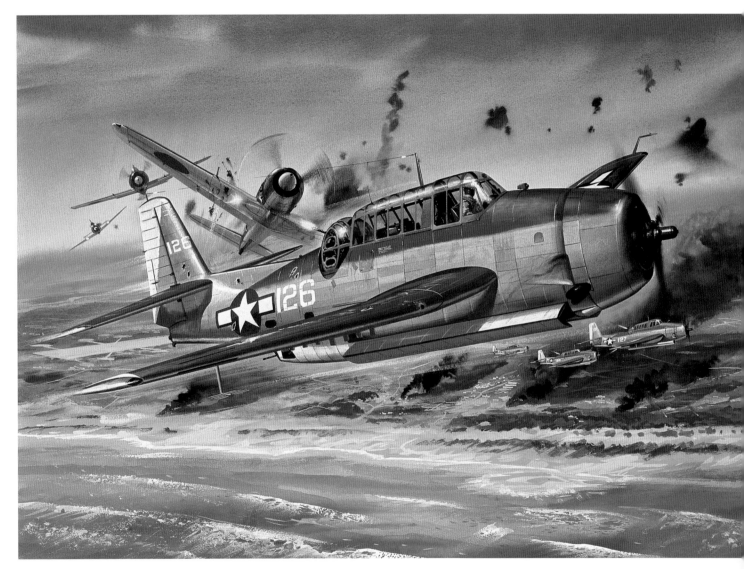

91

The P-40 and P-38 Lightning, illustrated earlier, are joined here by the Republic P-47 Thunderbolt, a P-47D-25 of the USAAF 84th Fighter Squadron, 78th Fighter Group, with a long-range under-fuselage fuel drop-tank and bombs carried beneath the wings. The P-47 amazed all by its vast bulk for a single-engined single-seater. The deep belly housed long asbestos-covered piping and air ducting connecting the powerful Pratt & Whitney Double Wasp radial engine to the rear fuselage turbo-supercharger via an intercooler. Even its designer said it was 'too big', and the great loaded weight (more than a twin-engined Bristol Blenhemim bomber!) should have placed it at a grave disadvantage against agile German opponents. Yet despite its internal complexity it had a good reputation for reliability and surviving battle damage, an excellent speed/height performance and was produced in larger numbers (15,683) than any other American Second World War fighter. The version illustrated had a top speed of 429 mph (690 kph) and a service ceiling of 42,000 ft (12,800 m) with the Double Wasp R-2800-59 engine of 2,300 hp (war emergency power with water-injection).

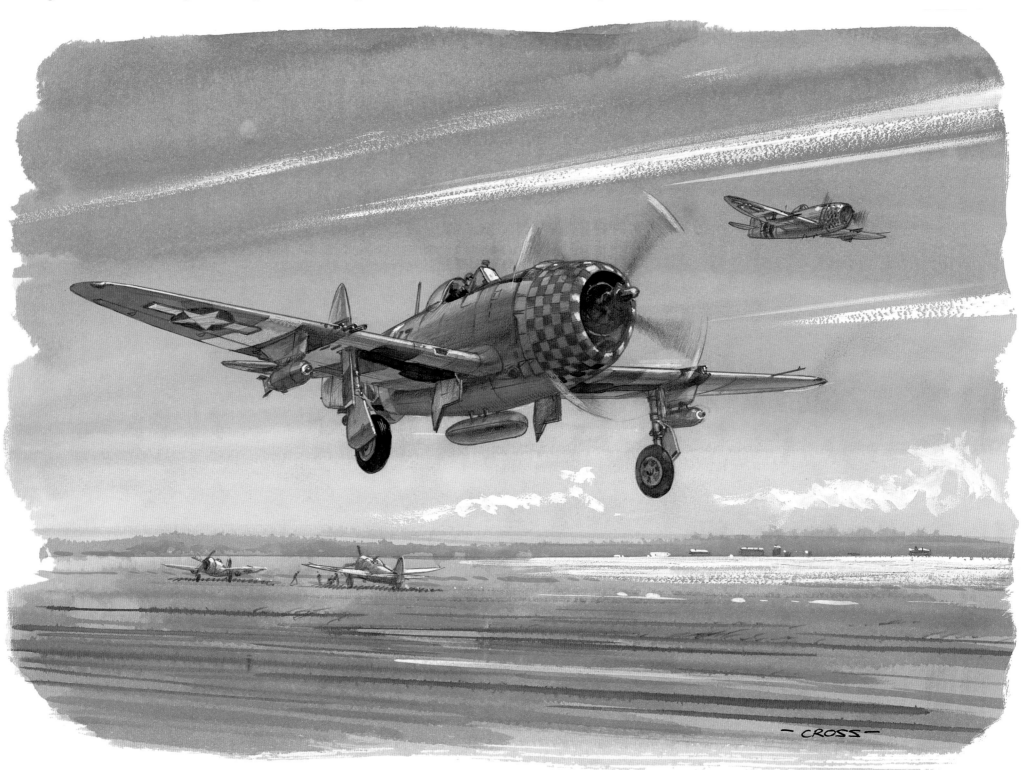

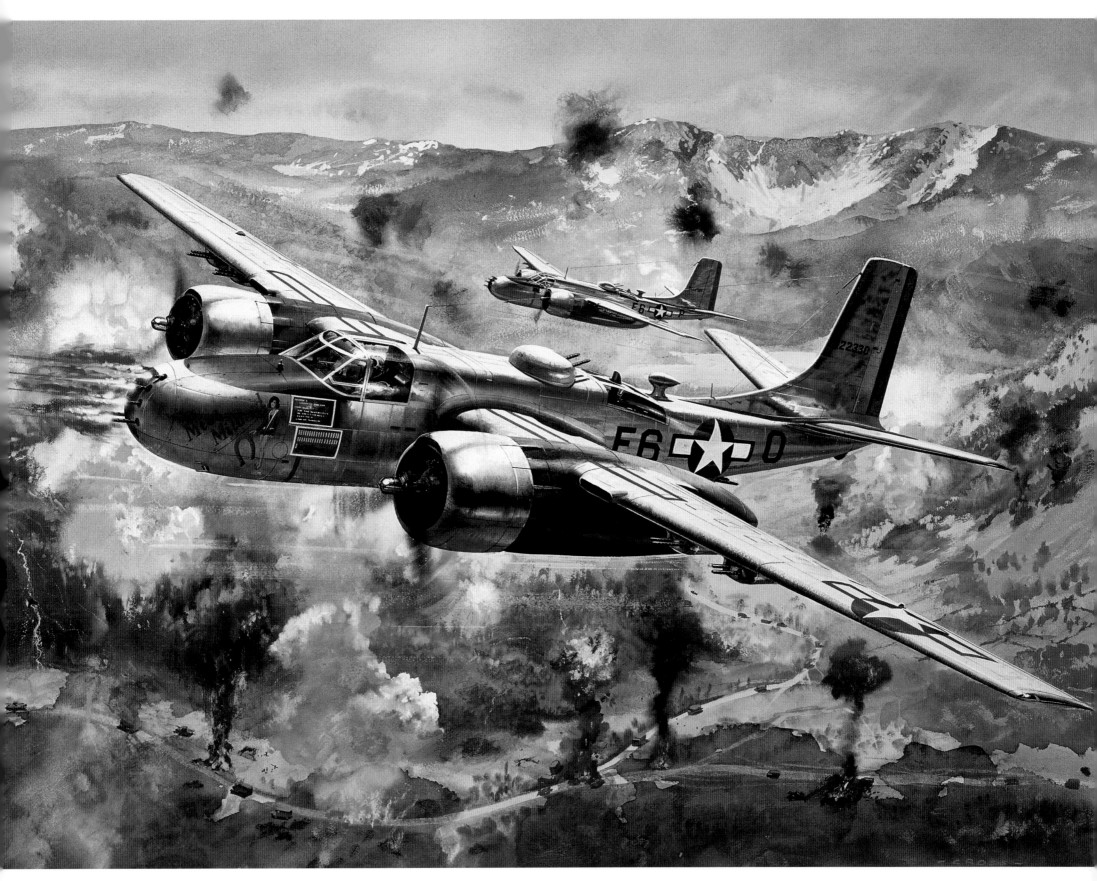

The successor to the A-20 in American service was the Douglas A-26 Invader with a large power increase, refined aerodynamics, including a laminar-flow wing, and remotely controlled defensive armament in twin gun turrets. Later it served in the Korean War and in Vietnam. This is an A-26B serving with the 670th Squadron, 416th Bomb Group, France 1944.

Many historians rate the P-51 Mustang as the best US single-seat fighter of the Second World War after the airframe had been mated to the Rolls-Royce Merlin engine. Featured below is a P-51C model with Malcolm bubble hood for improved visibility.

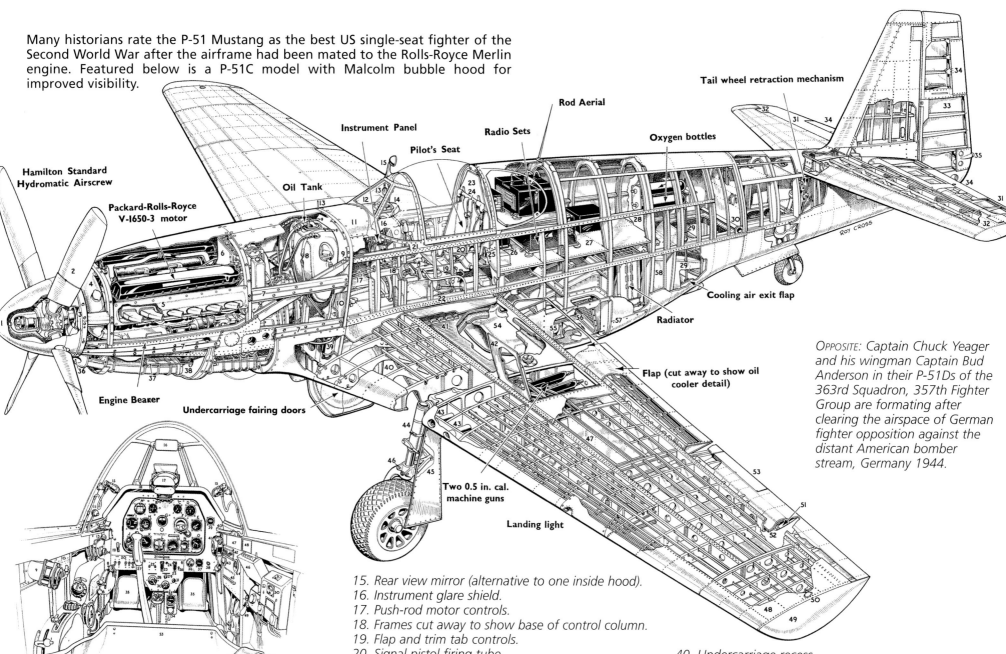

Tail wheel retraction mechanism
Rod Aerial
Instrument Panel
Radio Sets
Oxygen bottles
Pilot's Seat
Hamilton Standard Hydromatic Airscrew
Oil Tank
Packard-Rolls-Royce V-1650-3 motor
Engine Bearer
Undercarriage fairing doors
Cooling air exit flap
Radiator
Flap (cut away to show oil cooler detail)
Two 0.5 in. cal. machine guns
Landing light

ROY CROSS

OPPOSITE: Captain Chuck Yeager and his wingman Captain Bud Anderson in their P-51Ds of the 363rd Squadron, 357th Fighter Group are formating after clearing the airspace of German fighter opposition against the distant American bomber stream, Germany 1944.

P-51 MUSTANG

Key

1. Spinner cut-away to show airscrew mechanism.
2. 11 ft 2 in diameter paddle-blade airscrew.
3. Armour-plate protecting coolant tank.
4. Coolant tank.
5. Stub exhaust fairing (cut-away to show inner heat-retaining box).
6. Motor intercooler.
7. Framework for attaching cowling panels.
8. Metal straps holding oil tank.
9. Top attachment point to engine mount.
10. Armour integral with fire wall.
11. Access panel to hydraulic reservoir.
12. Bullet-proof glass panel 1½ inches thick.
13. Ring and bead gun sight.
14. Gyroscopic gun sight.

15. Rear view mirror (alternative to one inside hood).
16. Instrument glare shield.
17. Push-rod motor controls.
18. Frames cut away to show base of control column.
19. Flap and trim tab controls.
20. Signal pistol firing tube.
21. Top longeron.
22. Bottom longeron.
23. Armour-plate protecting pilot.
24. Seat suspension frame.
25. Lower portion of crash pylon.
26. Batteries.
27. Shelf for radio and equipment.
28. Draught-proof screen.
29. Jack for operating cooling air exit flap.
30. Lifting tube.
31. Fabric-covered elevator.
32. Elevator mass balance.
33. Fabric-covered rudder.
34. Plastic trim tabs.
35. Navigation light.
36. Carburettor air intake.
37. Push-rod control for regulating air-flow to carburettor.
38. Engine mount reinforcing tie.
39. Fuel filter.

40. Undercarriage recess.
41. Port wing self-sealing fuel tank (cut-away to show radiator air intake).
42. Access door to guns.
43. Gun blast tube.
44. Undercarriage leg shock-absorber and half-fork.
45. Fairing strip.
46. Towing lugs.
47. Ammunition boxes.
48. Wing-tip sub-assembly.
49. Detachable tip.
50. Navigation light.
51. Aileron sectioned showing internal aerodynamic balance diaphragm (52).
53. Plastic trim tab.
54. Main air intake (radiator and oil cooler).
55. Oil cooler and exit flap.
56. Floor of main tunnel cut-away to show oil cooler.
57. Access panel to radiator.
58. Rear tunnel.

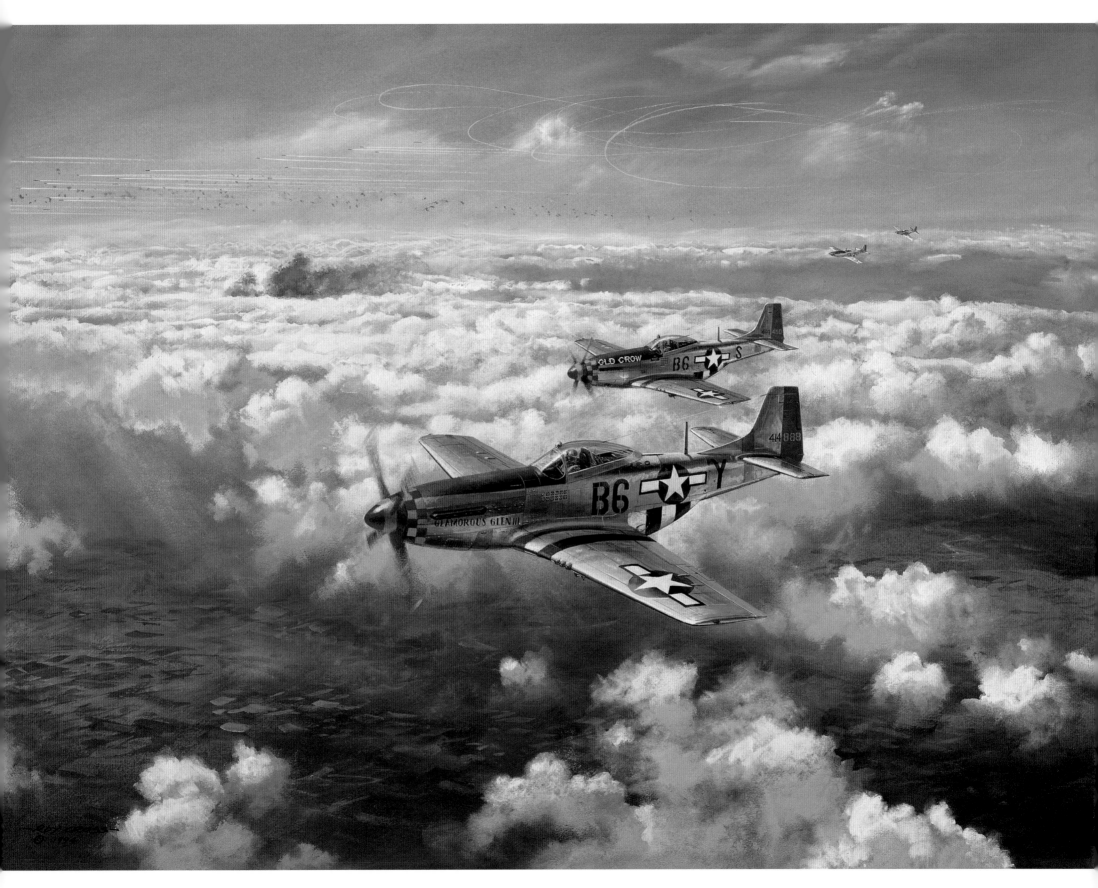

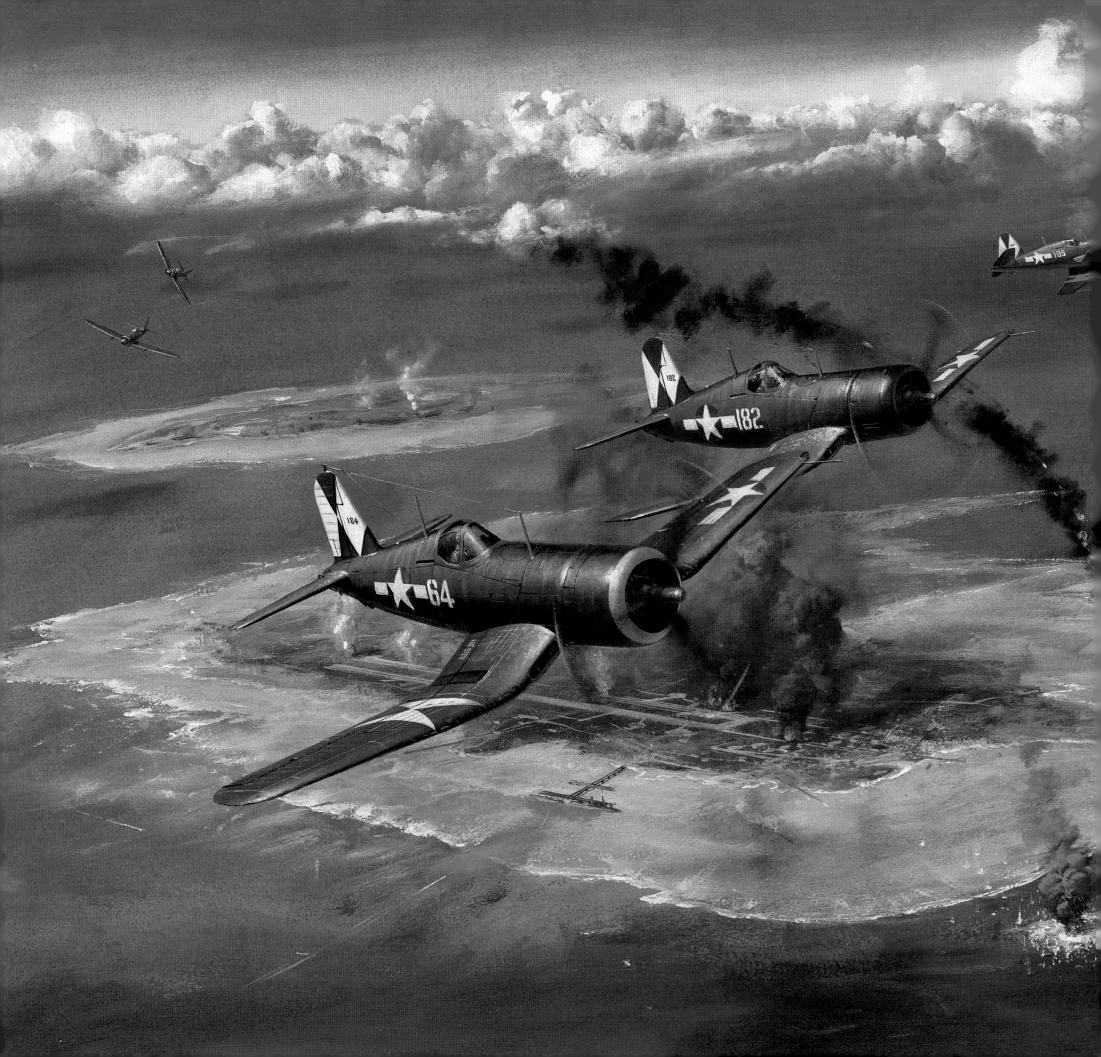

OPPOSITE: Chance Vought F4U-1D Corsair fighters of VBF-83 from the US aircraft carrier USS *Essex* in action against Mitsubishi Zeros over a typical Japanese-held island stronghold somewhere in the Pacific area of operations. The Corsair made its debut with Marine Fighting Squadron 124 in February 1943, flying from Guadalcanal during the Solomons' campaign. Designed as a carrier-borne fighter to a 1938 requirement the new design was to be powered by the Pratt & Whitney XR-2800 Double Wasp radial engine initially giving around 1,800 hp and a top speed of 405 mph (652 kph). A setback occurred when the Navy assessed the early F4U-1 as unsuitable for carrier operations and for a time the Corsair was used entirely from land bases with Navy and particularly Marine squadrons. In fact, the Royal Navy pioneered carrier operations with their Corsairs after which, suitably reassured, the US Navy put them aboard its carriers. As well as air fighting, the Corsairs proved particularly suitable for rocket and bomb attacks on ground targets. The developed F4U-4 with uprated Double Wasp R-2800-18W giving 2,350 hp war emergency power with water injection had a top speed of 425 mph (684 kph) at 23,000 ft (7,010 m).

Corsairs would often have come up against the Nakajima Ki-84 Army Type 4 Hayate, code-named Frank by the Allies, shown below in the markings of the 73rd Sentai. The best Japanese Army fighter of 1944–5, it makes an interesting comparison with the American Corsair and Hellcat, having a 1,825 hp Nakajima Ha-45 radial engine, heavy cannon/machine-gun armament, excellent manoeuvrability and a 388 mph (624 kph) top speed. The all-round view for the pilot must have been excellent through that near-bubble cockpit hood.

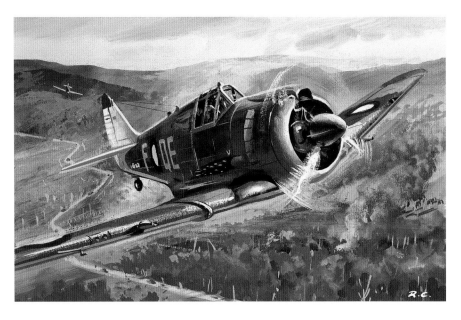

COMMONWEALTH CA-12 BOOMERANG

The service record of Australian (as well as other Commonwealth) aircrews during the war was legendary, although they usually had to fly British/American or licence-built aeroplanes. One exception was the CA-12/14 fighter designed to use as much of the structure of the Commonwealth Aircraft Wirraway (NA-33) (and the locally manufactured Pratt & Whitney Twin Wasp) as possible. Only 250 Boomerangs were produced, but with the Wirraway usually were used in the army co-operation role against the Japanese and for local defence. They performed sterling service until more modern Allied fighters could be provided.

Key

1. De-icing glycol tank.
2. Hydraulic hand pump and cowling flap control levers.
3. Rudder and elevator trim tab control wheels.
4. Fuel tank selector switch.
5. Oil cooler air shutter lever.
6. Map satchel beneath seat.
7. Landing gear and flap control levers.
8. Engine controls.
9. Hood jettison lever.
10. Rudder pedals and heel slides.
11. Aileron control torque tube.
12. Hamilton 3T50 constant speed propeller.
13. 1,200 hp Pratt & Whitney S3C4-G air-cooled 14-cylinder radial engine.
14. Carburettor air intake.
15. Oil cooler inlet.
16. Detachable engine access panels.
17. Adjustable cooling gills.
18. 14-gallon oil tank.
19. Fuel filter.
20. Ring and bead gun sights (alternative to reflector sight).
21. 1½" bullet proof glass windshield.
22. Rear view mirror.
23. Engine compartment firewall.
24. Pilot's seat adjustable for height.
25. Pilot's armoured back shield.
26. Undercarriage warning horn behind seat.
27. Tubular truss turnover pylon.
28. Electric generator.
29. Radio.
30. Fuselage tank fuel filler.
31. 70-gallon fuselage fuel tank.
32. ATR3 radio aerial. (Not fitted when ATR5 radio installed.)
33. External battery socket and master switch.
34. Fuselage navigation light.
35. Anti-ricochet plate on fuel tank.
36. Oxygen bottle.
37. Main fuselage tubular structure.
38. Wooden fuselage top fairing.
39. Monocoque bottom fuselage fairing.
40. Tail wheel lock.
41. Navigation lights.
42. Main wheel fairing.
43. Wheel retraction cutout.
44. Cool air duct (cockpit ventilation).
45. 70-gallon belly fuel tank.
46. Port 45-gallon wing fuel tank.
47. Centre section/outer wing joint.
48. Hispano Mk.II or CAC 20 mm cannon each side.
49. Two Browning Mk.II. 0.303 in wing guns each side.
50. Main wheel fairing doors.
51. Landing light.
52. Type G45 camera gun.
53. Aluminium alloy wing tip.

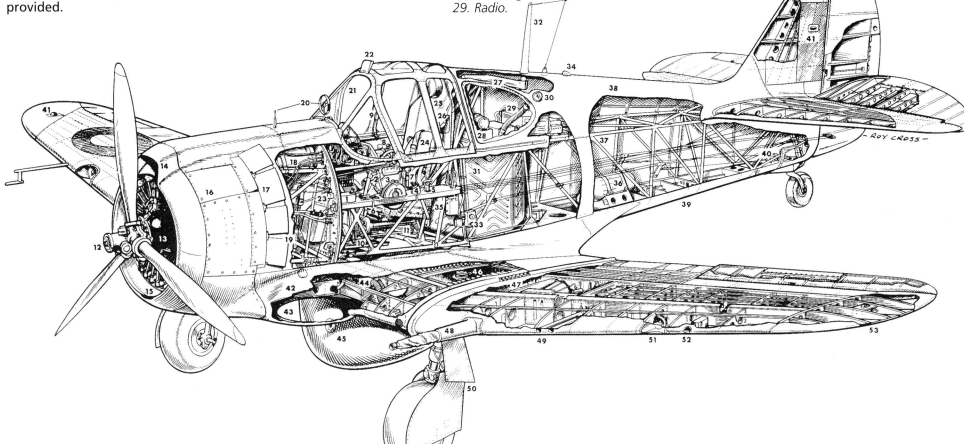

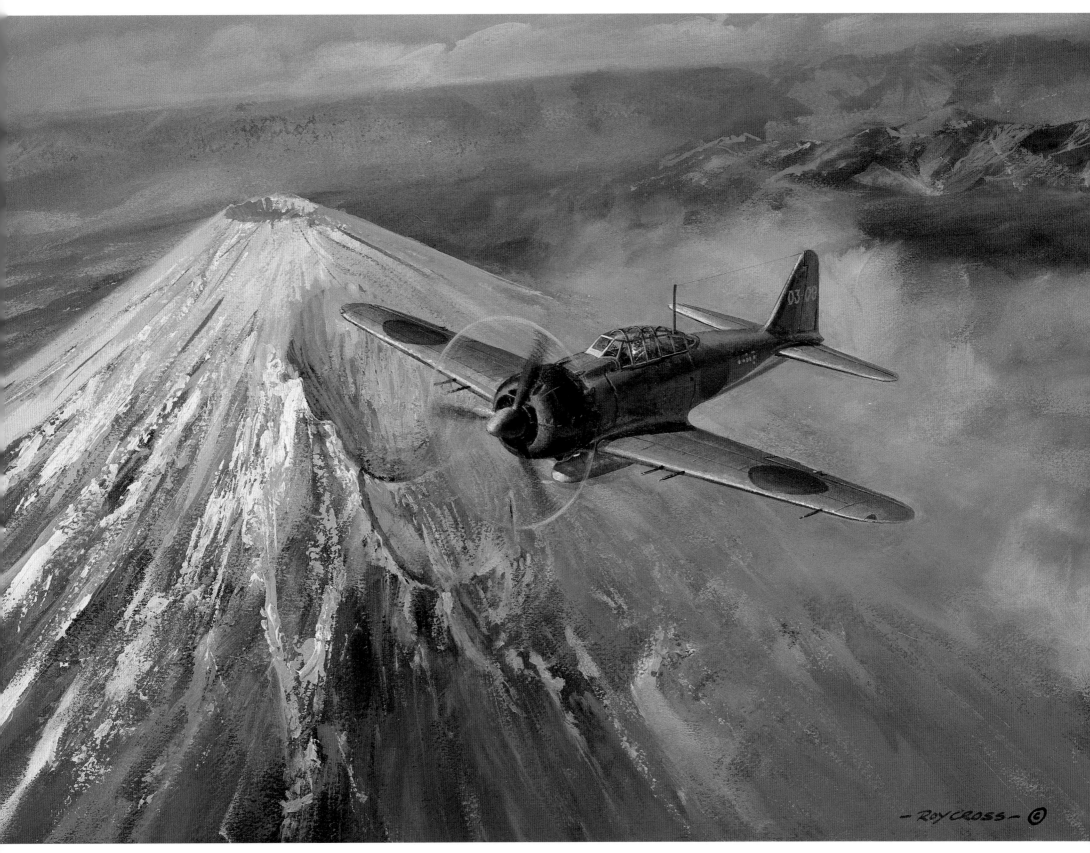

The best-known Japanese Second World War fighter was the famous Zero, Mitsubishi A6M (Reisen), which gained spectacular results in China and against the Allies in the early part of the Far East war, usually it must be said against inferior or outdated opposition. This machine is the later A6M5c flown by NAP1/C Takeo Tanimizu, June 1945, Japan.

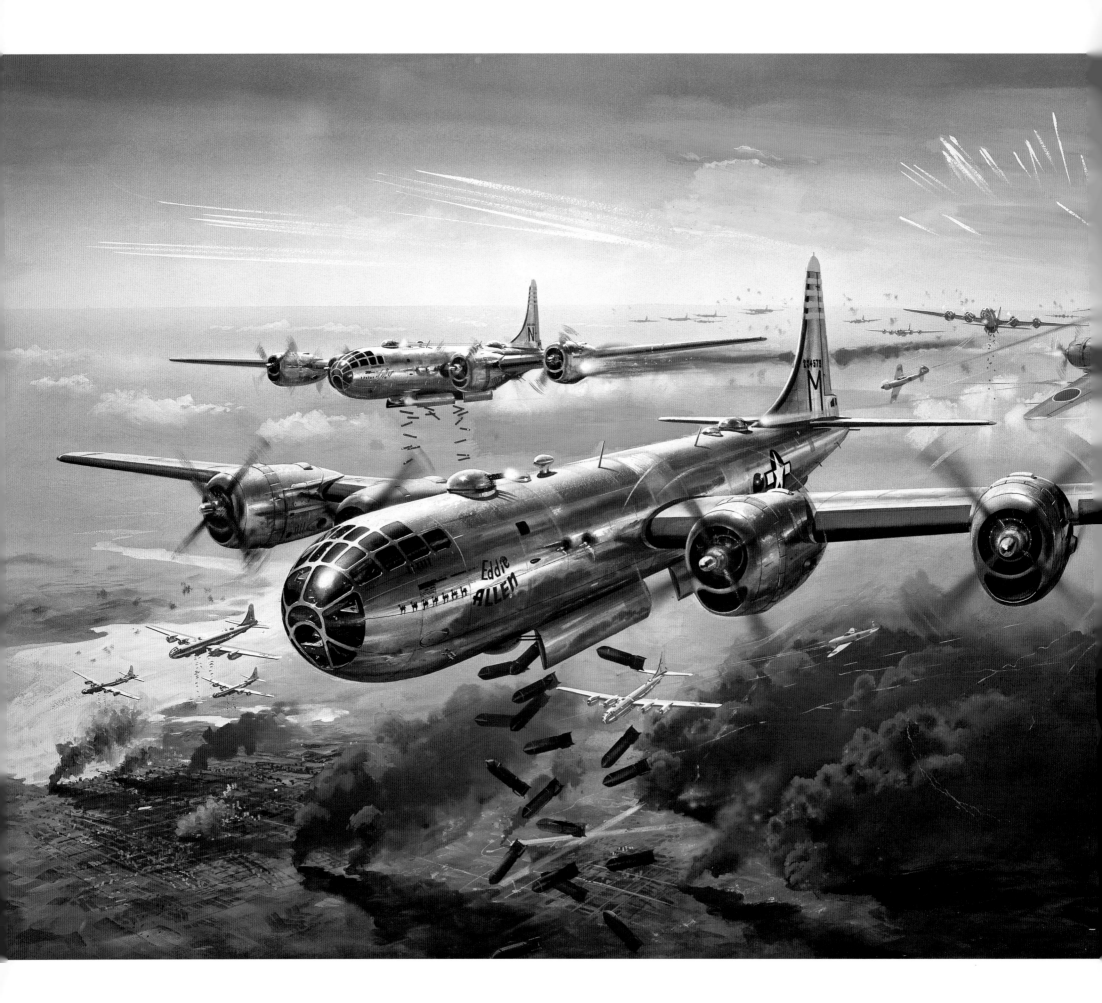

As the Allied forces closed in upon the Japanese homeland, captured island strongholds were transformed into vast staging posts and landing grounds for the final air assault on Japanese cities and industrial capacity. Systematic bombing from high altitude was to be by perhaps the most sophisticated bomber of the war, the Boeing B-29. Initially based in the India-China-Burma theatre, the B-29s were transferred to the island bases closer to Japan, and set about pulverising Japan's war industries and her capacity to continue military operations. The painting opposite typifies the massed formations eventually deployed, latterly by night using a deluge of incendiary bombs. The B-29 was roughly twice the weight of a typical B-17 Flying Fortress, carried nearly four times the maximum bombload, had pressurized accommodation for the eleven- or twelve-man crew and a typical armament of ten 0.5 in (12.7 mm) machine-guns and one cannon. The two atomic bombs dropped by B-29s (Hiroshima and Nagasaki) were the finale to the Second World War.

BELOW: SBD Dauntless US Navy dive bombers were gradually replaced by the Curtiss SB2C Helldiver with the Wright R-2600 engine, internal stowage for bombs and other stores, four 0.5 in (12.7 mm) guns (or two cannons) in the wings, and twin guns for the rear gunner. These machines are with a post-war reserve unit.

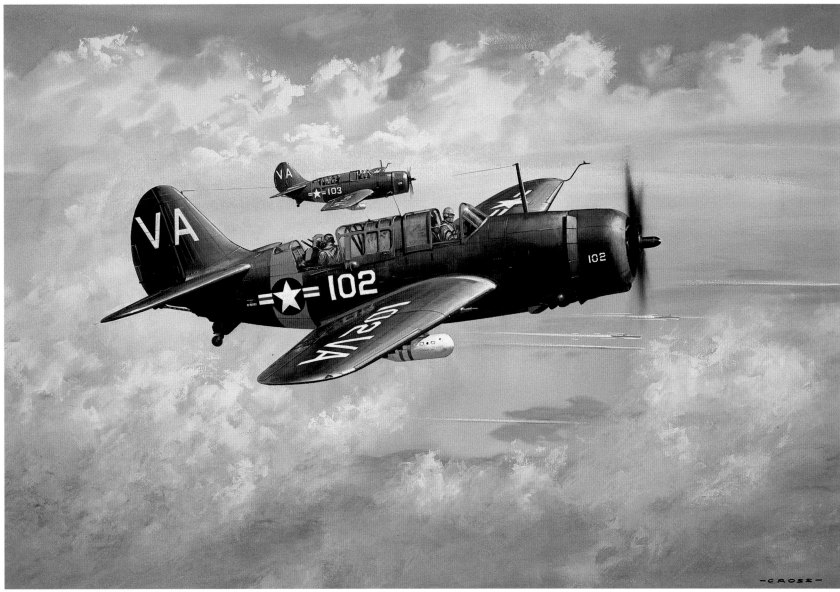

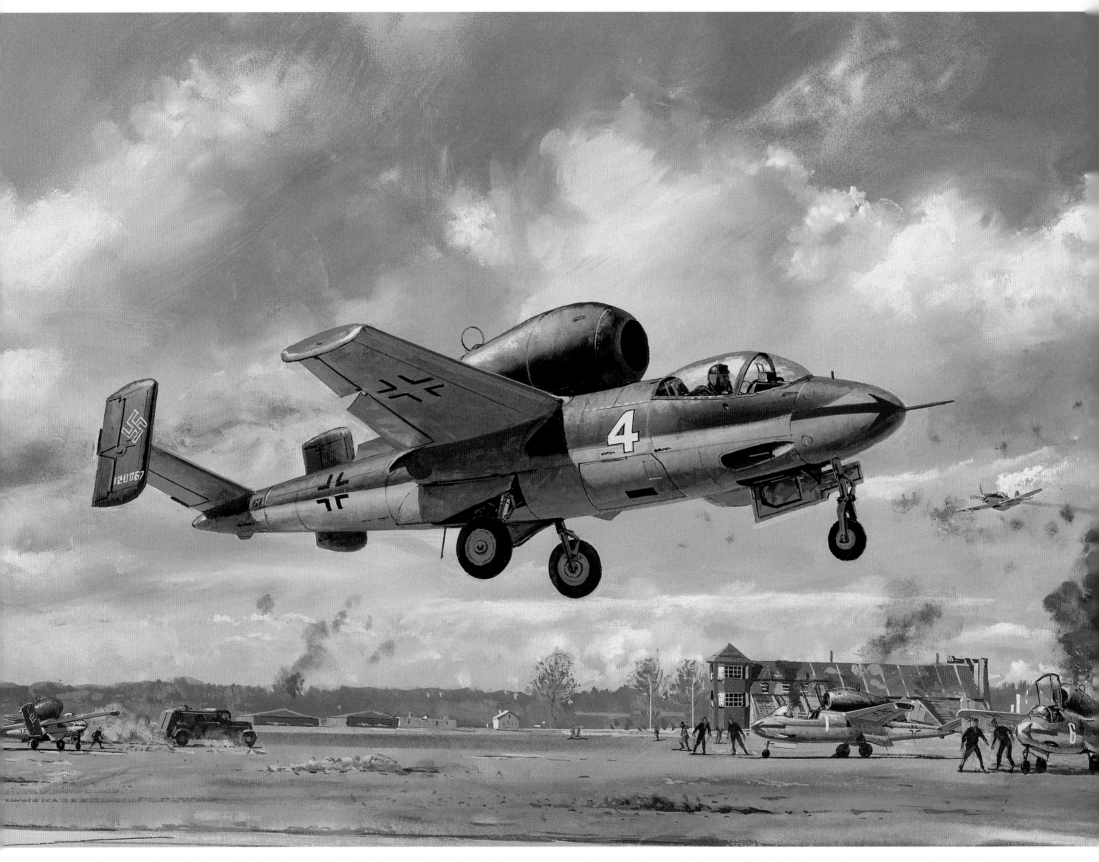

Totally outnumbered, short of fuel and materials, with the manufacturing industry going underground and experienced aircrew in short supply, the Luftwaffe resorted to emergency measures in 1944–5. One result was the concept of a jet-powered lightweight 'People's Fighter' using non-strategic materials and construction capaci-

ty. Heinkel, pioneers in jet-propelled aircraft, got the contract and produced the minimalist He 162 seen above. This machine is from a unit of JG1 formed in the early months of 1945 but there is little evidence that the He 162 ever flew in combat.

Compared with the He 162, the Messerschmitt Me 262 was perhaps the most influential aircraft of its day, heralding the age of jet propulsion. Had circumstances been different it could have seriously interrupted the Allied air war on Germany. However, despite its revolutionary design, Germany lacked the single-minded High Command decision-making and the industrial capacity to deploy it in large numbers. Jet-propelled aircraft were under development by the Allies but the Me 262 was well ahead in terms of design, the advanced swept-back wings affording a high 0.86 limiting Mach number, and performance, typically around 535 mph (861 kph) maximum speed. The first flights of prototypes began in 1942 with twin BMW axial-flow jet engines, whereas the Gloster Meteor twin-jet fighter conceived as early as 1940 did not achieve its first flight until March 1943, and was of more conventional aerodynamic design with the top speed of the early Mk 1 service version over 100 mph (160 kph) slower. The Schwalbe's main armament was deadly, comprising four nose-mounted 30 mm (1.2 in) Mk 108 cannon, and twelve 55 mm (2.2 in) R4M air-to-air unguided rocket projectiles under each wing could be rippled off in a lethal salvo against Allied bomber formations.

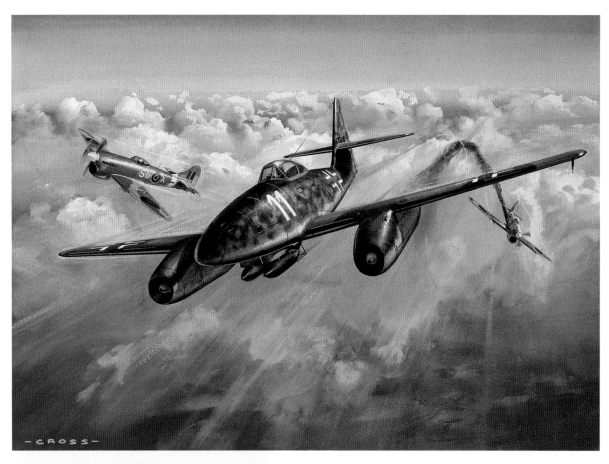

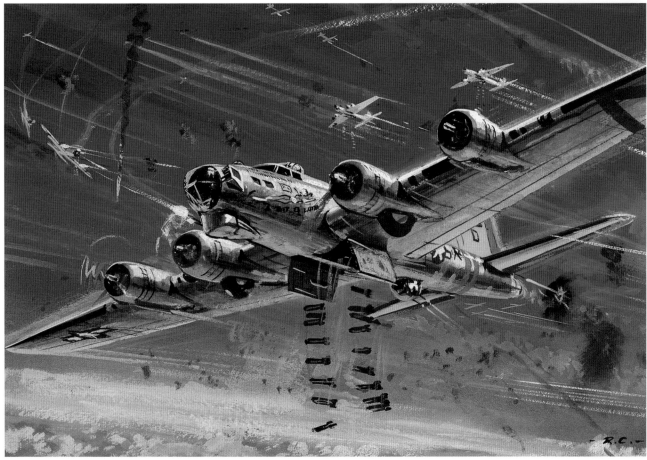

The Me 262, He 162 and other advanced jet or rocket fighters could have outperformed Allied escort fighters and caused even more devastating casualties among B-17 Flying Fortress (LEFT) and B-24 heavy bomber formations over Germany, had they been produced more quickly and in greater numbers. The B-17 was the principal daylight high-altitude precision bomber used by the US 8th Air Force over Germany, augmented by the B-24 Liberator.

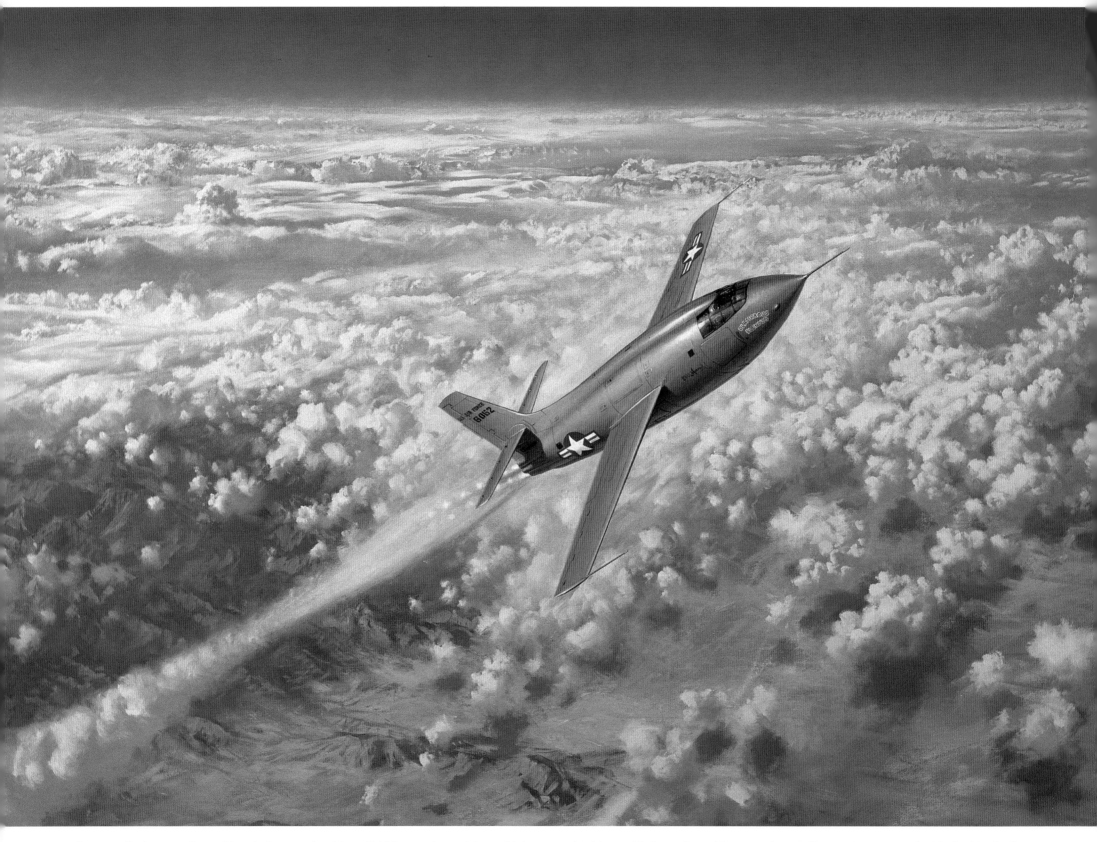

Apparently the term 'sound barrier' was coined by a British aerodynamicist to high-light the increasing control difficulties and erratic flight behaviour of many high-performance combat aircraft as level and dive speeds inexorably increased. That there was no barrier was proved by Captain Charles E. Yeager on 14 October 1947 when he flew the Bell X-1 rocket-powered research aircraft to Mach 1.04 at

the Muroc Air Force Base. Yeager quipped, 'It wasn't a very soft ride [at Mach 1] ... Physically there was no sensation; I mean your ears didn't drop off or anything!' Probably the Wright brothers felt much the same in 1903. Yeager's flight and subsequent supersonic research opened the way for today's Concorde airliner.

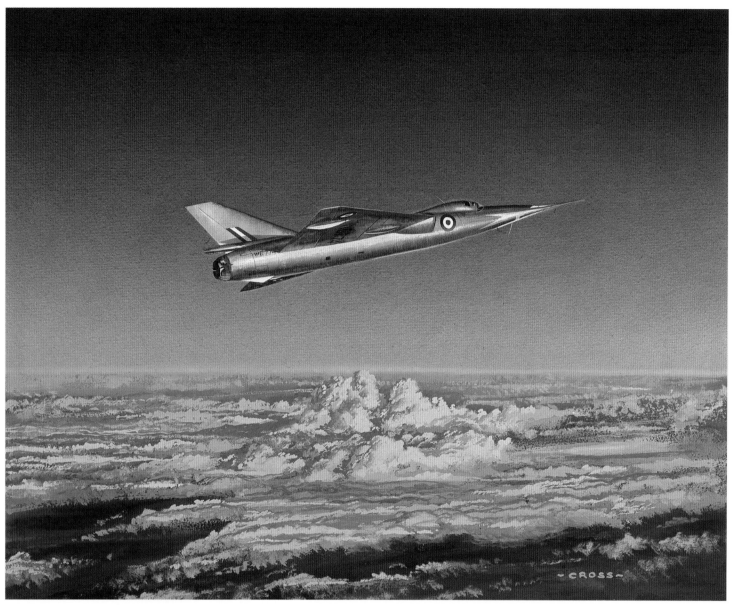

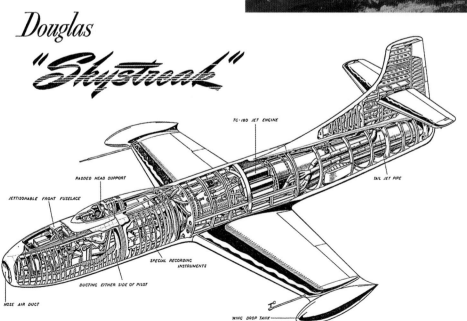

Douglas
"*Skystreak*"

JETTISONABLE FRONT FUSELAGE

PADDED HEAD SUPPORT

NOSE AIR DUCT

DUCTING EITHER SIDE OF PILOT

SPECIAL RECORDING INSTRUMENTS

TG-180 JET ENGINE

TAIL JET PIPE

WING DROP TANK

The Bell X-1 was a simple straight-thin-wing design but with astonishing strength factors including a positive 18 g loading. The Douglas Skystreak (*LEFT*) was an alternative turbo jet-powered trans-sonic research vehicle.

A belated alternative approach to supersonic research in Britain was the Fairey FD 2 (*ABOVE*) with a delta wing layout, a powerful Rolls-Royce jet engine, eventually with afterburning, and the novelty of a drooping nose section to improve the pilot's view at touchdown, a feature carried over to the Concorde supersonic airliner. The FD 2 took the world airspeed record at 1,132 mph on 10 March 1956 with Peter Twiss at the controls.

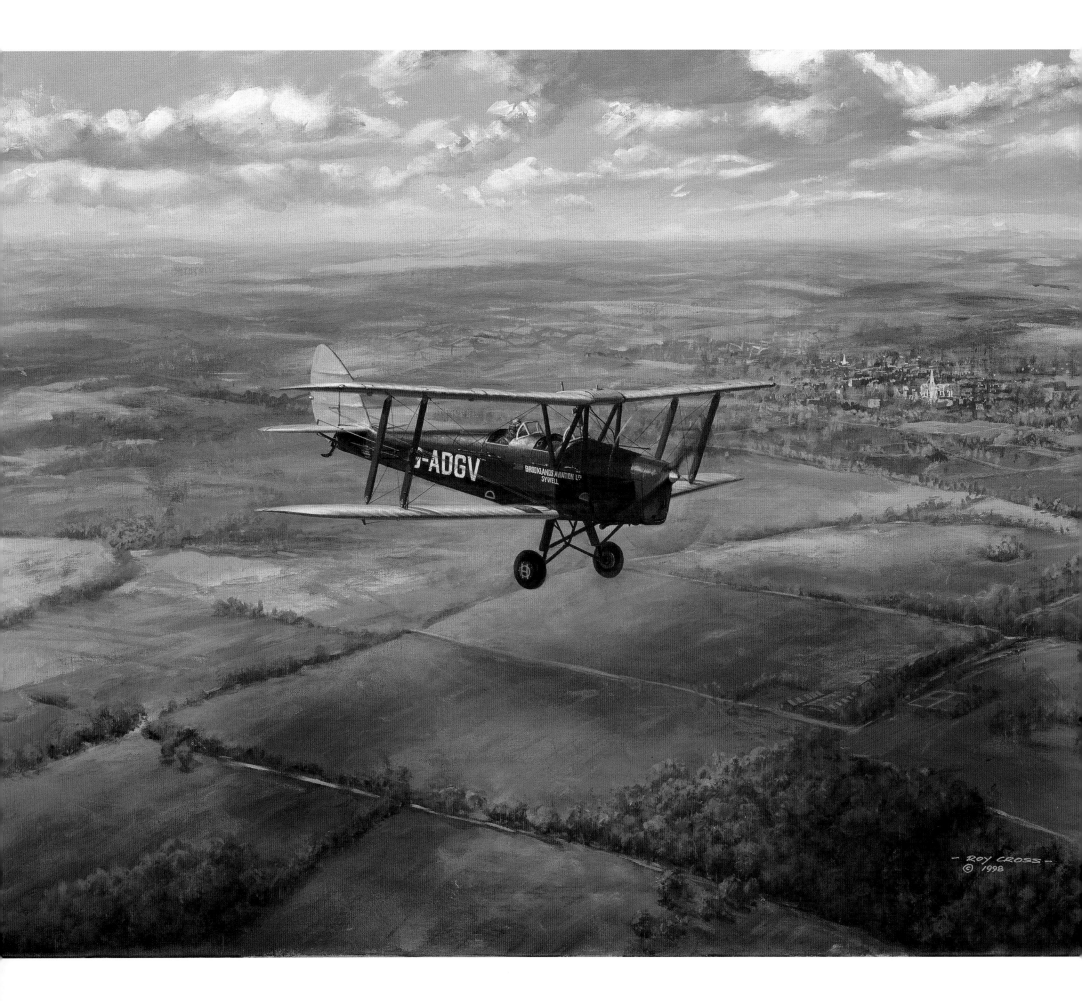

In Britain, club flying and civilian instruction were epitomized by the famous de Havilland Moth and Gipsy Moth two-seaters of the 1920s and 1930s, the latter model introducing the superb Gipsy four-cylinder air-cooled in-line engine of 100–120 hp. Both models served with the RAF (and abroad) as elementary trainers, and in 1931 an RAF specification (23/31) for a revised version for *ab initio* training with full dual controls was issued. By bringing the top wing centre section with its supporting struts forward, access to the front cockpit was improved. The resulting backward sweep of the wings was a lasting characteristic of what came to be the Tiger Moth standard RAF trainer, many civilian examples of which are still flying today. Its contribution to the war effort cannot be exaggerated for the majority of British and Commonwealth pilots started their training on the type. Only the advent of the de Havilland Chipmunk finally replaced it in service use in the mid-1950s.

LEFT: A post-war Tiger Moth in the distinctive colours of Brooklands Aviation Ltd at Sywell.

Key
RIGHT: The Tiger Moth's rear cockpit fitted up for night flying. A, airspeed indicator; B, altimeter; C, position for spirit level, actually not installed on this particular machine; D, turn and bank indicator; E, rpm; F, fuel-pressure gauge; G, compass; H, speaking-tube mouthpiece; I, dash floodlight; J, dimmer switch for floodlight; K, Morse light tapping key; L, flare release button; M, wing tip flare and navigation light switches; N, locking lever for auto-slots, shown in unlocked position; O, electrical panel; P, stick; Q, rudder pedals; R, bag for course and height indicator; S, seat; T, longitudinal trim lever; U, throttle and altitude levers; V, fuel cock; W, front seat; X, side panels hinged down for entrance and exit.

BELOW: An exterior view of the rear cockpit, with the folded blind-flying hood (2) and the catch which keeps the hood in the closed position (1). 3, elastic hood-retaining cord; 4, pilot pulls on this strap when in flight to close hood; 5, engine switches.

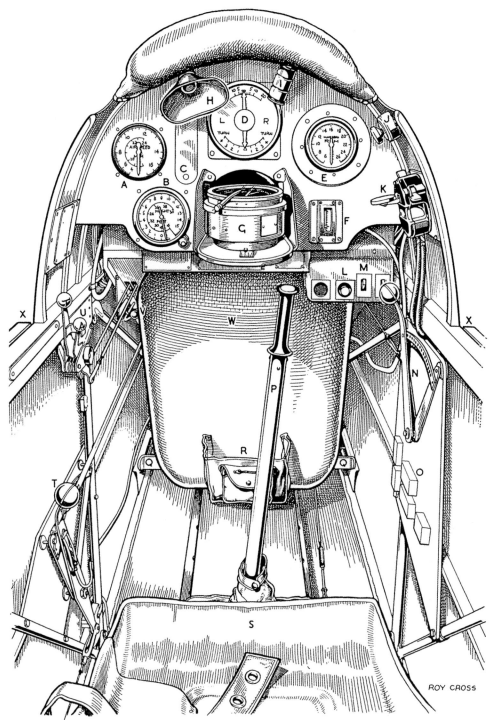

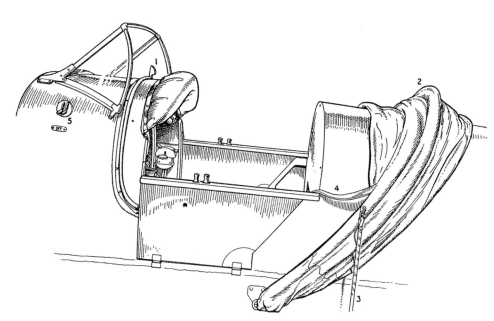

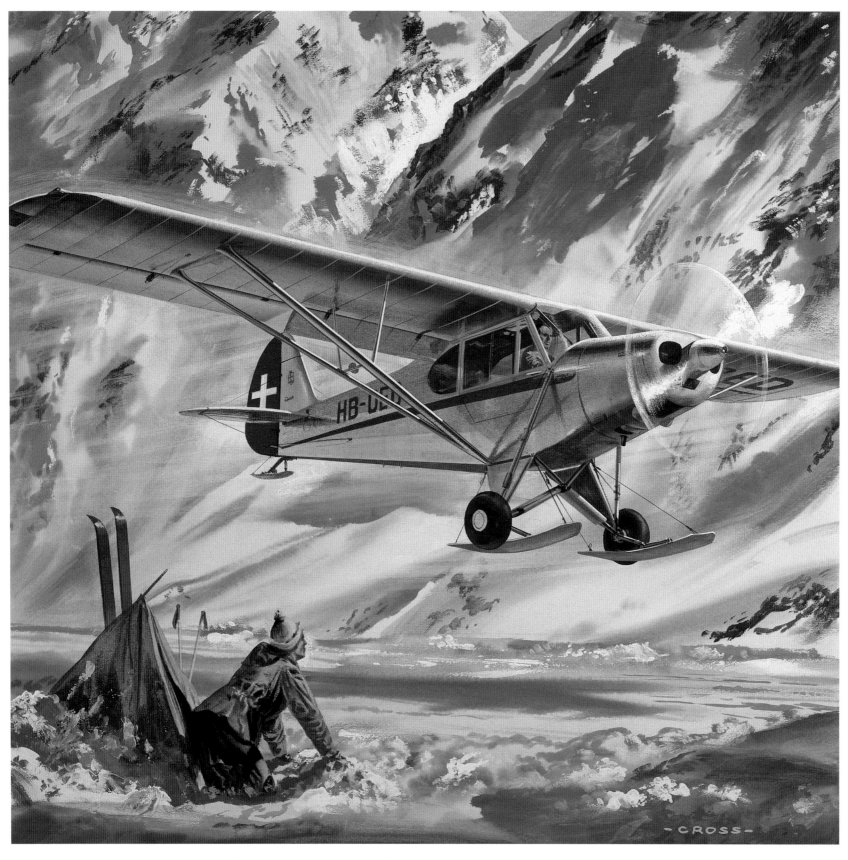

FAIREY REED
FIXED PITCH
METAL AIRSCREW

SILENCER
CABIN HEA

During the war, light plane manufacturers had lent all their efforts to production for the military, and after the war firms like Taylorcraft and Piper in the USA and Auster in Britain quickly adapted their products for the civilian market. ABOVE: The PA-18 Super Cub. RIGHT: The Auster B.4 ambulance-freighter. Both had their roots back with the Taylor Brothers Aircraft Corporation in the 1920s and their $4,000 Chummy.

THE AUSTER B.4 AMBULANCE/FREIGHTER
(One 180 b.h.p. Blackburn Cirrus Bombardier)

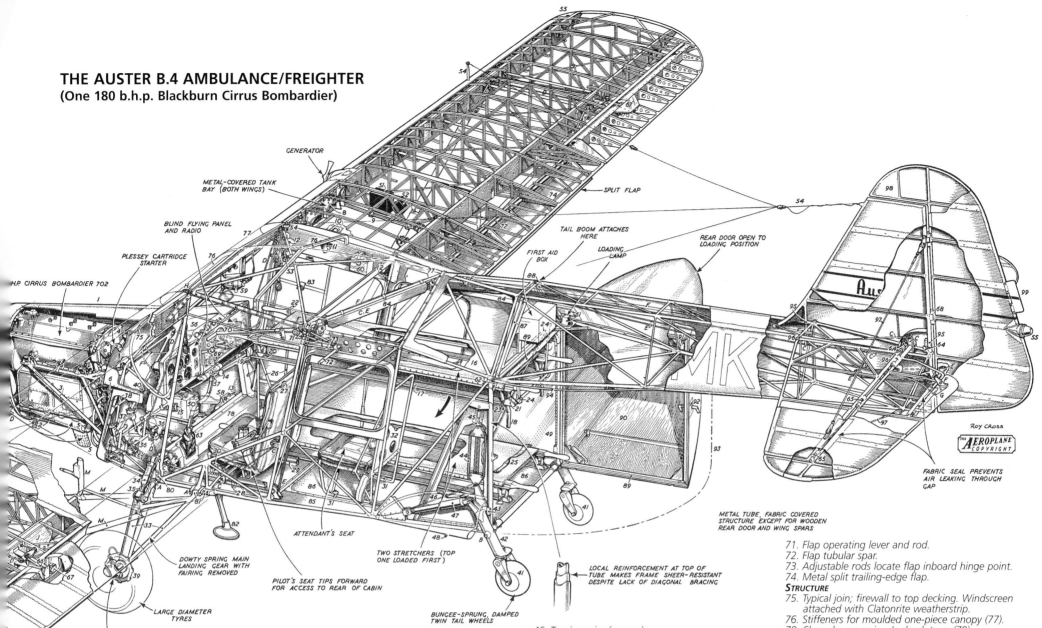

Roy Cross

THE AEROPLANE COPYRIGHT

Key

POWERPLANT

1. Top and front cowling panels not normally removed for routine maintenance.
2. Side panels (one each side) quickly detachable, anchored to bottom beam by King fasteners.
3. Tube engine mounting with rubber damping at engine attachments and four-point fix to main frame at firewall.
4. Unit-built BTH twin magnetos.
5. Fresh air in through front tube which passes through exhaust manifold. Heated air carried up rubber duct, through firewall on to baffle plate, into cabin. Exhaust stub perforated to subdue noise.
6. Hot-pot oil tank on front face of firewall.
7. Oil cooler beneath floor.
8. Fuel tanks (both sides) slung from supports enclosed by bottom cover secured at (9).
10. Small window gives light on to contents gauge (set in tank) which is seen from cabin through window (11).
12. Fuel lines from starboard wing to non-return valve (13).
14. Push-pull throttle.
15. Cartridge starter trigger – pull to fire. Next cartridge is not selected until trigger is clipped back into socket.

STRETCHERS, ACCOMMODATION

16. Top stretcher loaded first by lowering channel (17) on to legs (18) about fixed hinged point (19). Trolley (20) runs down to aft end of channel, and into it is fitted front legs of stretcher, which is then slid easily forward until aft legs engaged in bracket (21). Stretcher is retained by stops (22) and pin (23) and then swung up to hook on to hinged frame (24), which stows in roof when not used.
25. Bottom stretcher is then loaded in similar fashion.
26. Stretcher end frame.
27. Operate this lever on pilot's seat to withdraw pins from brackets (28) and tip seat forward for access to rear cabin.
29. Seat slides on rails, is adjustable fore and aft by disengaging plunger (30).
31. Easily removed 'Pip'-pins secure rear seat(s) to floor.
32. Seat structure steel tube and 20-g sheet.

LANDING GEAR, BRAKES

33. Tube truss leg hinged at points (A).
34. Dowty liquid spring.
35. Tension link.
36. Heel brake pedals.
37. Brake fluid reservoirs connected to fixed top crosstube (38).
39. Goodyear single disc brake.
40. Cable from parking brake branches off to brake reservoirs.
41. Castoring tail wheels.
42. Tail wheel leg pivots above (B).
43. Buffer.
44. Bungee springing.
45. Check cable.
46. Tension wire (sprung).
47. Damper.
48. Fairing blister (ghosted).
49. Hinged interior inspection panel.

GENERAL EQUIPMENT

50. Easily removed accumulator housing incorporates master switch and fuse panel.
51. Cutout and voltage regulator.
52. Suppressor.
53. Dash light.
54. Radio masts, aerial, and cabin lead-in.
55. Navigation lights. (Down light beneath front fuselage).
56. Dash carries blind flying panel and radio.
57. Radio button on stick.
58. Fire extinguisher.
59. Compass.
60. Stowage, spare down light glasses.
61. Loading lamp with adjacent zip inspection panel.
62. Loading lamp switch.

FLYING CONTROLS

63. Control column.
C. Elevator run.
64. Elevator lever stops.
65. Elevator hinges.
D. Aileron run.
66. Aileron operating rod.
67. Aileron hinges.
E. Rudder run.
68. Rudder hinges.
69. Elevator trim lever on dash.
F. Elevator trim run.
70. Flap lever with thumb catch.
71. Flap operating lever and rod.
72. Flap tubular spar.
73. Adjustable rods locate flap inboard hinge point.
74. Metal split trailing-edge flap.

STRUCTURE

75. Typical join; firewall to top decking. Windscreen attached with Clatonrite weatherstrip.
76. Stiffeners for moulded one-piece canopy (77).
78. Shroud over main u/c shock truss (79).
80. Landing gear attachment bolted on to end of shock truss.
81. Landing gear rear pickup and wing strut attachment points.
82. Footstep (both sides).
83. Slide-down windows in both doors.
84. Control runs in cabin shrouded over.
85. Fixed side floor.
86. Metal-balsa sandwich floor quickly replaceable by special units for sky shooting, photography, etc.
87. Light metal angle fabric former.
88. Tail boom fixes at four points.
89. Rear door rubber seals.
90. Wooden rear door in loading position, retained by stay (91).
92. Rear door lock with safety catch.
93. Position of door when closed.
94. Light tubular fabric former.
95. Fin fixings.
96. Tailplane fixings.
97. Tail unit bracing rods.
98. Rudder mass balance.
99. Fixed trim tab.
G. Elevator trim tab adjustable from cabin.
H. Wing spar-fuselage pickup points.
I. Wooden front spar.
J. Local reinforcing on rear spar.
K. Tubular drag struts.
L. Cross bracing.
M. Wing struts and jury struts.
N. Bracing tape (between all ribs) prevents ribs from twisting.

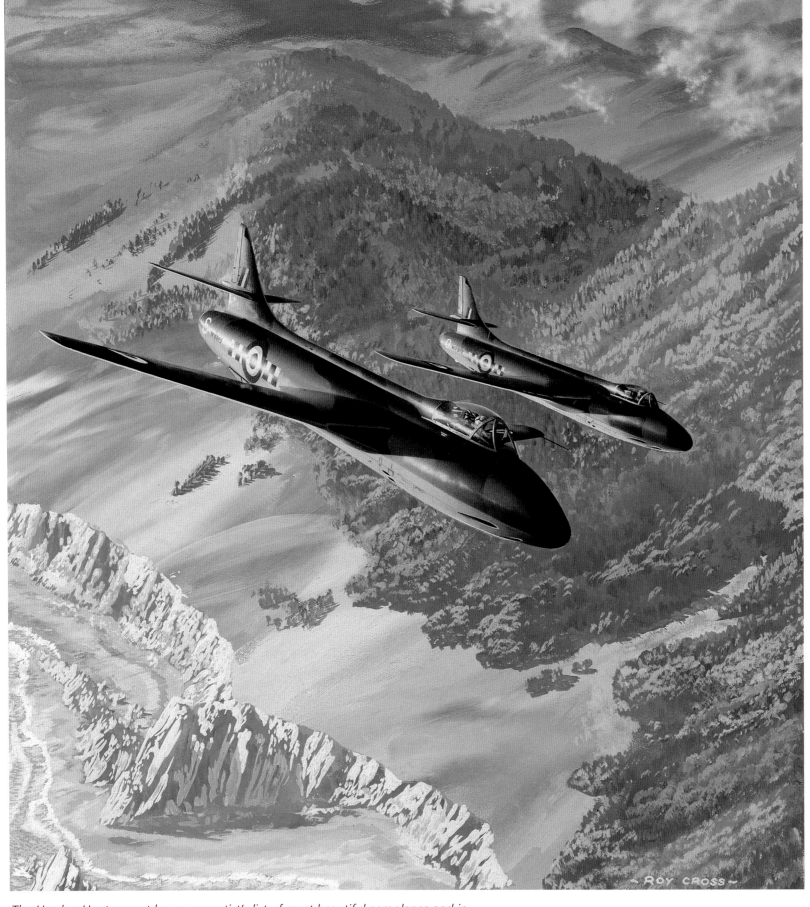

~Roy Cross~

The Hawker Hunter must be on any artist's list of most beautiful aeroplanes and in 1957 it had a personal significance because I was beginning to break into the lucrative advertising field with paintings like the one above, done for Hawker Aircraft Ltd and reproduced in the technical press. These are Hunter F Mk 1s of No. 43 Squadron 'the Fighting Cocks'.

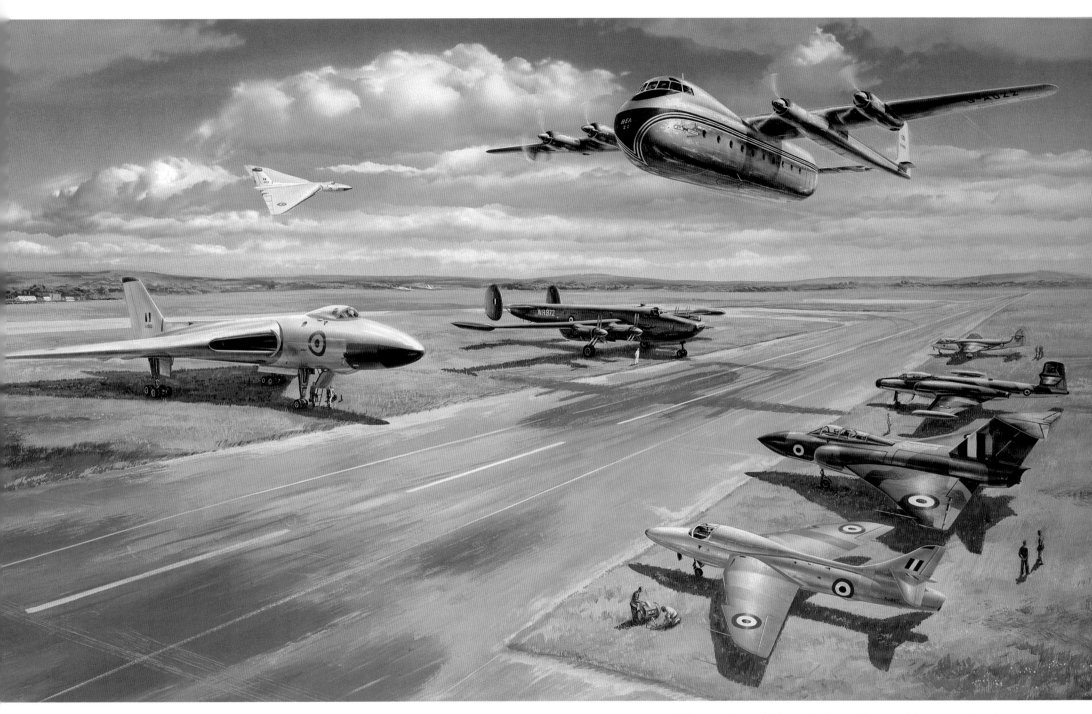

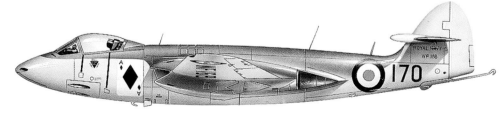

A double-page spread for Hawker Siddeley Aviation Ltd, comprising Avro, Hawkers, Armstrong Whitworth, Gloster and Folland aircraft as its main constituents.

TOP: the AW 650 Argosy transport: Middle row, the Avro Vulcan delta-wing bomber and the Avro Shackleton: Foreground, the Hunter two-seat jet trainer, the Gloster Javelin all-weather twin-engined fighter, the Avro–Canada CF 100 all-weather fighter and the Hawker Seahawk naval fighter.

LEFT: A Seahawk F Mk 1 of 806 Naval Air Squadron.

111

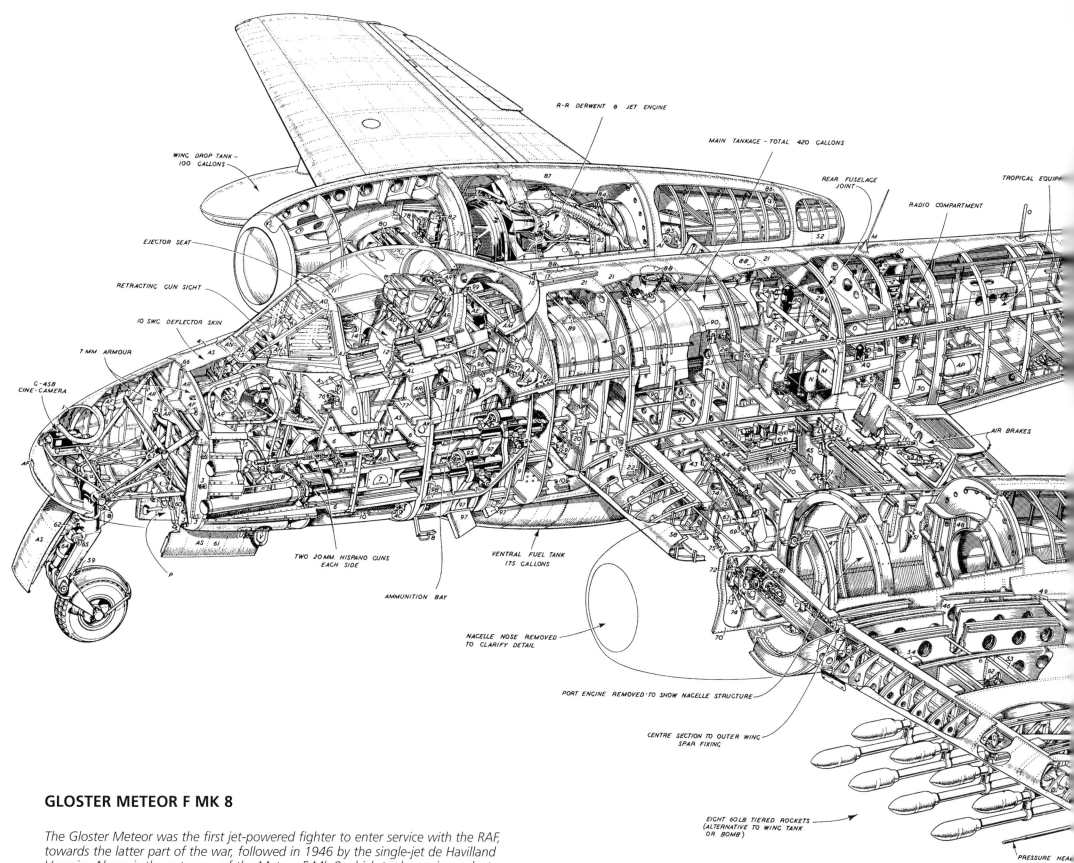

R-R DERWENT 8 JET ENGINE

MAIN TANKAGE - TOTAL 420 GALLONS

WING DROP TANK - 100 GALLONS

REAR FUSELAGE JOINT

TROPICAL EQUIPE

RADIO COMPARTMENT

EJECTOR SEAT

RETRACTING GUN SIGHT

10 SWG DEFLECTOR SKIN

7 MM ARMOUR

G-45B CINE-CAMERA

AIR BRAKES

TWO 20 MM. HISPANO GUNS EACH SIDE

VENTRAL FUEL TANK 175 GALLONS

AMMUNITION BAY

NACELLE NOSE REMOVED TO CLARIFY DETAIL

PORT ENGINE REMOVED TO SHOW NACELLE STRUCTURE

CENTRE SECTION TO OUTER WING SPAR FIXING

EIGHT 60LB. TIERED ROCKETS (ALTERNATIVE TO WING TANK OR BOMB)

PRESSURE HEAI

GLOSTER METEOR F MK 8

The Gloster Meteor was the first jet-powered fighter to enter service with the RAF, towards the latter part of the war, followed in 1946 by the single-jet de Havilland Vampire. Above is the cut-away of the Meteor F Mk 8 which took me six weeks to complete and in part persuaded me that colour renderings perhaps in advertising might be more rewarding!

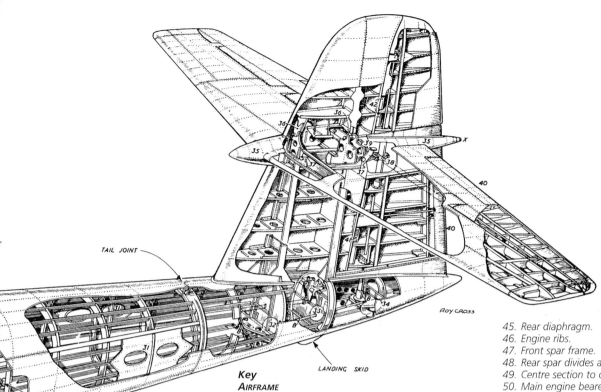

TAIL JOINT

G 4F COMPASS TRANSMITTER

LANDING SKID

Roy CROSS

AUTO BALANCE TAB

DETACHABLE TIP

Key

AIRFRAME

1. Camera gun access door.
2. Tubular nosewheel support.
3. Fixings allow complete nose to be removed.
4. Access panels to rear of instruments.
5. Nosewheel housing between rudder pedals.
6. Horizontal gun diaphragms.
7. Footstep and access to trimmer pulley.
8. Retractable footstep.
9. Rear gun-mounting diaphragms.
10. Front fuselage bottom spar.
11. Sandwich-section canopy with dry-air space to prevent misting.
12. Sliding-canopy rails.
13. Frameless bullet-resisting windscreen with dry-air space.
14. Canopy-winding electric motor.
15. Rear canopy-retaining shoe.
16. Release lever disengages rear trolley from rail. (17), enables canopy to be raised and propped on jury strut for access to magazine bay.
18. Top longeron front fix.
19. Magazine frames have vertical rails down into which ammunition boxes are slid and retained by plungers in sockets.
20. Front-tank support beam.
21. Fuel compartment covers.
22. Front spar attachment to bulkhead.
23. Main-tank support beams.
24. Centre section bottom longeron.
25. Centre section to rear fuselage lower fix.
26. Rear spar fix to centre section rear bulkhead (27).
28. Centre section to rear fuselage upper fix.
29. Radio shelf.
30. Manhole for access to radio compartment.
31. Rudder and elevator control run access panels.
32. Elevator and rudder trimmer cables access panel.
33. Elevator lever access panel.
34. Rudder lever access panel.
35. Detachable front and rear torpedo fairing.
36. Top fin fixings.
37. Tailplane fixings.
38. Rudder master hinge and tubular spar.
39. Elevator stub spar.
40. Servo trim tabs.
41. Rudder adjustable mass balance weight.
42. Other rudder mass balance weights.
43. Root rib.
44. Undercarriage beam.

45. Rear diaphragm.
46. Engine ribs.
47. Front spar frame.
48. Rear spar divides around jet exhaust pipe.
49. Centre section to outer wing fix.
50. Main engine bearer in mounting frame.
51. Rear engine bearer.
52. Detachable nacelle tail portion.
53. Local stiffening for tanks or bombs.
54. Rocket front attachment points.
55. Rocket rear mounting beam.
56. Aileron and tab mass balance weights.
57. Access panel to tank bottoms.
58. Removable nosing.

UNDERCARRIAGE

59. Pad on nosewheel leg breaks door linkage (60) when retracting and closes wheel doors (61).
62. Link connects front door to leg.
63. Nosewheel retracting jack.
64. Damper absorbs landing shocks on nosewheel.
65. Picketing ring.
66. Nosewheel down indicator.
67. Main undercarriage pivot.
68. Retracting jack.
69. Downlock.
70. Undercarriage doors.
71. Door-locking linkage.
72. Linkage prevents retraction until aircraft is airborne.
73. Uplock roller.
74. Door closing links.
75. Front and side stays.

ENGINE

76. Throttle and (77) linkage to engine at (78).
79. Engine oil tank and filler.
80. Starboard gearbox with generator, vacuum pump and hydraulic pump.
81. Port gearbox with generator, vacuum pump and compressor.
82. Starter.
83. Fire extinguisher ring.
84. Engine rear steady mounting.
85. Gun-heating duct (both sides).
86. Jetpipe suspension link.
87. Removable covers give access to engine.

FUEL

88. Three filler caps.
89. Tank sling point.
90. Tank retaining straps.
91. Ventral tank release.
92. Wing drop-tank release.

ARMAMENT

93. Gun front mounting.
94. Gun rear mounting.
95. Ammunition chutes and feed mechanism.

96. Ammunition boxes (two above, two below).
97. Case and link ejection chutes and airflow deflators.
98. Frame for main access panel to guns.
99. Ammunition loading ramp.

CONTROLS

A. To elevator.
B. To rudder.
C. To ailerons.
D. For auto balance tab.
E. Landing flap.
F. Flap jack and operating arm.
G. Pulley & coupler cables sychronize flaps.
H. One of two air-brake operating jacks on port side. Outboard jack omitted to show flap gear.
I. Crosshead trolley on guide rails opens or closes air brakes.
J. Channel strut connects crosshead with synchronizing pulleys (K) and coupler cables (L) to starboard airbrake installation.

RADIO AND ELECTRICAL

M. TR.1430 transmitter-receiver and aerial.
N. Power unit type 16.
O. A.R.I.5131 IFF set and aerial.
P. Accumulators.
Q. Interior lamp for radio compartment.
R. Coloured identification lamps.
S. Starter panel.
T. Fuse panel.
U. Ground-starter plug-in.
V. Ground-flight switch.
W. Landing lamp.
X. Navigation lamp.
Y. Recognition lamps.
Z. DR compass control panel.

SYSTEMS, MISCELLANEOUS

AA. Oxygen bottles.
AB. Oxygen economizer.
AC. Oxygen charging valve.
AD. Emergency oxygen bottle in dinghy pack.
AE. Hydraulic-fluid reservoir.
AF. Cold-air intake.
AG. Pressure system ground-test connection.
AH. Hot-air pipe to windscreen.
AI. Ducts (one each side of engine) carry cabin pressure air from heater muff.
AJ. Inflatable hood seal.
AK. Stale-air extractor.
AL. Silica-gel (dry-air anti-misting) containers for wind screen and (AM) canopy.
AN. De-icing spray for windscreen.
AO. Electrically heated panels.
AP. Pneumatic air bottle.
AQ. Fire extinguisher bottles.

ARMOUR PROTECTION

AR. 7 mm armour plate.
AS. 10 swg deflector skin.

Note: Underwing load shown in drawing is hypothetical. Normal underwing stores would be symmetrical, i.e. rockets, bombs or tanks each side.

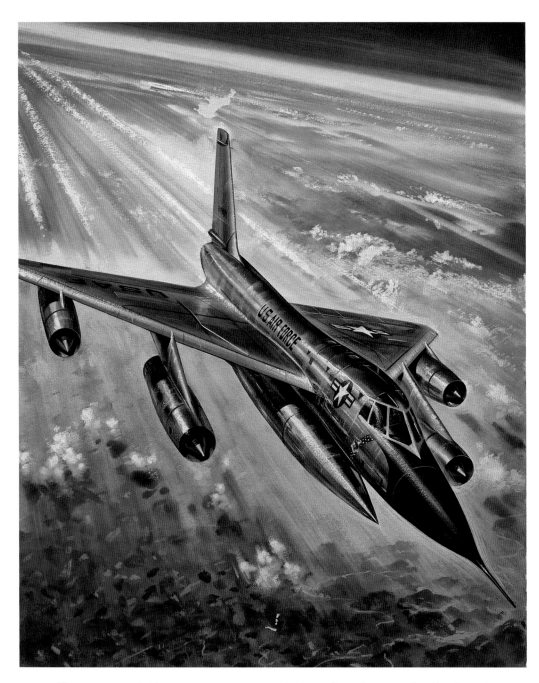

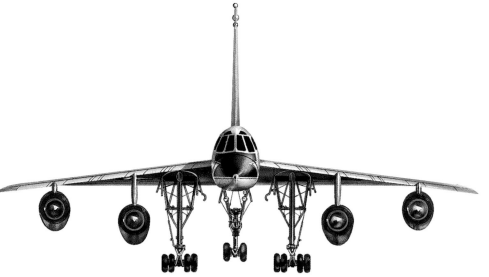

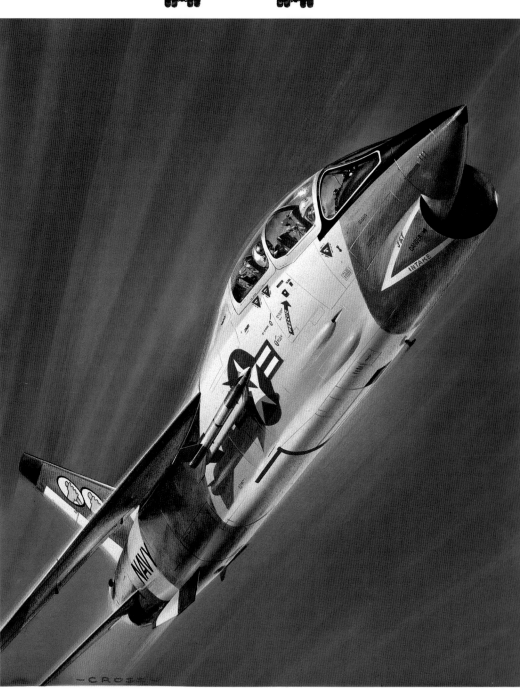

These two paintings were among a whole series of covers for the boys' paper *Swift*. The brief called for exciting images but obviously no blood and thunder. The 1960s and 1970s was a fascinating time for plane-watchers, with cold hostility between the West and the Soviet Bloc spurring competitive design and performance ever onwards; many of these aeroplanes featured on the *Swift* covers.

ABOVE: not long after the successful Bell X-1 flights the USAF was already thinking in terms of a supersonic bomber, one result being the Convair B-58 Hustler with Mach 2 performance. The advanced structure and aerodynamics led to flight characteristics which were labelled as unusual and relatively few reached service. Interestingly, ideas were broached for a supersonic airliner derivative seating 52 passengers. A front view (TOP RIGHT) reveals some of the design peculiarities.

RIGHT: The original Chance Vought F8U Crusader was the first carrier-borne super-sonic fighter when it flew in 1955. This is the prototype two-seater TF-8A trainer version, a variant of which was offered to the British who instead chose the McDonnell Phantom.

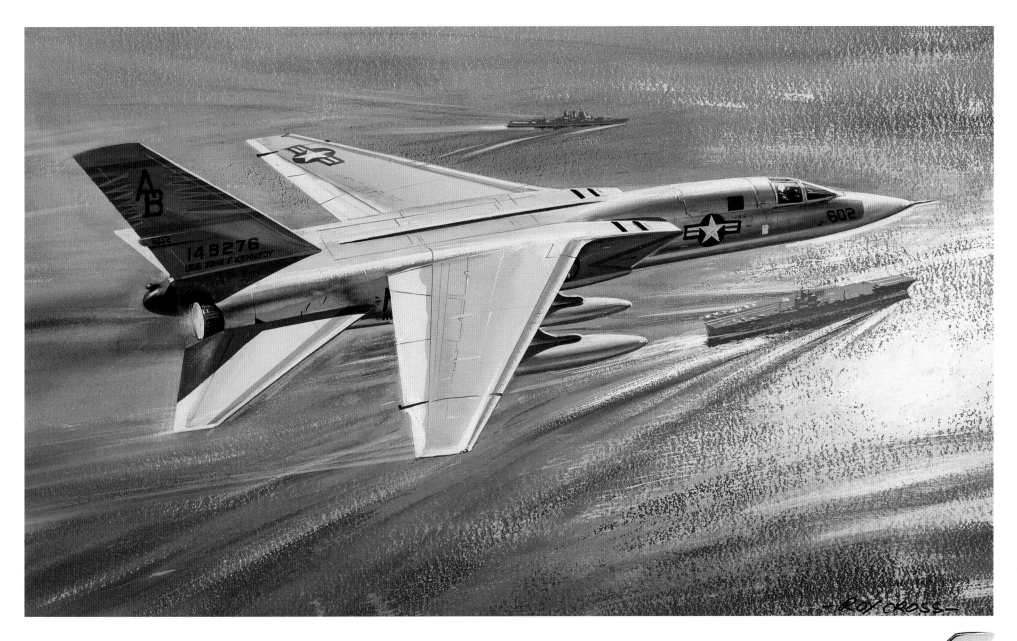

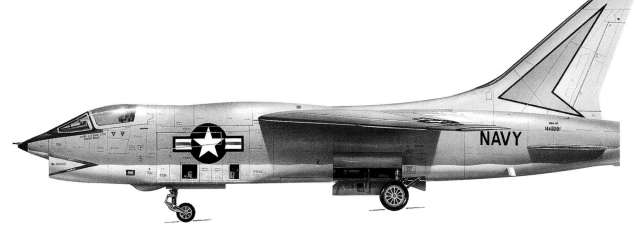

ABOVE: Even more visionary for a carrier-borne type was the swept-wing North American Vigilante twin-jet strike/reconnaissance aircraft of 1958. The bomb delivery system envisaged seems unique for the time. A long bomb/equipment bay was sandwiched between the side-by-side engine installations. The bomb itself was attached to fuel tanks, the contents of which would be used first and were jettisoned rearwards still attached to the bomb upon release via the detachable tail cone. A Mach 2 capability was built in on production versions.

RIGHT: The F8U-1P photo-reconnaissance version of the Crusader.

THE CONVAIR 880 MODEL 22
Four 11,200-lb st General Electric CJ-805-3 Turbojets

Howard Hughes was behind the design of the Convair 880, originally intended for TWA. It lost out to competition from the Boeing 707 and Douglas DC-8 and not enough were built, or of the improved Coronado, to break even.

Key

CONTROL SURFACES
1. Outboard spoilers.
2. Inboard spoilers. Spoilers also act as air brakes.
3. Spoiler actuating jacks give 60° maximum spoiler extension.
4. Servo-tab-operated inboard ailerons, interconnected with spoilers.
5. Aileron trim tab.
6. Aileron servo tab.
7. Double-slotted inner and outer flaps.
8. Flap-extension rails.
9. Flap gearbox and screw jack.
10. Flap torque tube and gearboxes.
11. Servo-tab-operated elevators have steel counter-weight mass balances for flutter prevention.
12. Elevator servo tab.
13. Tailplane has 2° upwards and 14° downwards trim movement.
14. Tailplane pivot point.
15. Tailplane screw-jack mechanism.
16. Tailplane halves joint.
17. Stainless-steel leading edge.
18. Leading-edge electrical heating strips (anti-icing).
19. Servo tab-operated mass-balanced rudder.
20. Rudder servo tab.
21. Rudder trim tab.

POWERPLANT
22. General Electric CJ-805-3 turbojet.
23. Accessory gearboxes.
24. Thrust reverser with fairing doors.
25. Silencer.
26. Detachable nose cowl.
27. Stainless-steel firewall.
28. Main engine mounting.

29. Engine support yoke.
30. Front engine mounting.
31. Front engine brace connection to wing.
32. Rear engine brace incorporating top main engine mounting.
33. Stainless-steel/titanium top panel acts as fire wall to isolate pod from wing in case of fire.
34. Hinged panels give complete access to engine, latched together along bottom edges.
35. Main pod support-box beam.
36. Pod box beam to front-spar pick-up.
37. Engine controls cable run.
38. Engine control pylon torque box.
39. Power control and fuel shut-off torque box.
40. Reverse thrust-actuating jack.
41. Engine-start/fuel shut-off controls.
42. Power and reverse-thrust controls.
43. Fire-extinguisher nozzles.
44. Fire extinguisher bottle.
45. Fire-detector control.
46. Outer replenishment fuel tank (all tanks integral, formed by sealed wing structure).
47. Outer main tank.
48. Fuel tank well.
49. Inner replenishment tank.
50. Inner main tank.
51. Flush vent scoop under wing.
52. Vent valve.
53. Fuel jettison pipes.

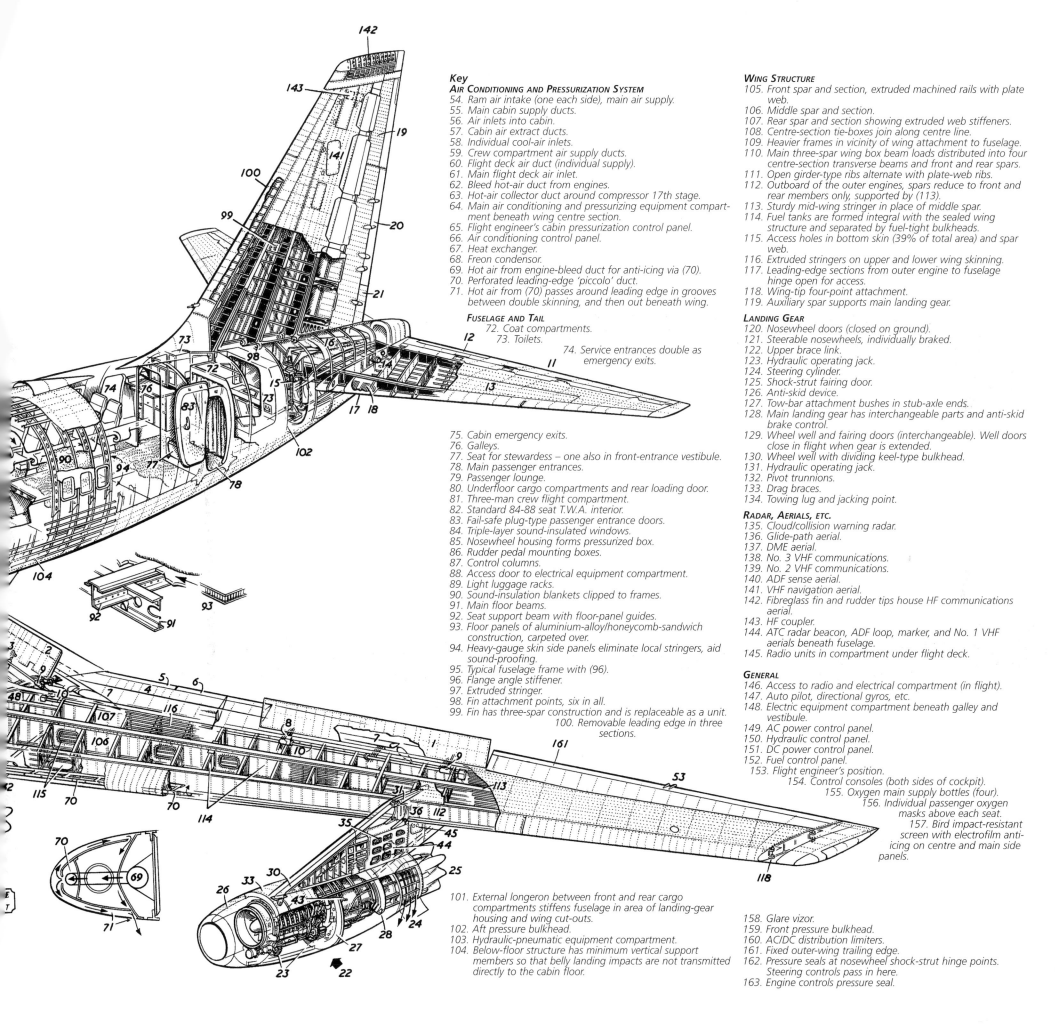

Key

Air Conditioning and Pressurization System

54. Ram air intake (one each side), main air supply.
55. Main cabin supply ducts.
56. Air inlets into cabin.
57. Cabin air extract ducts.
58. Individual cool-air inlets.
59. Crew compartment air supply ducts.
60. Flight deck air duct (individual supply).
61. Main flight deck air inlet.
62. Bleed hot-air duct from engines.
63. Hot-air collector duct around compressor 17th stage.
64. Main air conditioning and pressurizing equipment compartment beneath wing centre section.
65. Flight engineer's cabin pressurization control panel.
66. Air conditioning control panel.
67. Heat exchanger.
68. Freon condensor.
69. Hot air from engine-bleed duct for anti-icing via (70).
70. Perforated leading-edge 'piccolo' duct.
71. Hot air from (70) passes around leading edge in grooves between double skinning, and then out beneath wing.

Fuselage and Tail

72. Coat compartments.
73. Toilets.
74. Service entrances double as emergency exits.
75. Cabin emergency exits.
76. Galleys.
77. Seat for stewardess – one also in front-entrance vestibule.
78. Main passenger entrances.
79. Passenger lounge.
80. Underfloor cargo compartments and rear loading door.
81. Three-man crew flight compartment.
82. Standard 84-88 seat T.W.A. interior.
83. Fail-safe plug-type passenger entrance doors.
84. Triple-layer sound-insulated windows.
85. Nosewheel housing forms pressurized box.
86. Rudder pedal mounting boxes.
87. Control columns.
88. Access door to electrical equipment compartment.
89. Light luggage racks.
90. Sound-insulation blankets clipped to frames.
91. Main floor beams.
92. Seat support beam with floor-panel guides.
93. Floor panels of aluminium-alloy/honeycomb-sandwich construction, carpeted over.
94. Heavy-gauge skin side panels eliminate local stringers, aid sound-proofing.
95. Typical fuselage frame with (96).
96. Flange angle stiffener.
97. Extruded stringer.
98. Fin attachment points, six in all.
99. Fin has three-spar construction and is replaceable as a unit.
100. Removable leading edge in three sections.
101. External longeron between front and rear cargo compartments stiffens fuselage in area of landing-gear housing and wing cut-outs.
102. Aft pressure bulkhead.
103. Hydraulic-pneumatic equipment compartment.
104. Below-floor structure has minimum vertical support members so that belly landing impacts are not transmitted directly to the cabin floor.

Wing Structure

105. Front spar and section, extruded machined rails with plate web.
106. Middle spar and section.
107. Rear spar and section showing extruded web stiffeners.
108. Centre-section tie-boxes join along centre line.
109. Heavier frames in vicinity of wing attachment to fuselage.
110. Main three-spar wing box beam loads distributed into four centre-section transverse beams and front and rear spars.
111. Open girder-type ribs alternate with plate-web ribs.
112. Outboard of the outer engines, spars reduce to front and rear members only, supported by (113).
113. Sturdy mid-wing stringer in place of middle spar.
114. Fuel tanks are formed integral with the sealed wing structure and separated by fuel-tight bulkheads.
115. Access holes in bottom skin (39% of total area) and spar web.
116. Extruded stringers on upper and lower wing skinning.
117. Leading-edge sections from outer engine to fuselage hinge open for access.
118. Wing-tip four-point attachment.
119. Auxiliary spar supports main landing gear.

Landing Gear

120. Nosewheel doors (closed on ground).
121. Steerable nosewheels, individually braked.
122. Upper brace link.
123. Hydraulic operating jack.
124. Steering cylinder.
125. Shock-strut fairing door.
126. Anti-skid device.
127. Tow-bar attachment bushes in stub-axle ends.
128. Main landing gear has interchangeable parts and anti-skid brake control.
129. Wheel well and fairing doors (interchangeable). Well doors close in flight when gear is extended.
130. Wheel well with dividing keel-type bulkhead.
131. Hydraulic operating jack.
132. Pivot trunnions.
133. Drag braces.
134. Towing lug and jacking point.

Radar, Aerials, etc.

135. Cloud/collision warning radar.
136. Glide-path aerial.
137. DME aerial.
138. No. 3 VHF communications.
139. No. 2 VHF communications.
140. ADF sense aerial.
141. VHF navigation aerial.
142. Fibreglass fin and rudder tips house HF communications aerial.
143. HF coupler.
144. ATC radar beacon, ADF loop, marker, and No. 1 VHF aerials beneath fuselage.
145. Radio units in compartment under flight deck.

General

146. Access to radio and electrical compartment (in flight).
147. Auto pilot, directional gyros, etc.
148. Electric equipment compartment beneath galley and vestibule.
149. AC power control panel.
150. Hydraulic control panel.
151. DC power control panel.
152. Fuel control panel.
153. Flight engineer's position.
154. Control consoles (both sides of cockpit).
155. Oxygen main supply bottles (four).
156. Individual passenger oxygen masks above each seat.
157. Bird impact-resistant screen with electrofilm anti-icing on centre and main side panels.
158. Glare vizor.
159. Front pressure bulkhead.
160. AC/DC distribution limiters.
161. Fixed outer-wing trailing edge.
162. Pressure seals at nosewheel shock-strut hinge points. Steering controls pass in here.
163. Engine controls pressure seal.

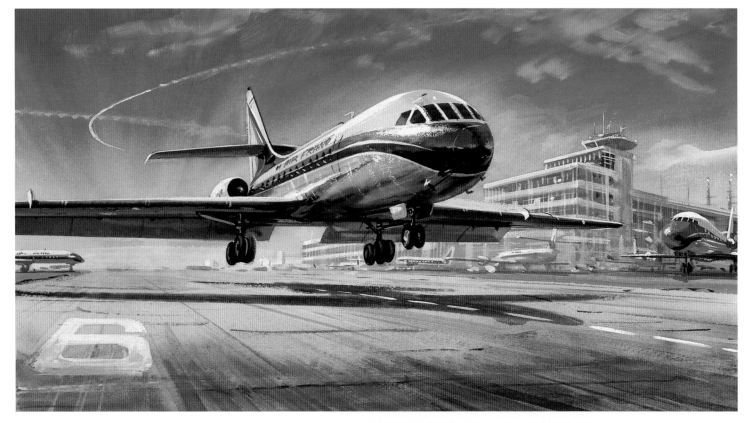

Opposite:
The shapely Handley Page Jetstream twin-turboprop light passenger/ executive transport was also used as a service pilot-crew trainer and communications aircraft.

These are two examples of coloured roughs to be presented to the client, in this case Airfix, for approval before progressing to the finished artwork. They are fairly detailed to forestall later alterations, and are sometimes more highly thought of than the more deliberate final painting!

Above: Production of the SE 210 Caravelle medium-range jet airliner was shared by many components of the French aircraft industry in the mid-1950s and the prototypes borrowed complete de Havilland Comet nose sections to hurry the project forward!

Right: the Vickers VC-10 employed the same rear fuselage-mounted configuration as the Caravelle, which cleared the swept-back wing for the optimum lift potential for good airfield performance demanded by BOAC's varied landing facilities on its worldwide routes. It was soon improved for transatlantic service and ordered by the RAF as a strategic transport, troop carrier and in-flight refuelling tanker.

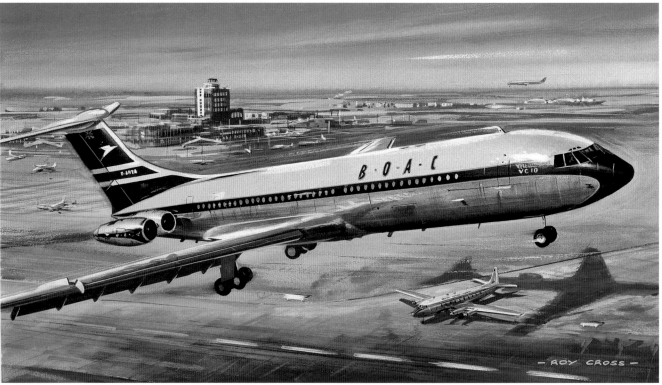

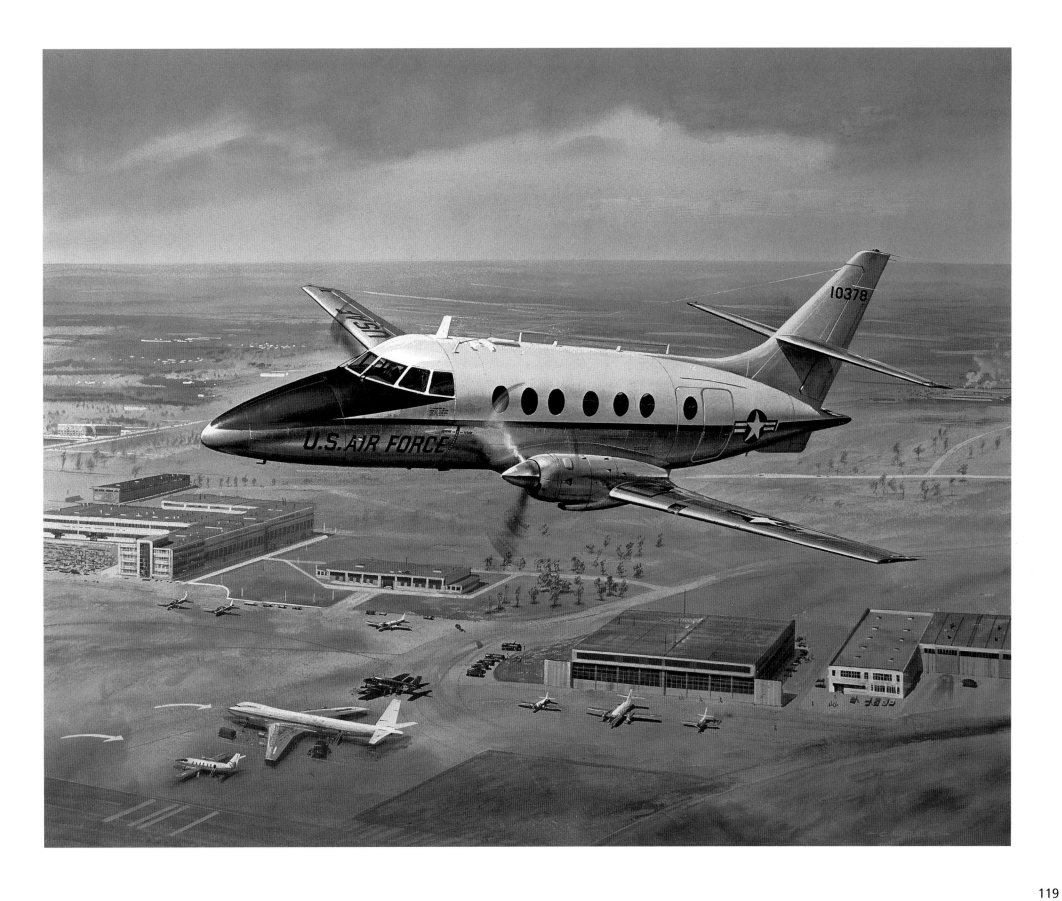

119

BRISTOL 188

Key

1. Hatch to forward instrument compartment.
2. Front pressure bulkhead.
3. Metal canopy with flat toughened-glass panels; glass with greater heat resistance to be used later in test programme.
4. Martin-Baker ejection seat.
5. Inner skin to cockpit area forms pressure-tight compartment.
6. Cockpit aft pressure bulkhead.
7. Nosewheel retracts forward.
8. Hatch to main pressurized test-instrument compartment; information is recorded in flight and also telemetered to ground stations.
9. Electrics panels.
10. Ducting for ventilation/refrigeration system.
11. Fuselage structure of 'puddle-welded' skin-stringer-frame construction in stainless steel. Practically the whole airframe is of stainless steel to withstand temperatures up to 280°C in high-speed flight.
12. Fuel tank compartment floor acts as stiffener against fuselage torsional stresses.
13. Service lines and ventilation system piping below fuel tank compartment floor.
14. Access panels to (13).
15. Central 27ft long keel stiffener in vicinity of main undercarriage doors and access panel cutouts.
16. Slight fuselage waisting opposite engine nacelles for area-rule aerodynamics.
17. Service lines grouped on central diaphragm/keel assembly to provide room for retracted main wheels.
18. Austenitic stainless-steel pipe for hydraulic system, which operates undercarriage, flaps, air brakes and power controls.

19. Undercarriage main legs hinge at point adjacent to wing/nacelle joint (see detail).
20. Main undercarriage legs retract inwards, occupy full depth of wing.
21. Wheels pivot about shock struts, possibly in manner shown here, to retract inside the limited fuselage cross-sectional area.
22. Fuel tanks take up a large part of the fuselage space from well forward of the wing to well aft; fuel is used as a heat sink for equipment cooling.
23. Light alloy used for fuselage bulkheads cooled by contact with fuel.
24. Main wing spar structure passes right through fuselage.
25. Cascade-type air brakes open outwards from rear fuselage.
26. Main fin members support all-moving tailplane.
27. Hinge-point for power-operated all-moving tailplane.
28. Two machined ribs of forged steel form strong central torsionally stiff structure at highly stressed portion of all-moving tailplane.
29. Outer tailplane structure similar to wing structure, with multiple webs.
30. Fixed fin with 65° leading-edge sweep.
31. Constant-chord rudder.
32. Stowage for braking parachute.

33. Powerplant nacelles are some 30ft in length.
34. Centre-body intake cone, initially fixed, but presumably to be replaced by variable-position cone for very high-speed trials.
35. Air intake ducting interchangeable for various experimental installations.
36. Inward-opening intake valves in cowling augment airflow to engine at low speeds and during ground running. They also act as spill flaps to maintain proper shock wave pattern during high-speed flight.
37. Strong local frame structure to support engine.
38. Local longitudinal members pick up with main engine mounts.
39. Access panel to engine, fuel-control equipment, etc.
40. De Havilland Gyron Junior DGJ.10 turbojet.
41. Long 2,000° K afterburner gives 200% thrust augmentation at Mach 2.5; engine/afterburner assembly is 25ft 6½in long.
42. Pneumatic operating jacks vary afterburner nozzle area.
43. Wing loads carried over each engine nacelle by three-piece cylindrical steel forgings with integrally machined frames, which are readily detachable from the wing structure to facilitate substitution of different size nacelles.
44. Nacelle structure ahead of integral steel barrels is of welded stainless-steel skin-stringer-frame construction.

45. Extra-strong local frame to support wing rear spar.
46. Modified bi-convex wing section 4% thick; maximum thickness is approximately 7 inches.
47. Main wing structural box formed by multiple spars.
48. Forged channel-section rear spar member takes main undercarriage retracting jack.
49. Ultra high-tensile steel (110-120 tons/sq in) forgings attached to ends of spar webs are inserted into 13 sets of slots each side of nacelle barrels and fixed chordwise bolts, forming main wing/nacelle attachments.
50. Spar end forging attached to spar web and bolted to surrounding skin (see detail).
51. Spar web construction with vertical currugations to minimize restraint of skin expansion following heating.
52. Sweepback of wing leading edges outboard of nacelles is 38°.
53. Outer wing spar box is swept back to conform with leading edge sweep.
54. Spanwise compressive stresses are caused by rapid heating of thin leading-edge skin which is stabilized only by multiple chordwise ribs.
55. Wing leading-edge fillet smooths flow at fuselage and nacelle junction.
56. Trailing-edge flaps between fuselage and nacelles.
57. All-moving wing tips are integral with ailerons and act as horn balances.
58. Aileron structure based on spanwise members.
59. Chordwise stiffeners for aileron tip.
60. Strong machined ribs and heavier skinning strengthen joint between aileron structural sections.
61. Power-control jack for aileron operations.

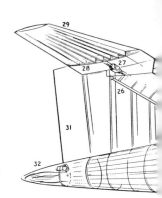

~ ROY CROSS S.M.A. ~

Key to Mirage

1. Nose radome. 2. Ferranti Airpass Mk IIC radar scanner. 3. Search display unit. 4. PAS display unit. 5. Radar controller, bombing computer. 6. Accelerometer and gyro unit. 7. Hand control unit. 8. Throttle. 9. Control column. 10. Martin-Baker Mk H.4 ejection-seat. 11. Side console. 12. Air conditioning control. 13. Guidance joystick for missiles. 14. Twin nose-wheel doors. 15. Aft nose-wheel door (also Doppler aerial). 16. Air intake with sliding bullet. 17. Operating jack and rails for automatic bullet. 18. Boundary layer bleed and spill. 19. Auxiliary slow-speed air intake. 20. Gun port. 21. Access to electrical equipment. 22. Radio/radar bay. 23. Air data, guns, and rockets computers. 24. Recuperator fuel tank for inverted flight. 25. Removable gun pack, interchangeable with rocket fuel tank or computer. 26. Main fuselage tanks. 27. Master gyro (Atar-Mirage). 28. Air ducts join. 29. Rolls-Royce Avon R.B.146 engine. 30. Engine gearbox unit. 31. Main fuselage frame. 32. Main engine bearer. 33. Afterburner. 34. Engine access panels. 35. Rear fuselage main frame. 36. Fin attachment points. 37. Tail parachute and anchorage. 38. Rudder operating-jack. 39. Yaw damper. 40 UHF aerial. 41. SEPR rocket pack. 42. Rocket tube. 43. Rocket fuel tank. 44. Rocket fuel pumps drive-shaft. 45. Conical camber on leading edge. 46. Outer elevon operating-jack and linkage. 47. Middle elevon operating-jack. 48. Inner elevon/trimmer operating-jack. 49. Rear fuselage double wall skinning. 50. Wing notch. 51. Integral fuel tank volume. 52. Main wing spar and attachment point. 53. Main undercarriage pivot point. 54. Undercarriage operating-jack. 55. Inner undercarriage door (closes when gear is down). 56. Air-brakes. 57. Air-brakes operating-jack. 58. Wing stores strong point. 59. Nord A.A. 20 missile. 60. Strong fuel-proof root-rib. 61. Under-wing drop-tank. 62. J.L.100 rocket/fuel pod. 63. Sidewinder AAM.

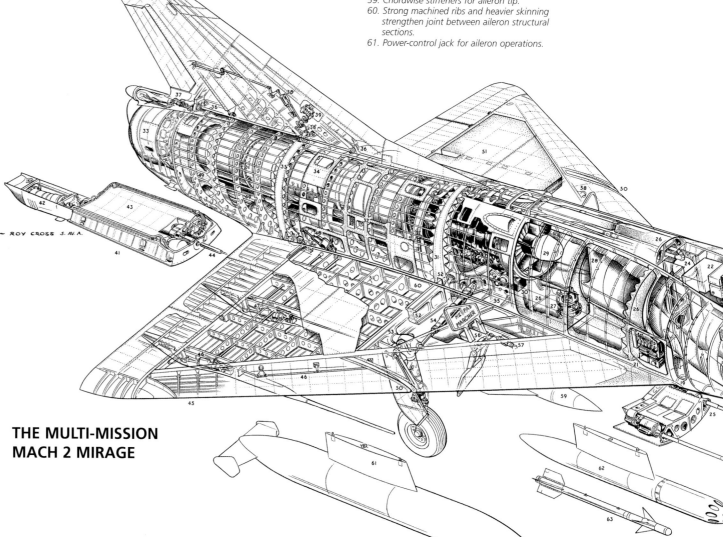

~ ROY CROSS S.AV.A. ~

THE MULTI-MISSION MACH 2 MIRAGE

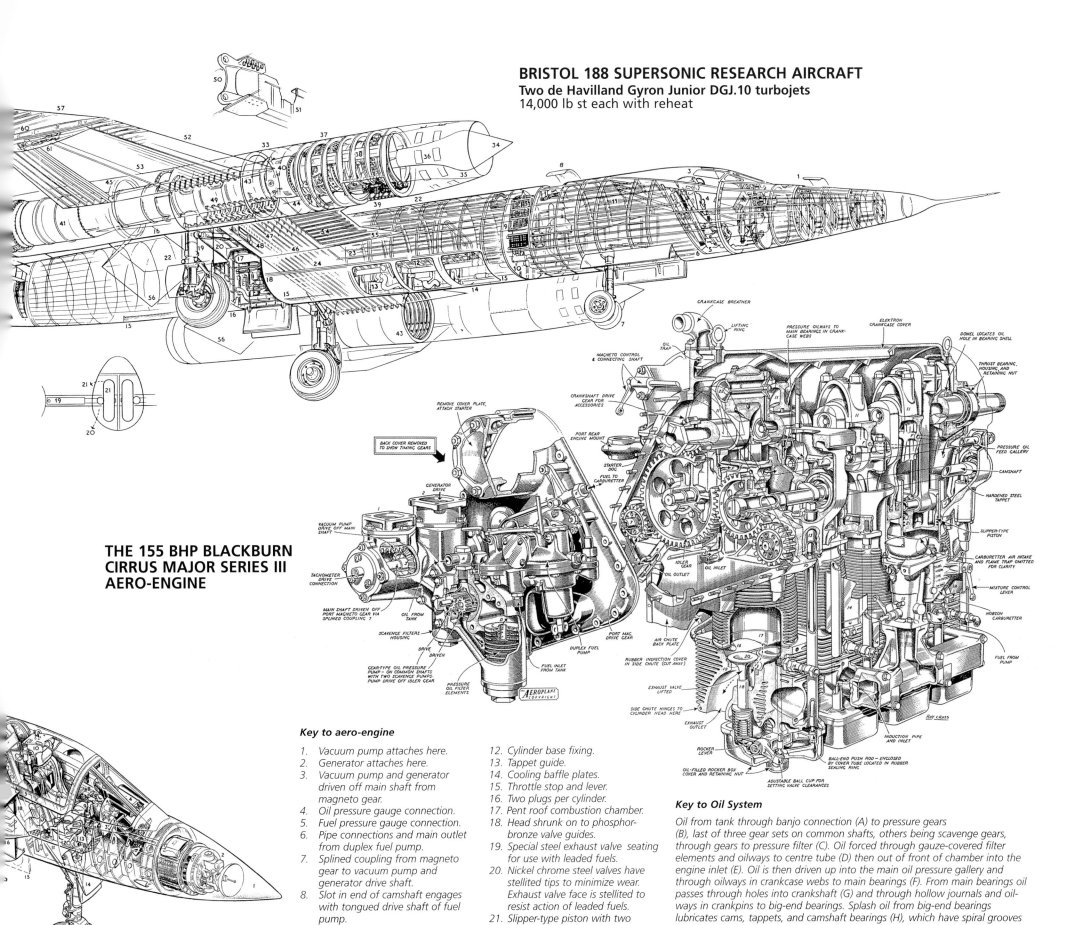

BRISTOL 188 SUPERSONIC RESEARCH AIRCRAFT
Two de Havilland Gyron Junior DGJ.10 turbojets
14,000 lb st each with reheat

THE 155 BHP BLACKBURN CIRRUS MAJOR SERIES III AERO-ENGINE

Key to aero-engine

1. Vacuum pump attaches here.
2. Generator attaches here.
3. Vacuum pump and generator driven off main shaft from magneto gear.
4. Oil pressure gauge connection.
5. Fuel pressure gauge connection.
6. Pipe connections and main outlet from duplex fuel pump.
7. Splined coupling from magneto gear to vacuum pump and generator drive shaft.
8. Slot in end of camshaft engages with tongued drive shaft of fuel pump.
9. Camshaft driving gear.
10. Starboard magneto and housing cut away to show crankcase interior.
11. Five bearing caps.
12. Cylinder base fixing.
13. Tappet guide.
14. Cooling baffle plates.
15. Throttle stop and lever.
16. Two plugs per cylinder.
17. Pent roof combustion chamber.
18. Head shrunk on to phosphor-bronze valve guides.
19. Special steel exhaust valve seating for use with leaded fuels.
20. Nickel chrome steel valves have stellited tips to minimize wear. Exhaust valve face is stellited to resist action of leaded fuels.
21. Slipper-type piston with two compression, one scraper, rings.
22. Dural oil retainers close crank shaft bore.
23. Camshaft thrust bearing.

Key to Oil System

Oil from tank through banjo connection (A) to pressure gears (B), last of three gear sets on common shafts, others being scavenge gears, through gears to pressure filter (C). Oil forced through gauze-covered filter elements and oilways to centre tube (D) then out of front of chamber into the engine inlet (E). Oil is then driven up into the main oil pressure gallery and through oilways in crankcase webs to main bearings (F). From main bearings oil passes through holes into crankshaft (G) and through hollow journals and oilways in crankpins to big-end bearings. Splash oil from big-end bearings lubricates cams, tappets, and camshaft bearings (H), which have spiral grooves to pass oil through. Splash oil and oil from the thrust bearing then drains into bottom of crankcase (J) and is drawn back by twin scavenge pumps through outlet (K) via internal oil gallery on port side or from rear of crankcase below the timing gears. Oil is filtered in the pump before being returned to oil tank.

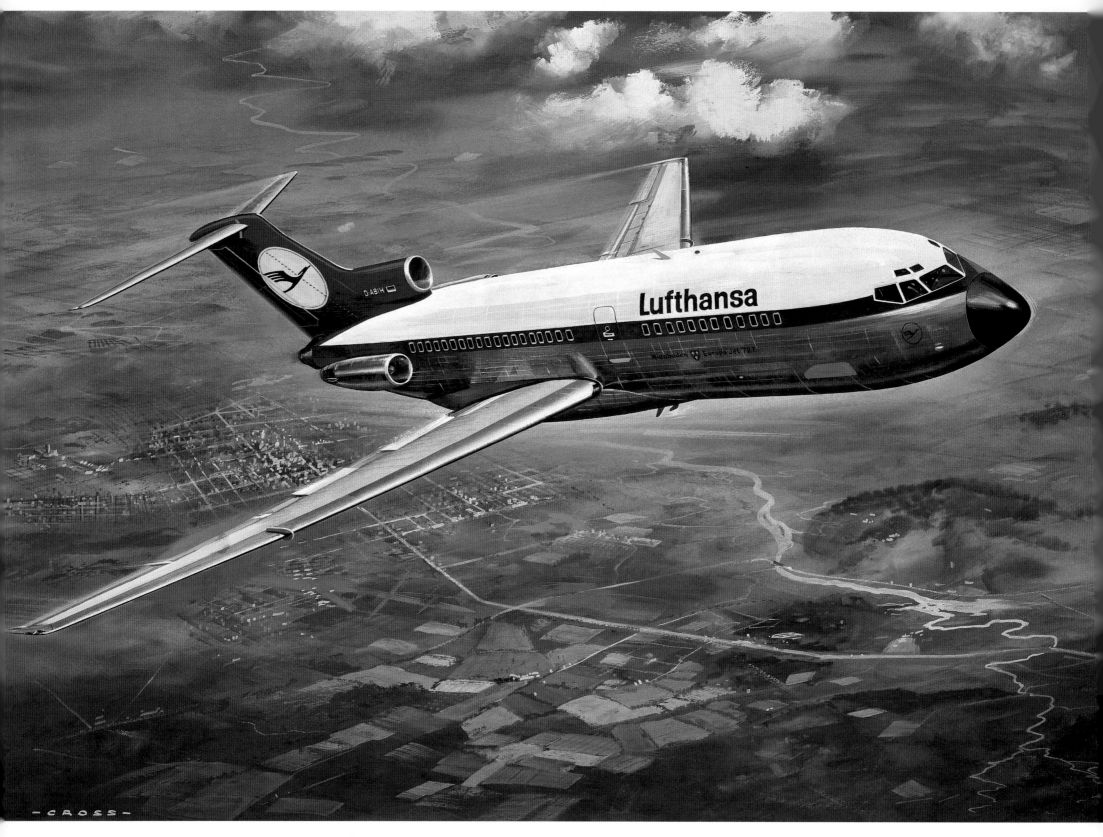

The world's first jet-engine-powered airliner was the revolutionary de Havilland Comet (RIGHT), but when Boeing in the USA were considering a new jetliner design they harked back to the B-47 jet bomber with the engines in pods beneath the swept-back wing, an arrangement which led to a whole series of successful passenger/transports, starting with the famous 707 series. The 727 short/medium range jetliner of 1963, however, used an entirely different layout with the powerplants grouped around the rear fuselage, leaving the wing entirely unobstructed, to the advantage of the aerodynamics (ABOVE).

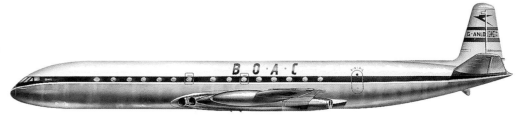

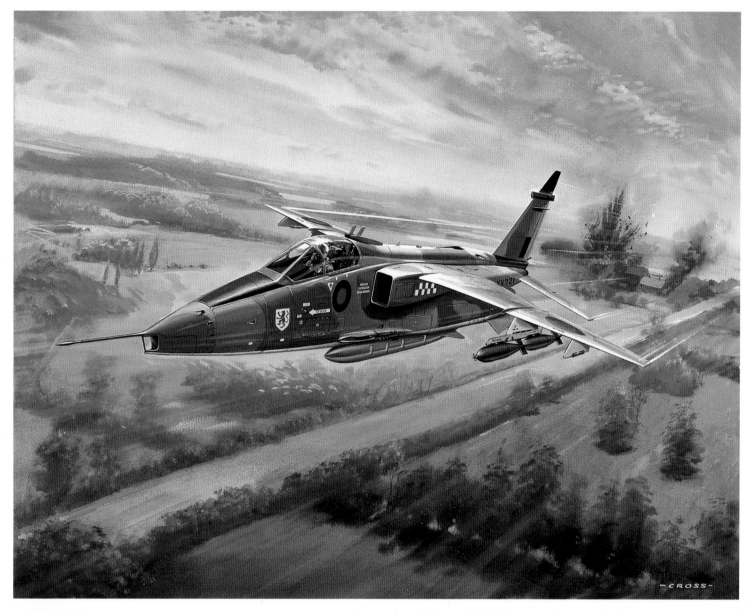

RAF Types

LEFT: Developed jointly by Britain and France, the SEPECAT Jaguar low-medium level strike aircraft.

BOTTOM LEFT: The English Electric P.1 Lightning supersonic all-weather interceptor fighter.

BELOW: The BAe-Scottish Aviation Bulldog 2/3 seat primary trainer.

Further enlarging the Boeing series of civilian jets, the 737 short-range airliner reverted to a wing-mounted powerplant arrangement, with two engines and using many of the structural features of the 727. Sales or orders number well over 4,000 of the ever-increasing stretched or otherwise uprated versions.

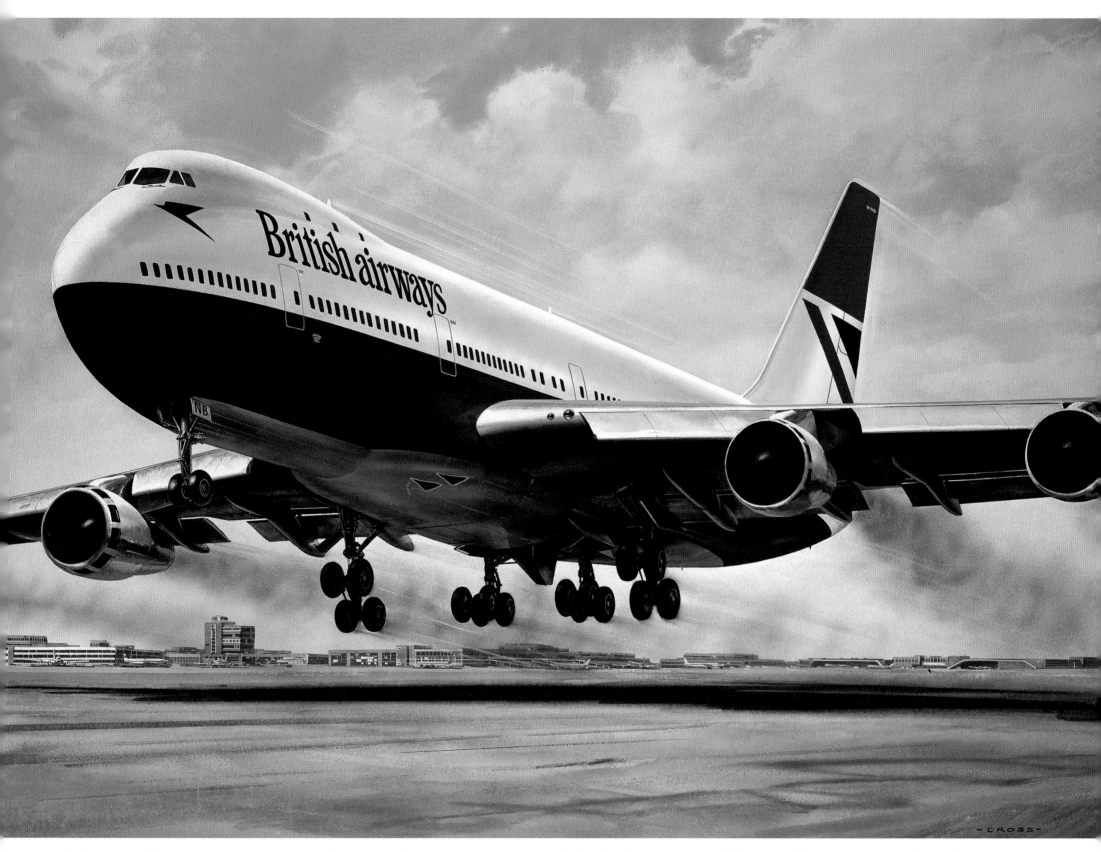

For long-range international and trans-ocean flights, the Boeing 747 reigns supreme. It first flew in 1969 and began service with Pan American on the transatlantic route early in 1970.

Featuring a wide body, upper-deck crew cabin and extra accommodation, the 747 doubled passenger capacity compared with existing types, with a top speed of 600 mph (965 kph) and a cruising range of over 5,000 miles (8,000 km). Like the previous Boeing jetliners, the 747 is produced in a variety of versions, including those for short-range domestic and ultra-long-range reduced-passenger routes and freighting. Lufthansa was the first European airline to receive 747s; BOAC started its 747 London–New York service in April 1971.

The ability to take off and land vertically brings obvious advantages for a high-performance fixed-wing military aircraft. Vulnerable complex airfield-installations can be dispensed with, close-to-the-front tactical operations are possible from basic well-hidden ground back-up facilities, and at sea such types can be launched from minimal deck space on naval vessels of moderate size.

The Hawker-BAe Harrier is the supreme embodiment of these characteristics and its design and load-carrying ability are well illustrated by the painting on the RIGHT.

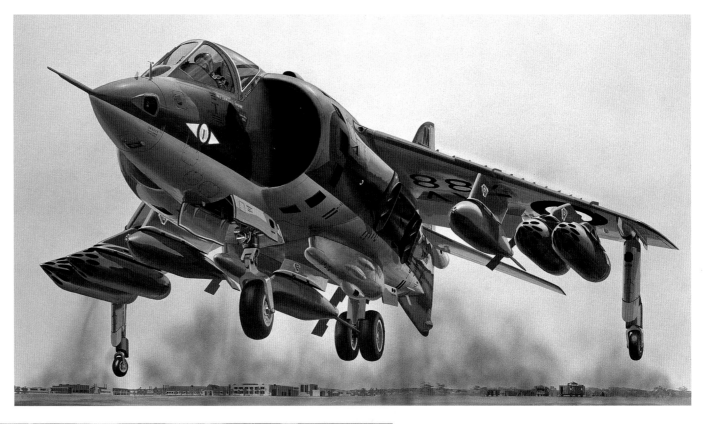

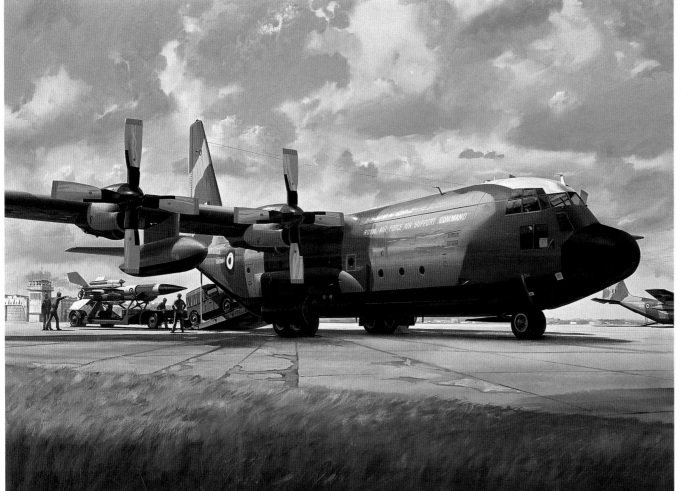

The Lockheed C-130 Hercules military transport was conceived as long ago as 1951. It had to have short take-off and landing characteristics from indifferent airfields and facilities for unloading military vehicles and freight, carry ninety paratroops and operate over medium to long ranges. So successful was the design that it is still used extensively by a number of foreign air services as well as the USAF and RAF. Versions have been modified for a variety of ancillary roles including gunships, for weather reconnaissance, with ski equipment, for search and rescue (US Coastguard), photo-reconnaissance, troop movement and humanitarian supply missions. Commercial versions are also in service.

LEFT: The original Hercules C.Mk 1, the later C.Mk 3s having a 15 ft (4.5 m) extension forward of the wing, added accommodation for 128 troops, extra cargo pallets or military vehicles, and a prominent in-flight refuelling probe above the crew cabin. The newest C.Mk 4/5s have an advanced two-pilot flight deck and improved integrated defence systems including missile and radar warning, integrated jammers and chaff-flare dispensers.

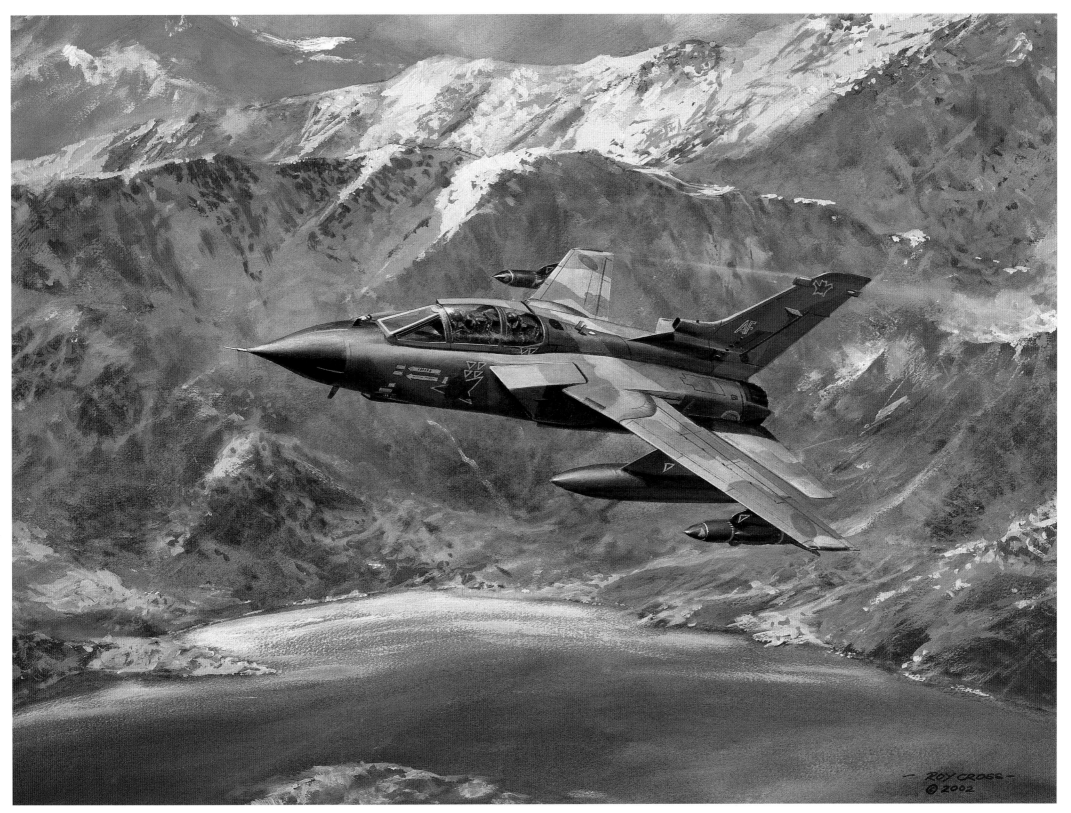

Such is the huge expense of financing a new combat aircraft of the complexity of the Tornado all-weather strike/air-defence/reconnaissance two-seater that the aircraft industries of the UK, Italy and Germany combined under the umbrella of Panavia Aircraft GmbH to produce it. The various recipient air forces have differing operational priorities, but in the case of the RAF, in various versions it replaces the Vulcan bomber, the Canberra bomber/reconnaissance/interdictor and the Buccaneer naval strike aircraft. Here a GR Mk 1 is flown by Sqn Ldr (now Group Captain) Ken Cornfield of No. 9 Squadron, RAF, the first unit to receive the Tornado.

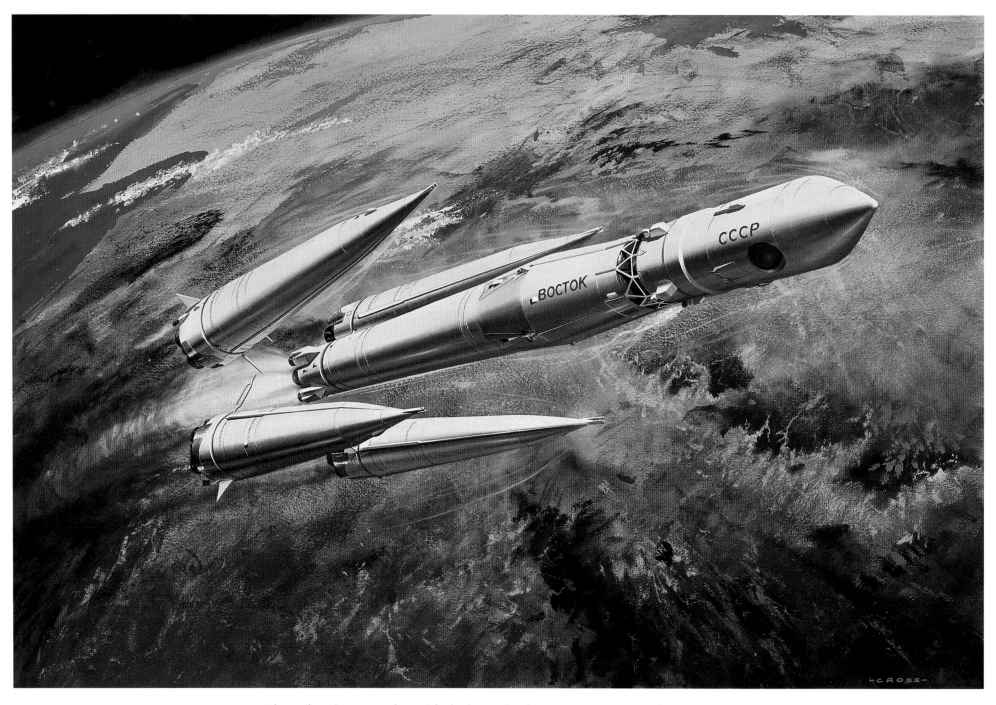

Always keeping up to date with the latest developments in aviation and indeed venturing into space, Airfix produced models of the Lunar Module and the Apollo Saturn V in 1969 and the following year the Russian Vostok rocket, the illustration for which is shown here and serves as a suitable end-piece for this gallery of aeronautical art.

Sopwith Pups